To Eliza[beth]
Could the
baby photos of you
totally cherished ?!

Mary McCartney
2018

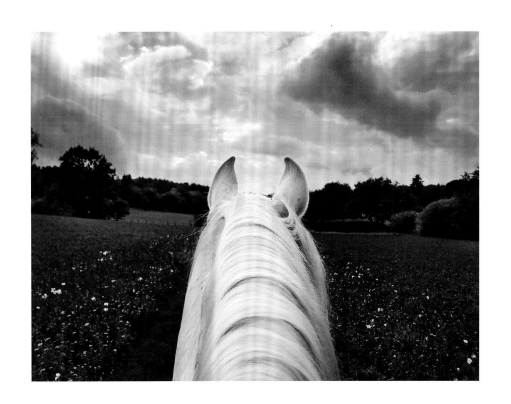

THE WHITE HORSE

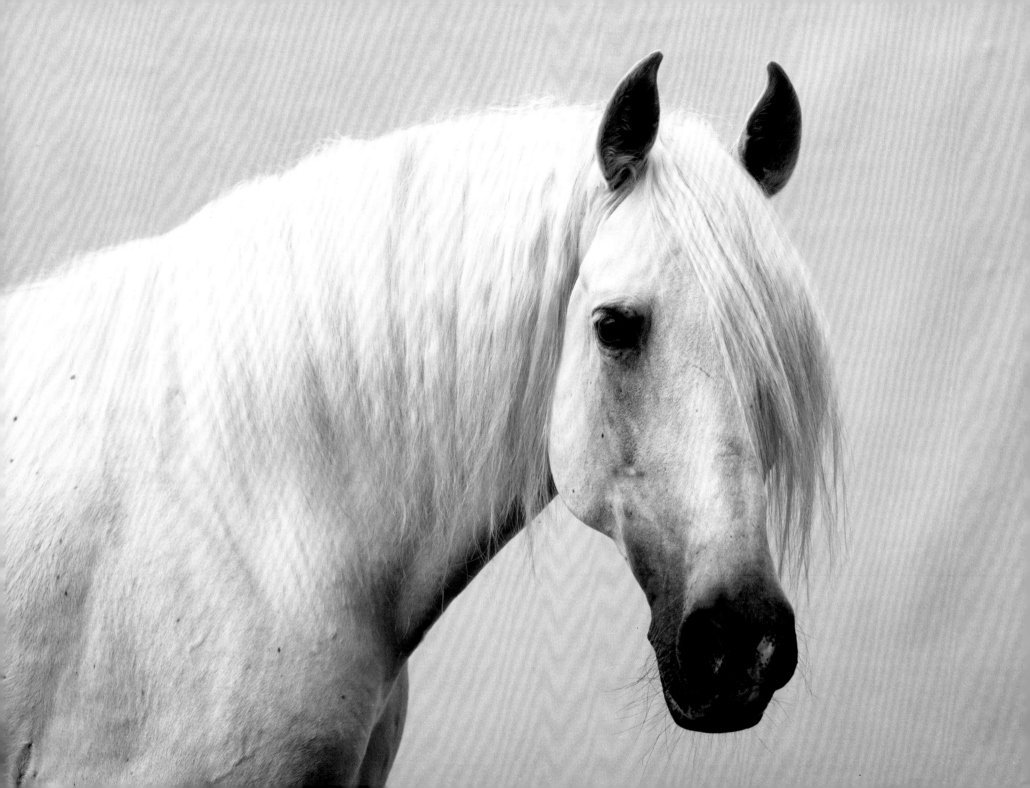

THE WHITE HORSE

MARY McCARTNEY

RIZZOLI
NEW YORK

To my mum and dad for sitting me on a horse before I could even walk.

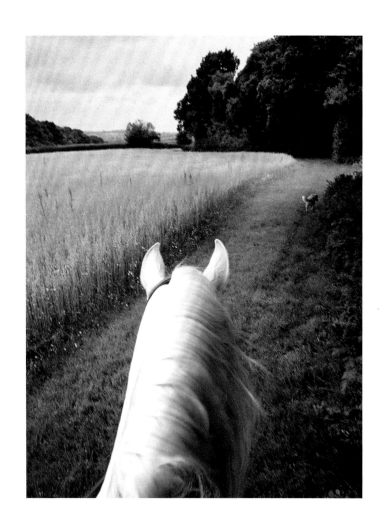

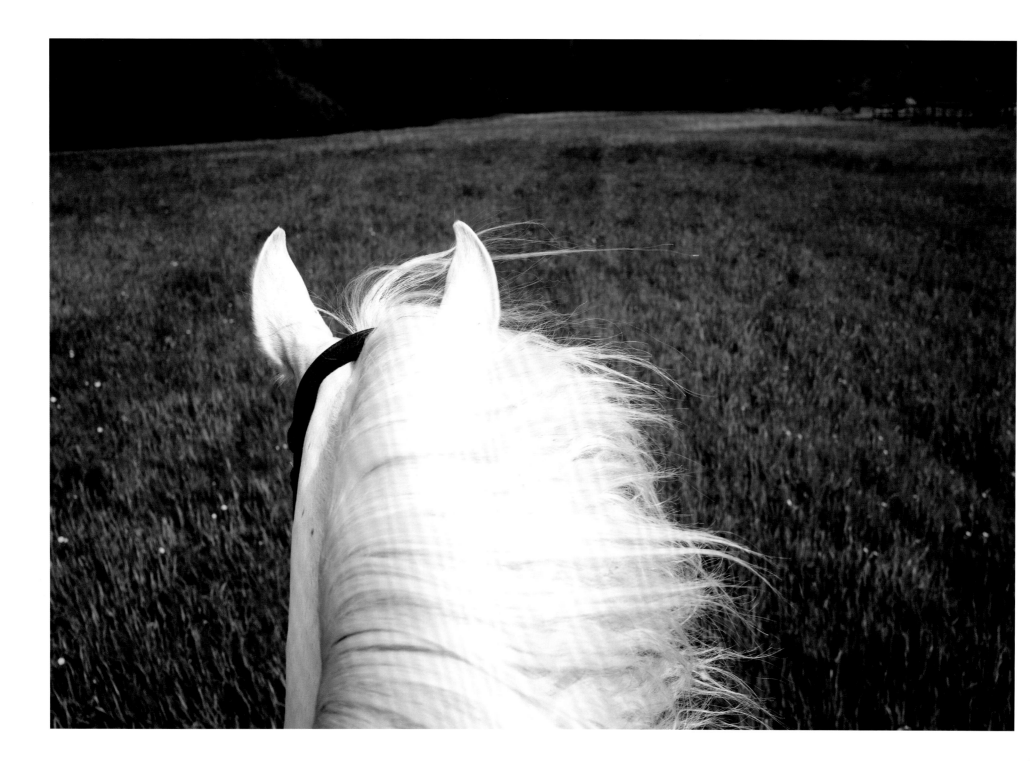

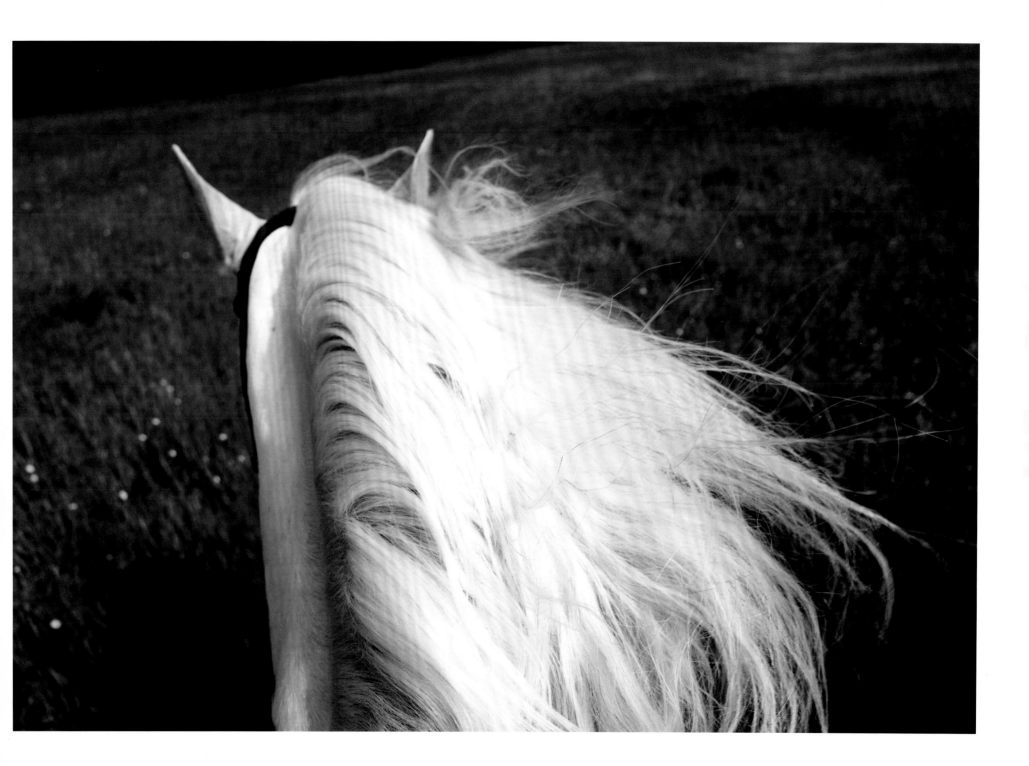

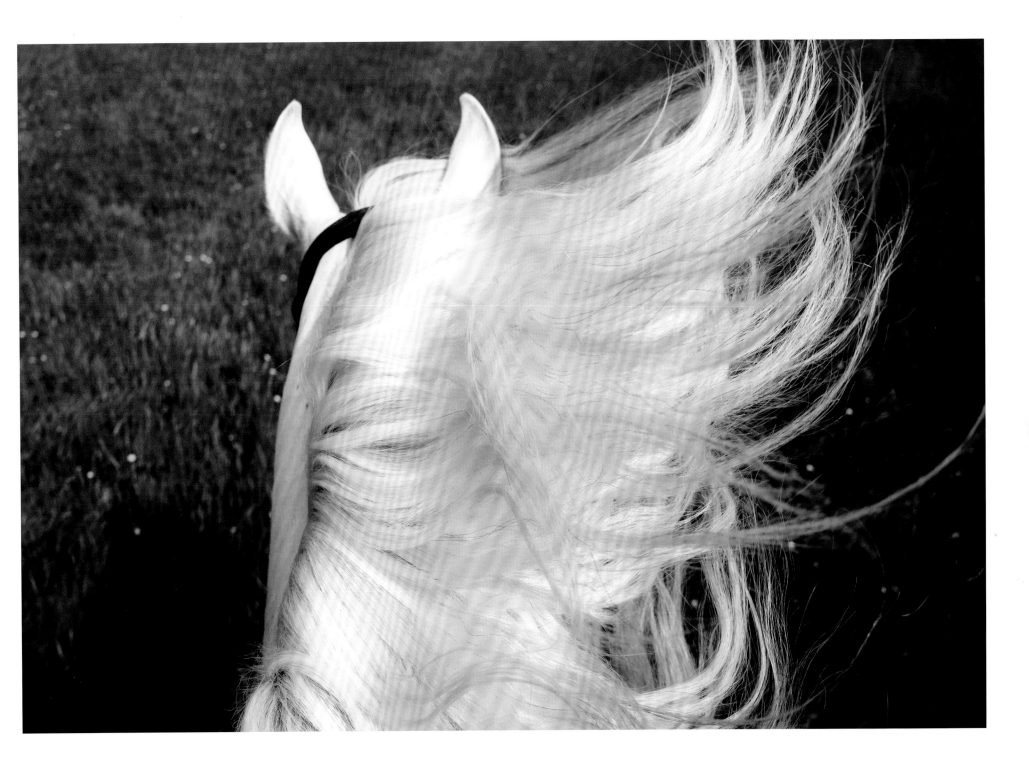

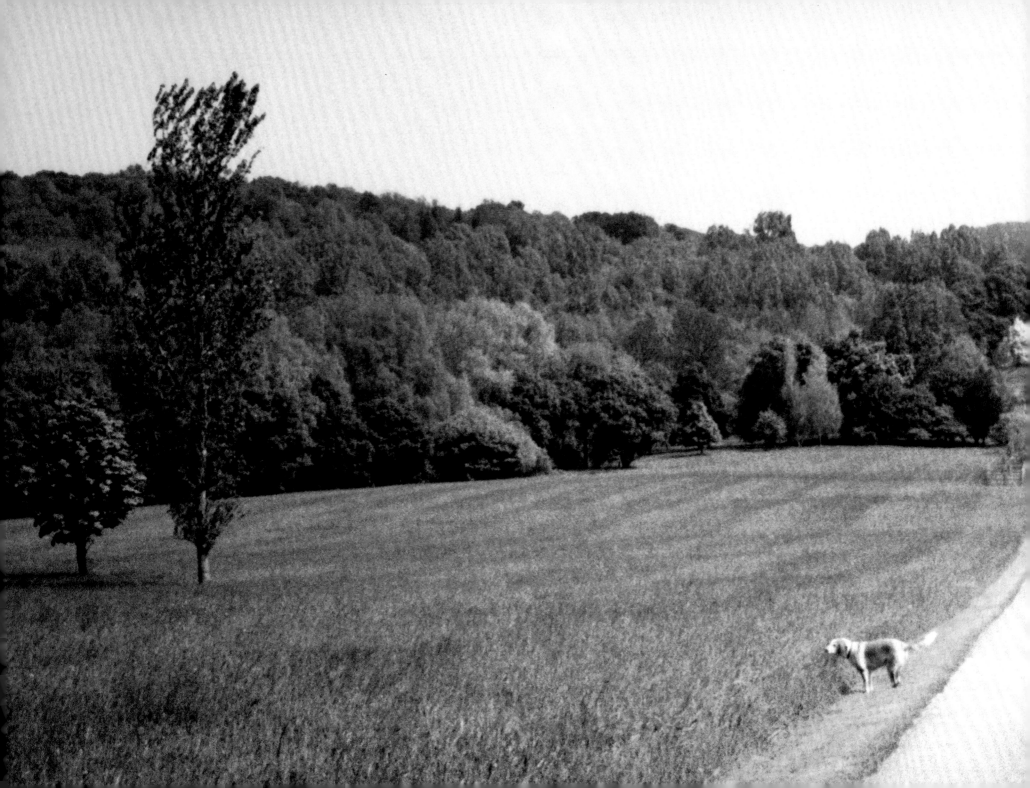

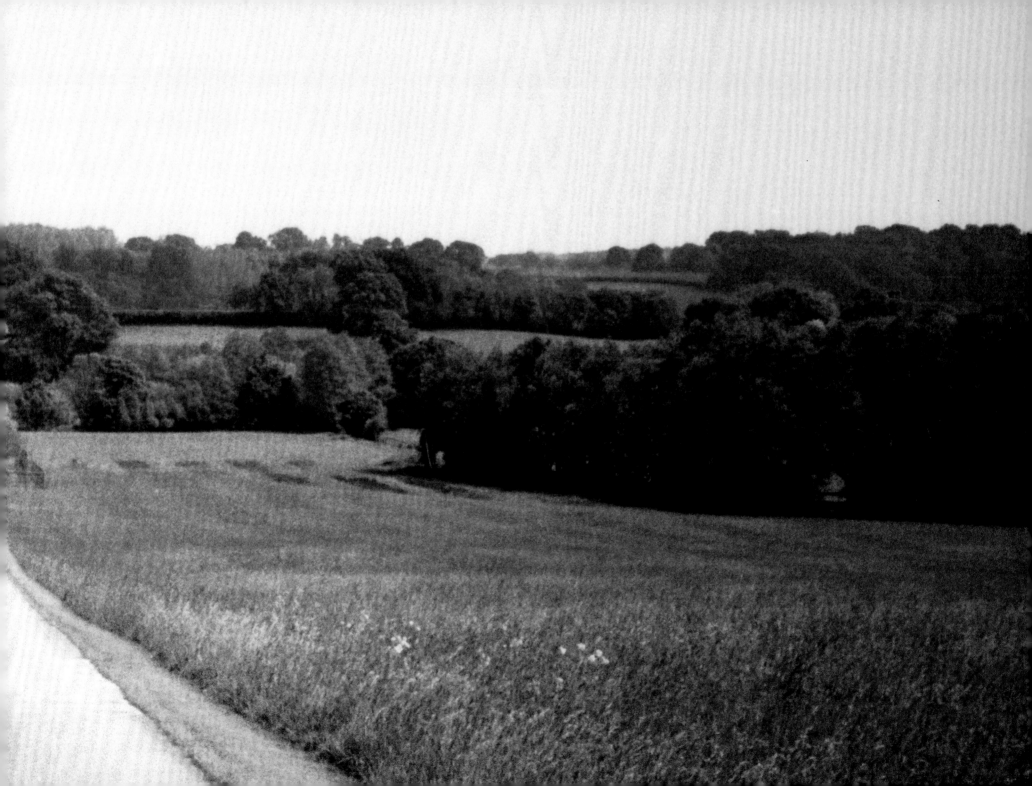

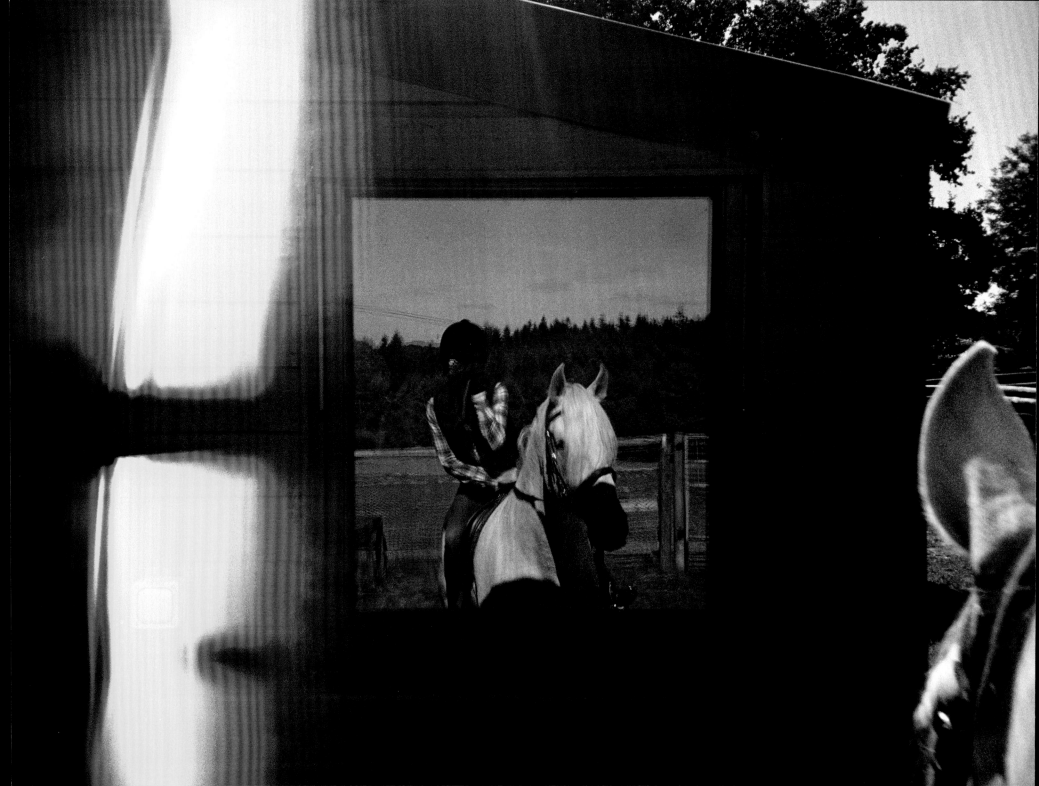

THE WHITE HORSE BY MARY McCARTNEY

Alejandro is the horse I ride. A stunning white Andalusian stallion, well aware of his own beauty. As in any relationship, there's good and bad. He can be difficult and moody, like any of us. But he has the most generous spirit. He's noble and kind. We have a partnership, an understanding. His strength carries me. I am the navigator only in the direction he takes. He lets me find the rhythm through which we travel together.

He is the viewing platform that offers me a constantly new perspective of an English landscape—that extraordinary place where I grew up, that was outside my door and demanded exploration. I know it intimately. It's where I go to disappear. We ride to find something unfamiliar in places we've seen before—and always to free my mind.

Each ride is unique, with my senses drawn to details, as the seasons unravel, offering up glimpses, like snapshots. New shoots on the forest floor, the first bluebells, the scent of wild flowers, skeletal trees in winter, the sound of ice under a hoof, swallows in the warm summer air.

The light is everything. Dappled sunlight, the longest shadows, the last light of day, the moonlight, the freezing winter dawn as I crunch my way to him in the stable.

Here, in the landscape I know best, everything comes into sharper focus. Seasonal colours up close and vivid, witnessing the onward march of time as we gallop through the silent countryside. This is where my dreams can find their intimate details. The inside out and upside down of everything I know. This is where negatives become positives, where I enjoy the elements in their extremes, finding simple and surprising exhilaration in returning soaked, sweating, or freezing.

It is a place to hang on and let go, to concentrate on nothing and conjure up something, to ignite a new idea or image. Together in glorious isolation. And all the time, the rhythm of many-legged breath and muscular power driving us both forward to where we began.

INTRODUCTION BY SIMON ABOUD

Mary came up with this idea out of the blue. A study of the horse she rides in a landscape she grew up in. One year of work that would take in the dramatic changes to the landscape as backdrop. The horse, an extraordinary white Andalusian stallion called Alejandro, seemed an appropriately stark contrast to the classic English landscape. She seemed so empowered by the possibilities. The idea lit her up.

Looking at the finished edit, the images are less about horse and landscape than the horse becoming part of the landscape. Part of the form, part of the texture. Alejandro is subsumed by light, night, rain, and sun. He becomes part of a deep red backdrop of Acer trees, part of the night, part of a bluebell wood that we know so well. He is presented as the sum of beautiful parts rather than the whole.

By constructing the work this way, Mary has managed to focus on elements of beauty. From the obvious musculature to the simplicity of a single, dark, giant eye. From the movement of the white mane that imitates white marble to the close-ups of matted hair, the images project the horse as subject, linking so closely with the intimate knowledge of a landscape she has known most of her life. A private world shared only with family and friends. A place of safety thrown open to public view. This is the soul laid bare.

In many ways, I think Alejandro represents Mary in these landscapes. Free from a prying eye, this is about freedom and potential. About moments of joyous solitude and a passion shared with a mother long gone. Moments shared with father and family as they travel the path well known but transformed into the ethereal and sometimes surreal. Alejandro becomes our guide to a journey of a young girl to confident woman, of a landscape full of memories to a dreamscape full of the imagination and the promise of things to come.

What was in her mind were incredibly bold, big prints that Alejandro would inhabit but, at every step, would play a slightly different character. From the Alejandro at night, lost in a dark forest, to the Alejandro in sharp focus, constructed of alabaster.

To me, the images seem to be representations of times, moments, dreams, and yearnings on a scale that draws us effortlessly in. There is not only undeniable power and stature but also vulnerability and truth.

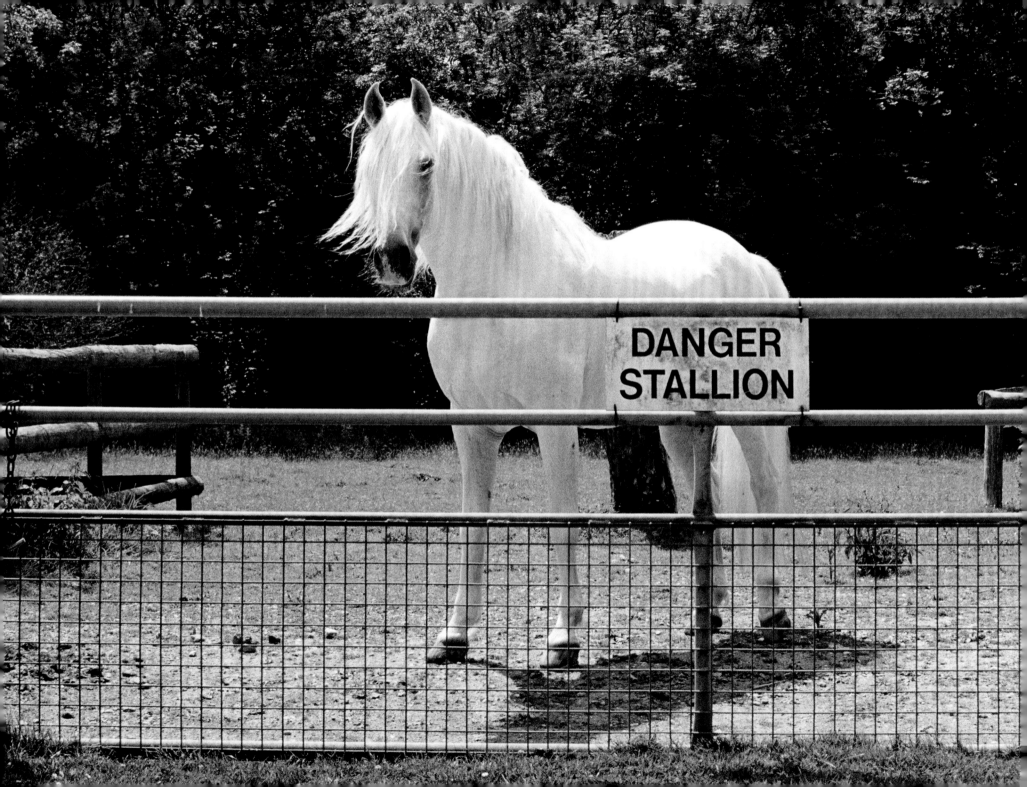

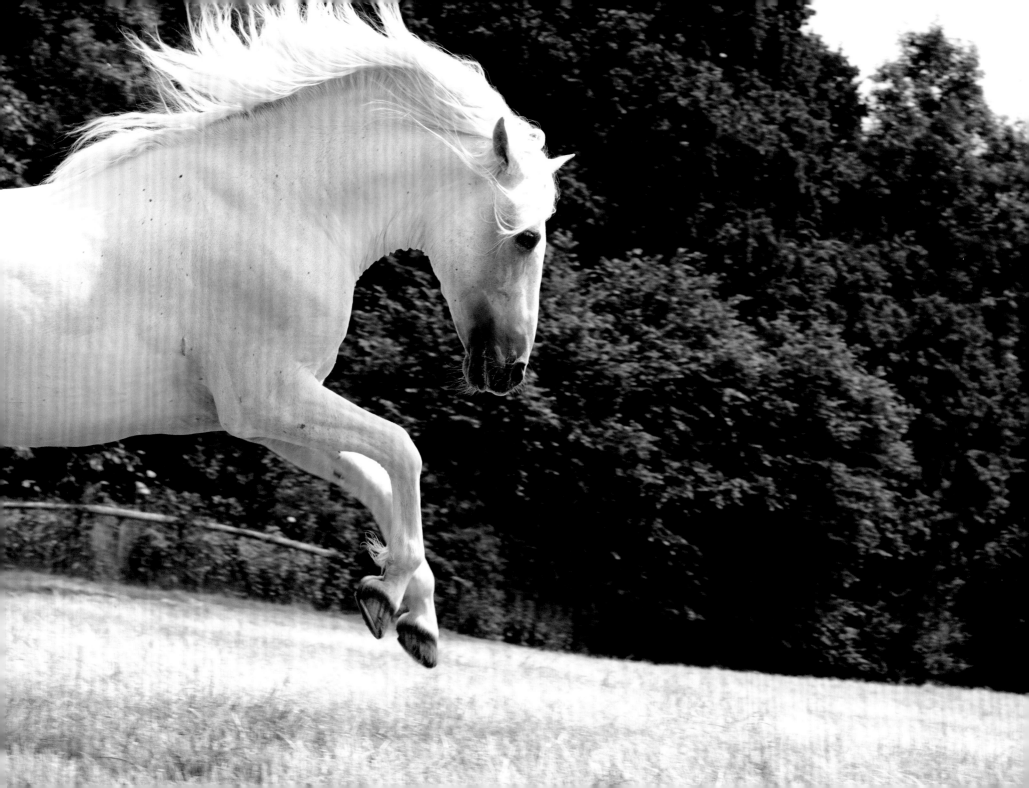

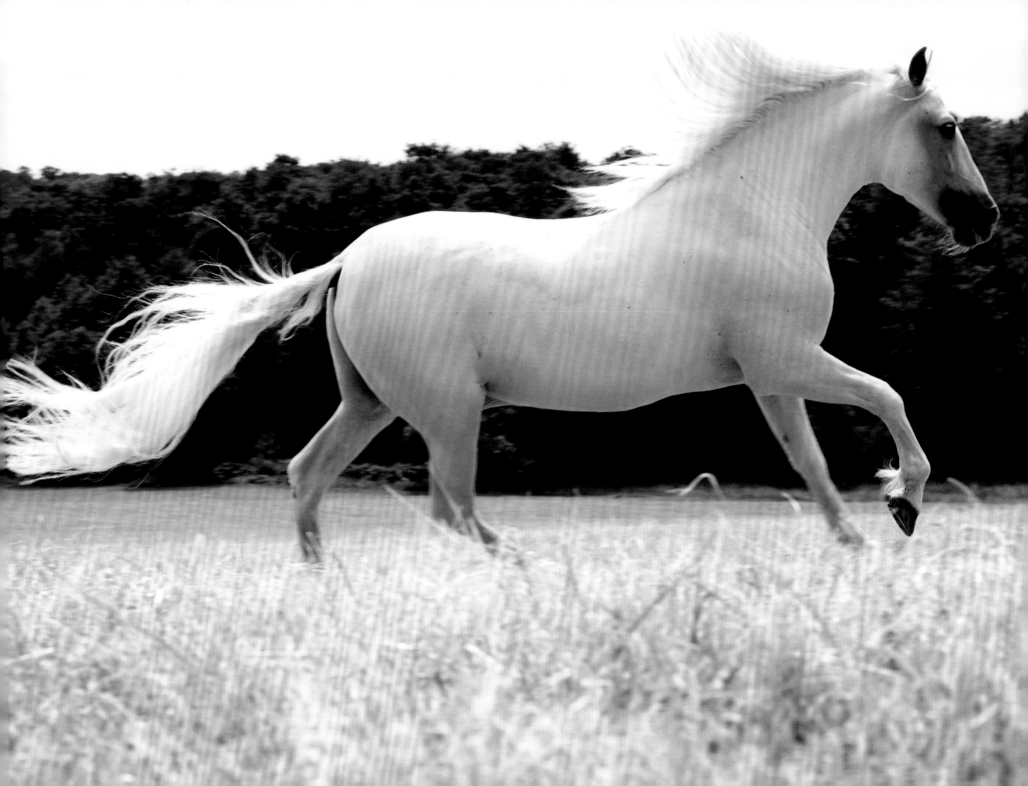

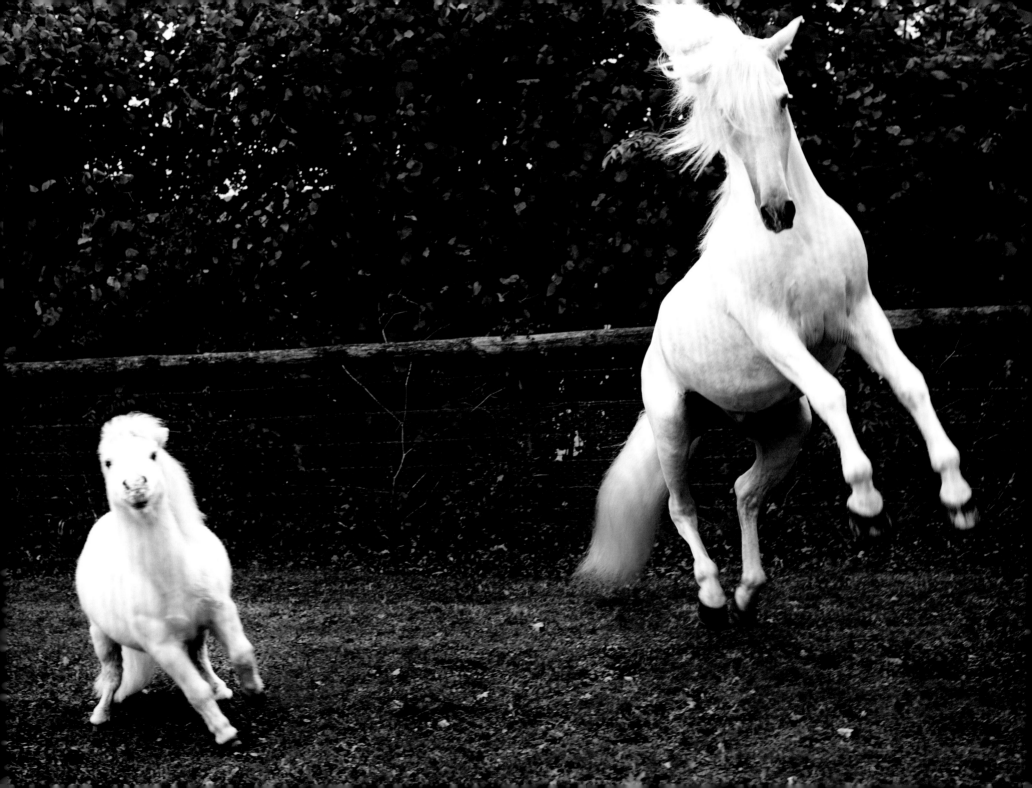

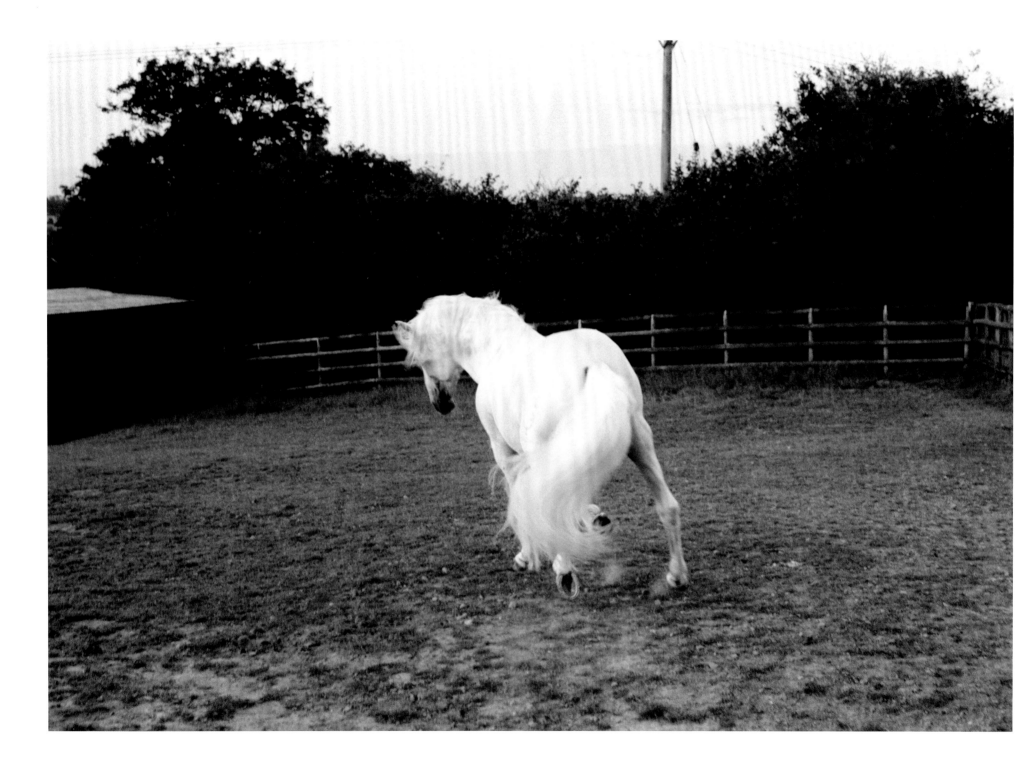

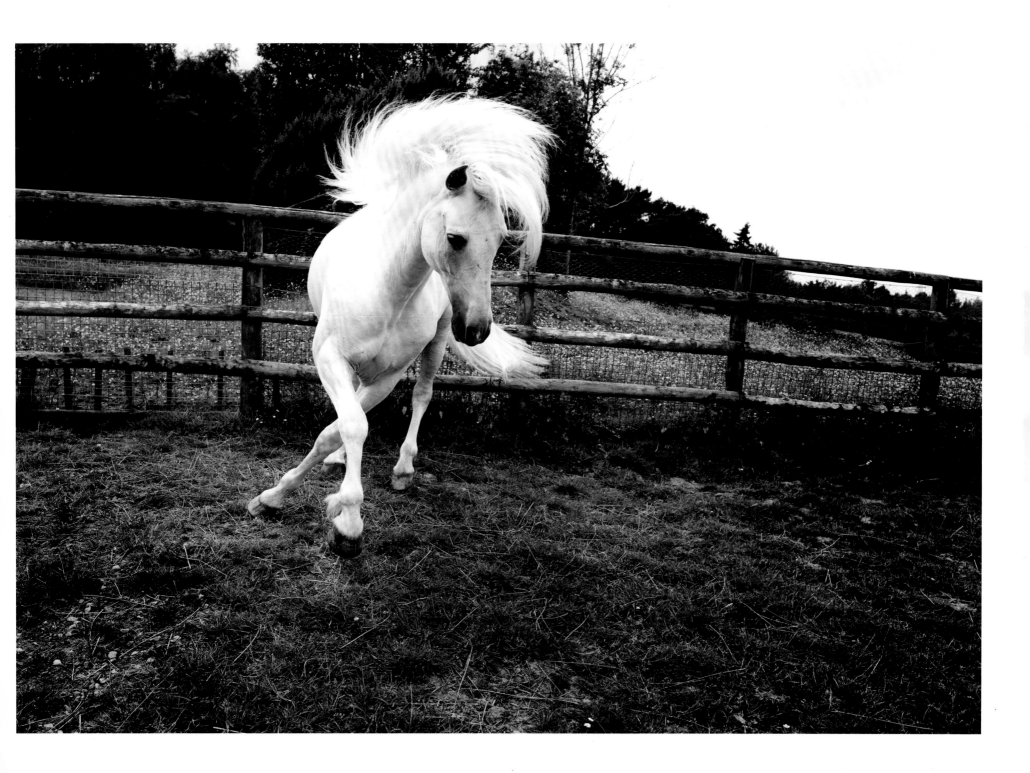

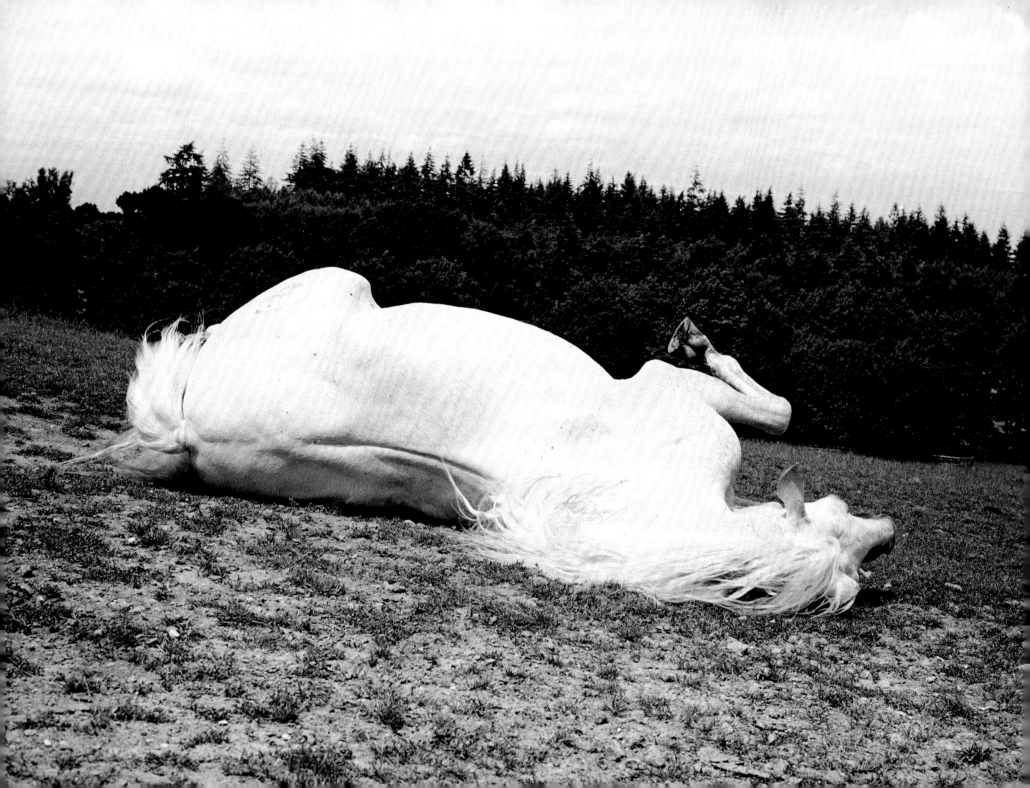

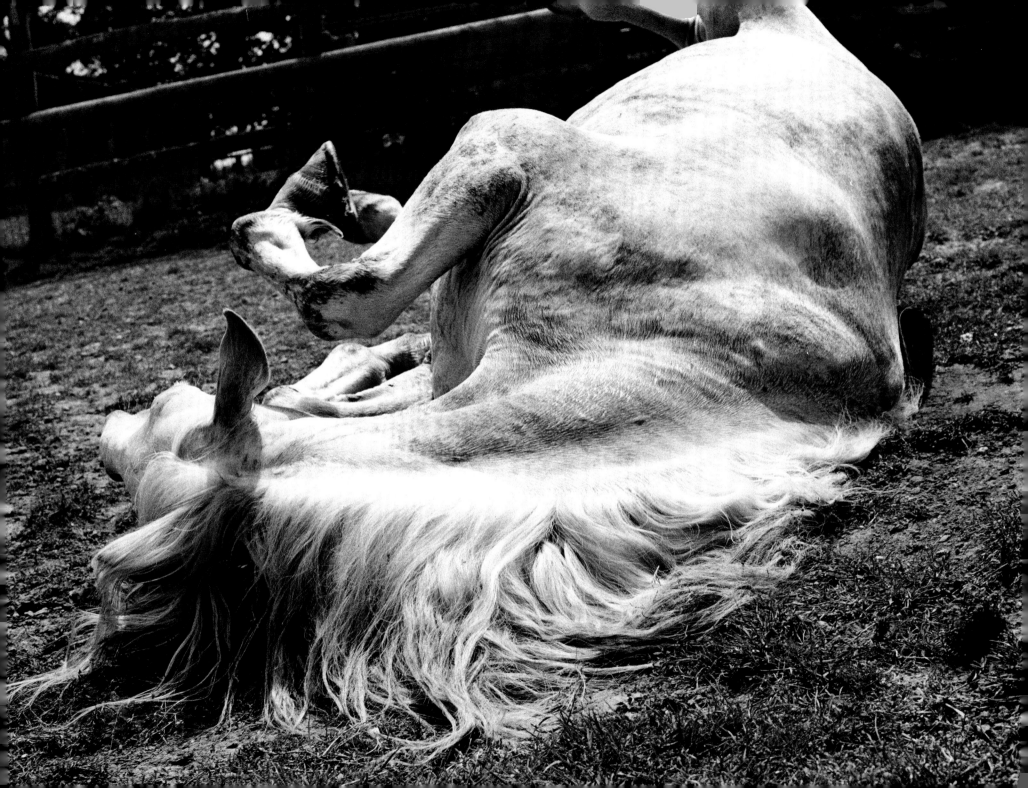

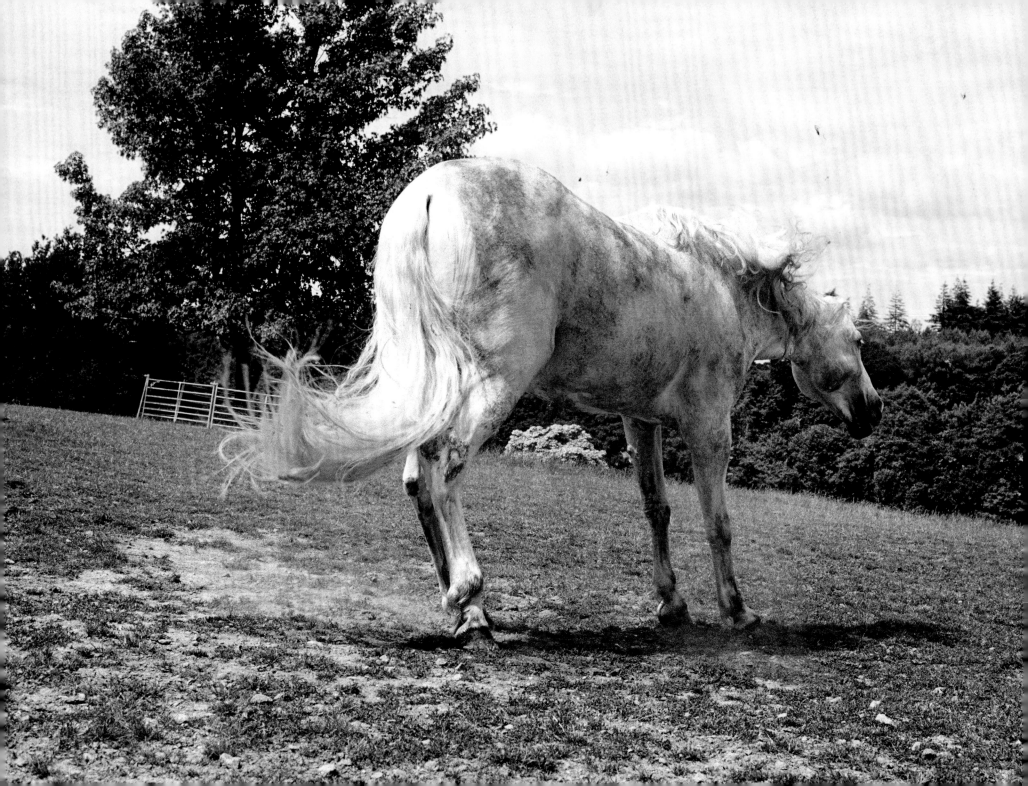

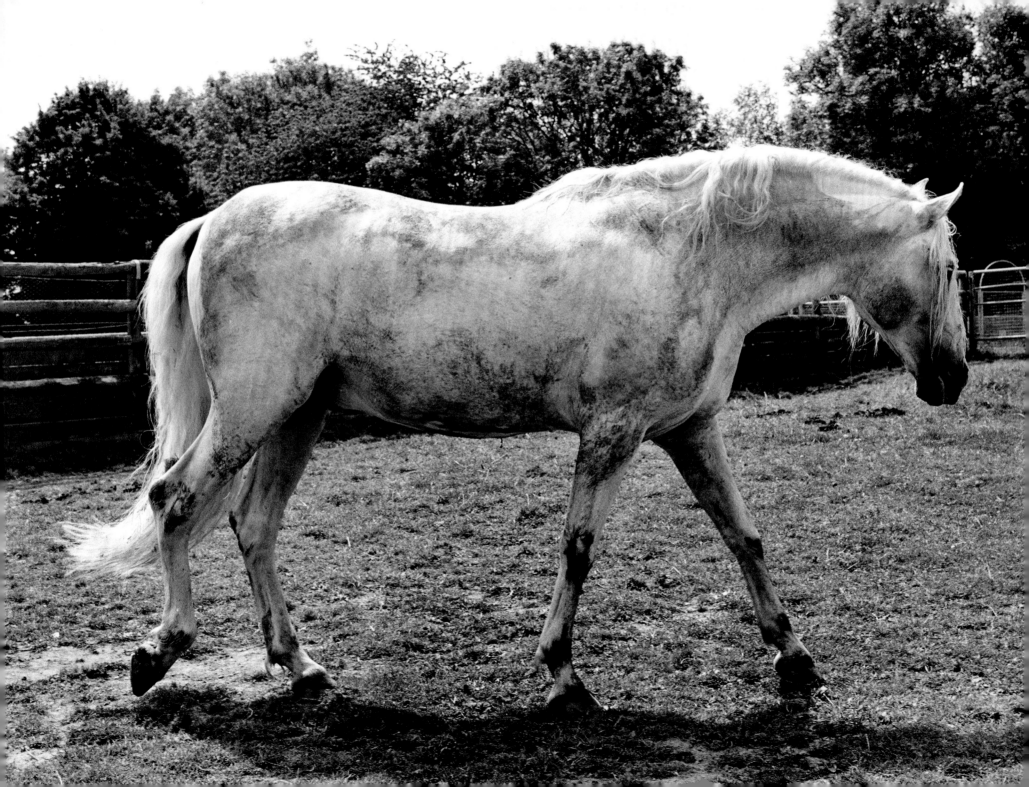

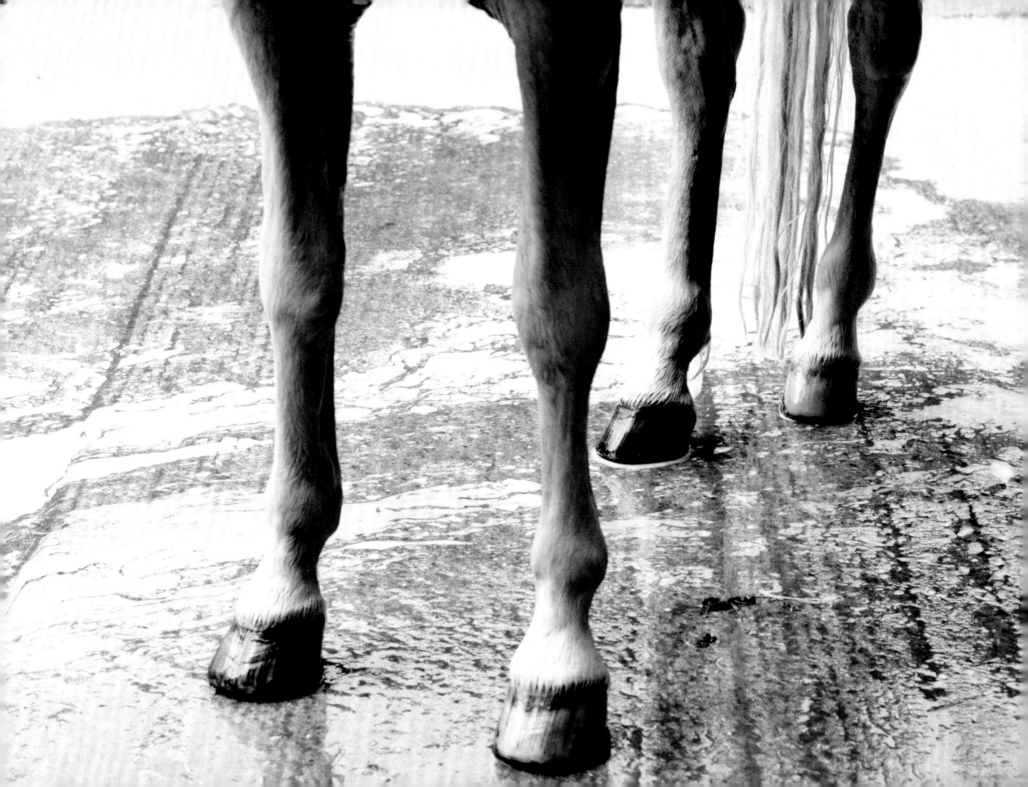

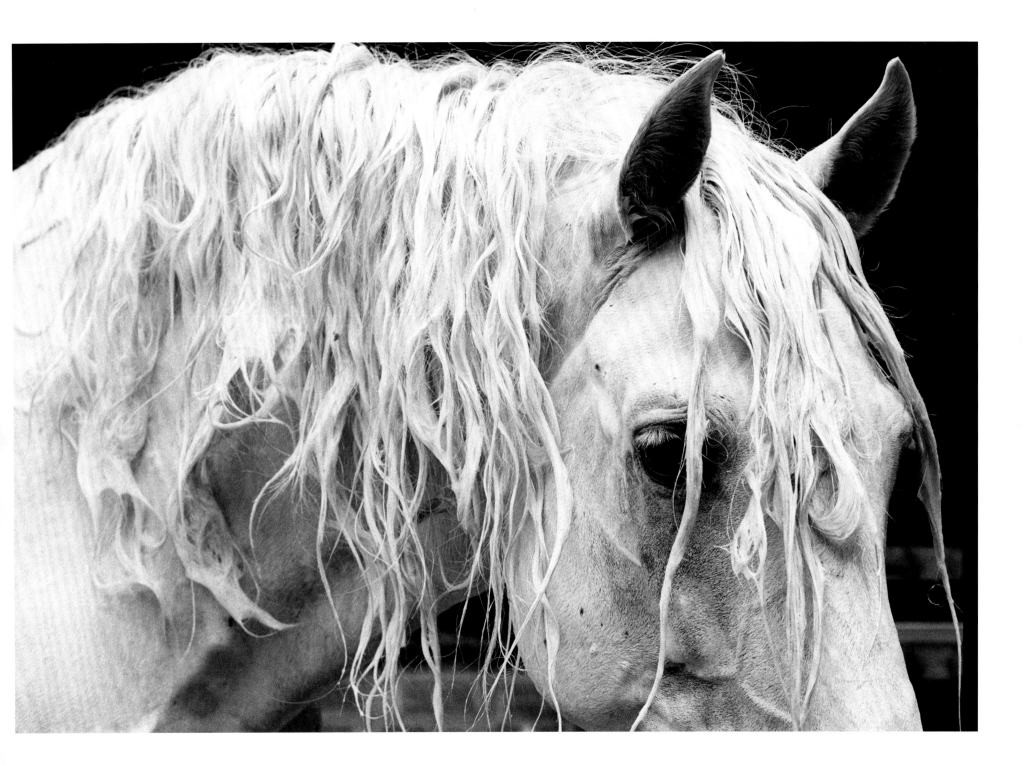

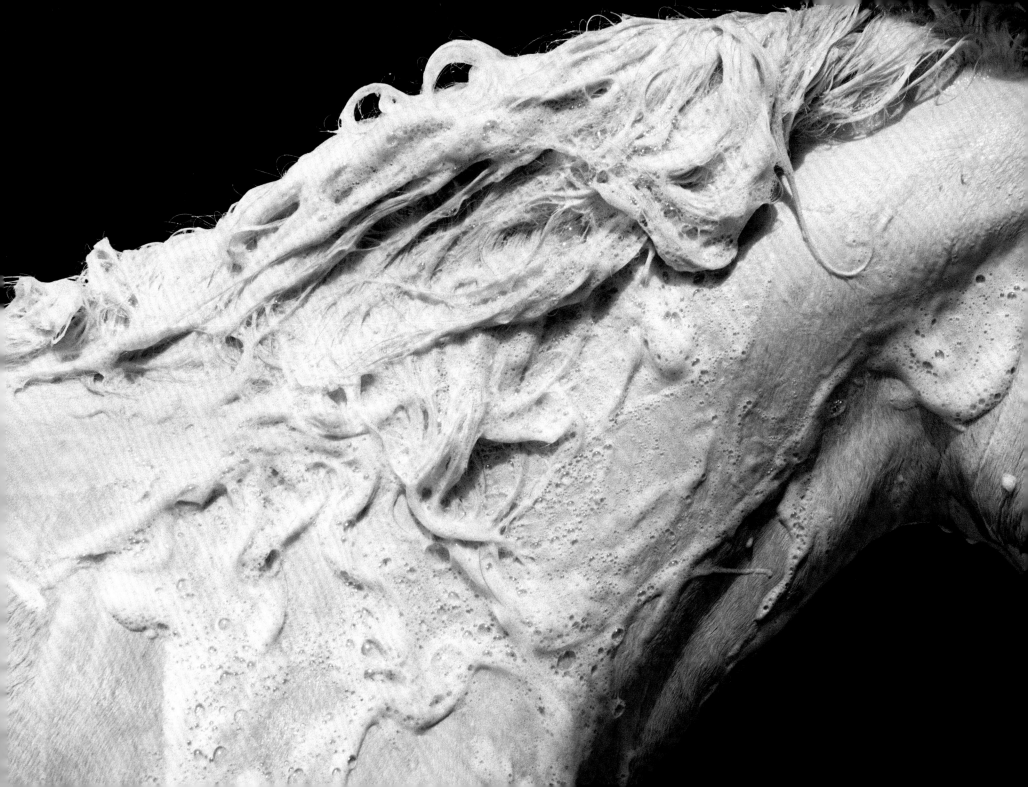

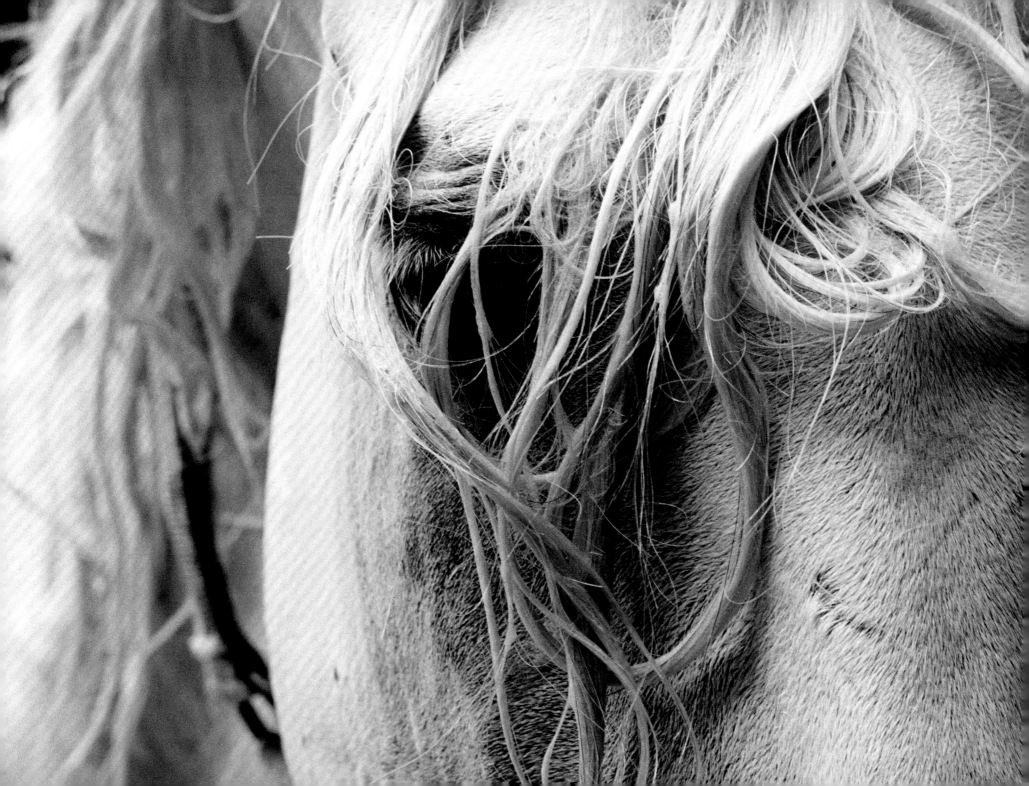

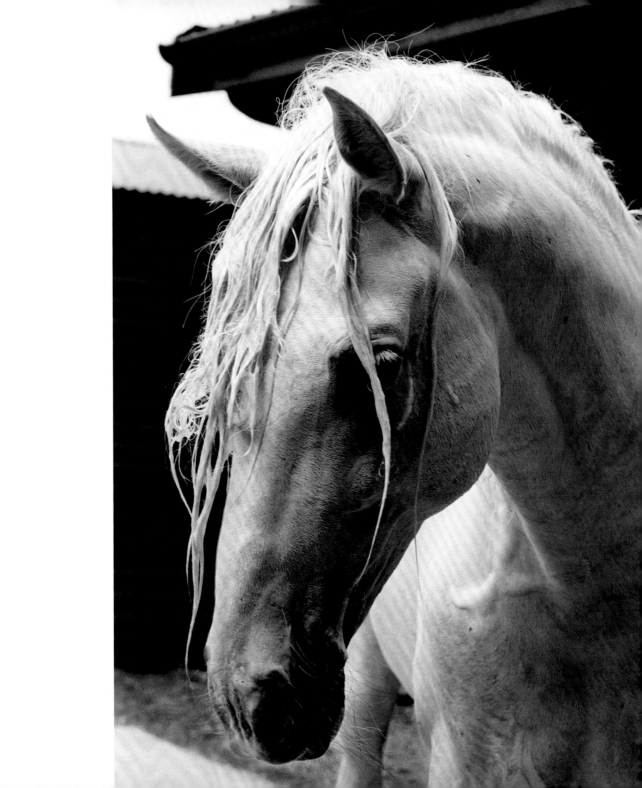

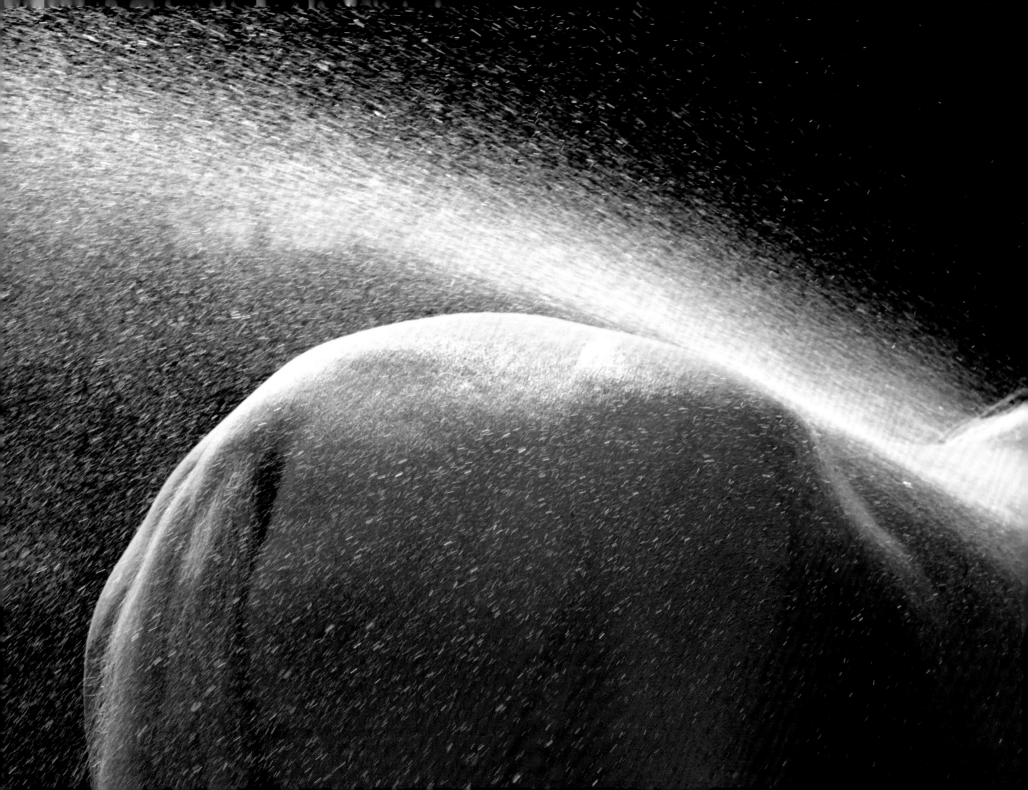

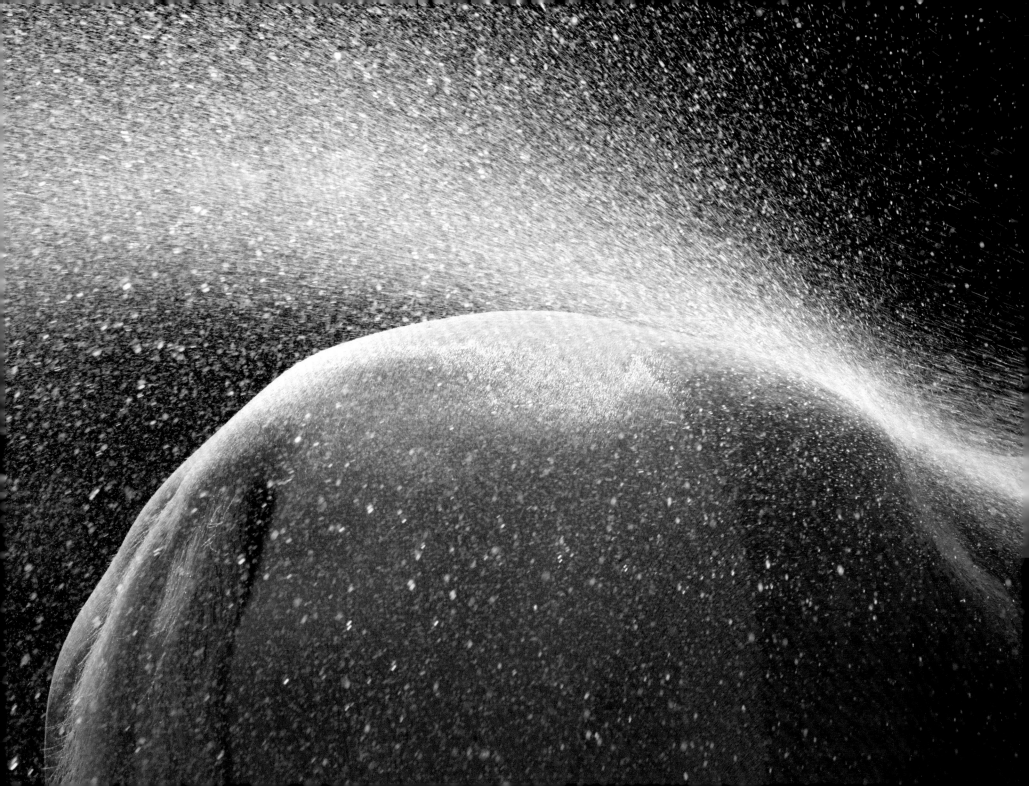

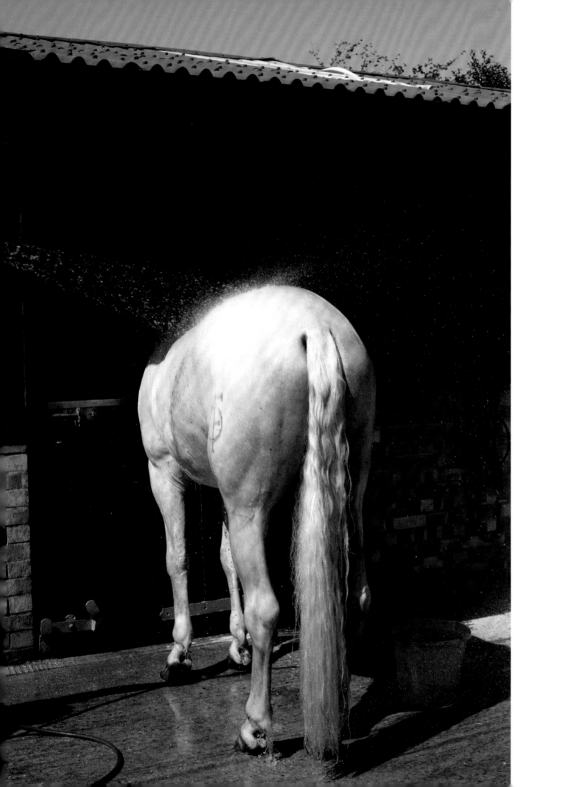

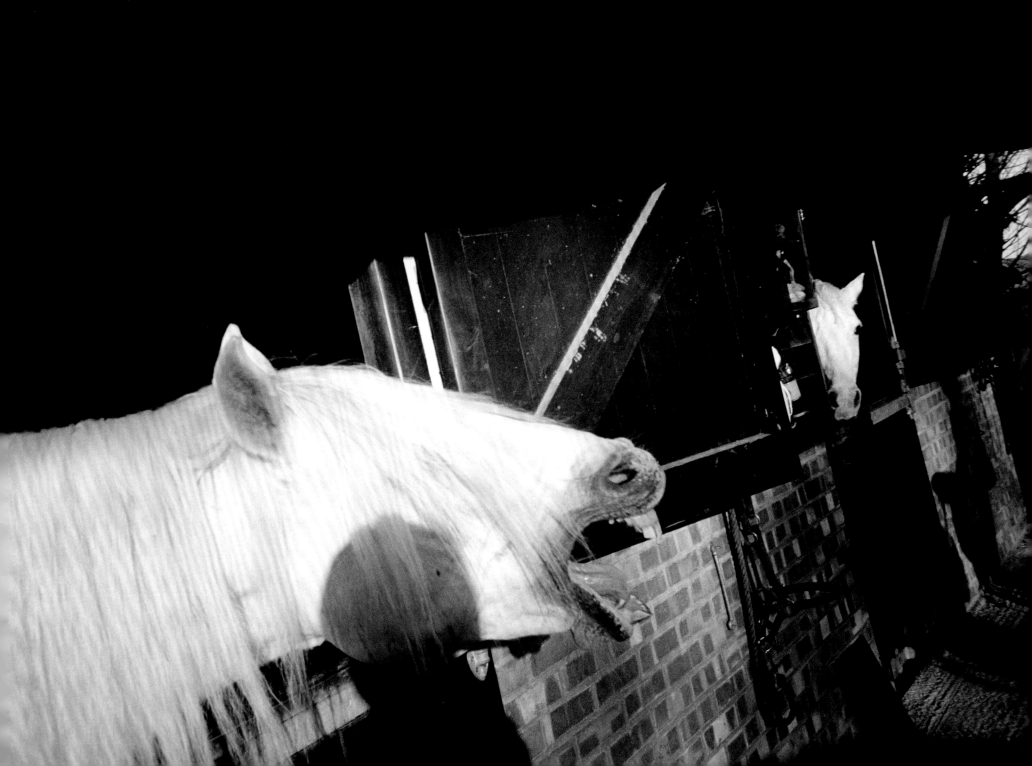

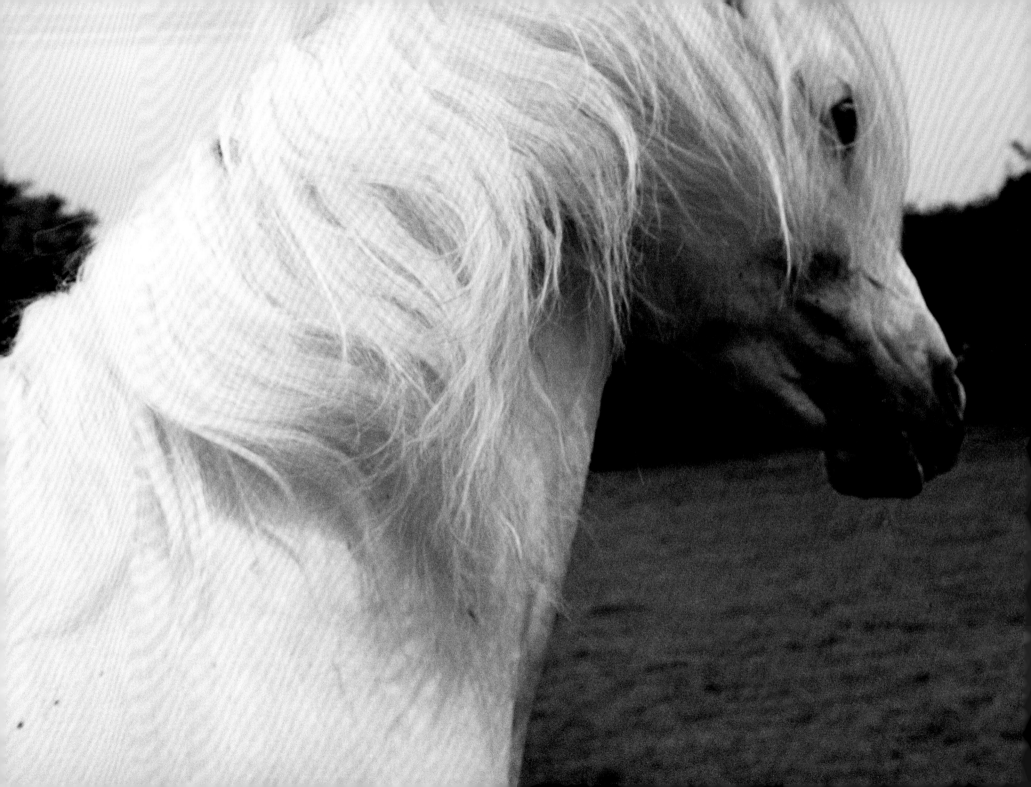

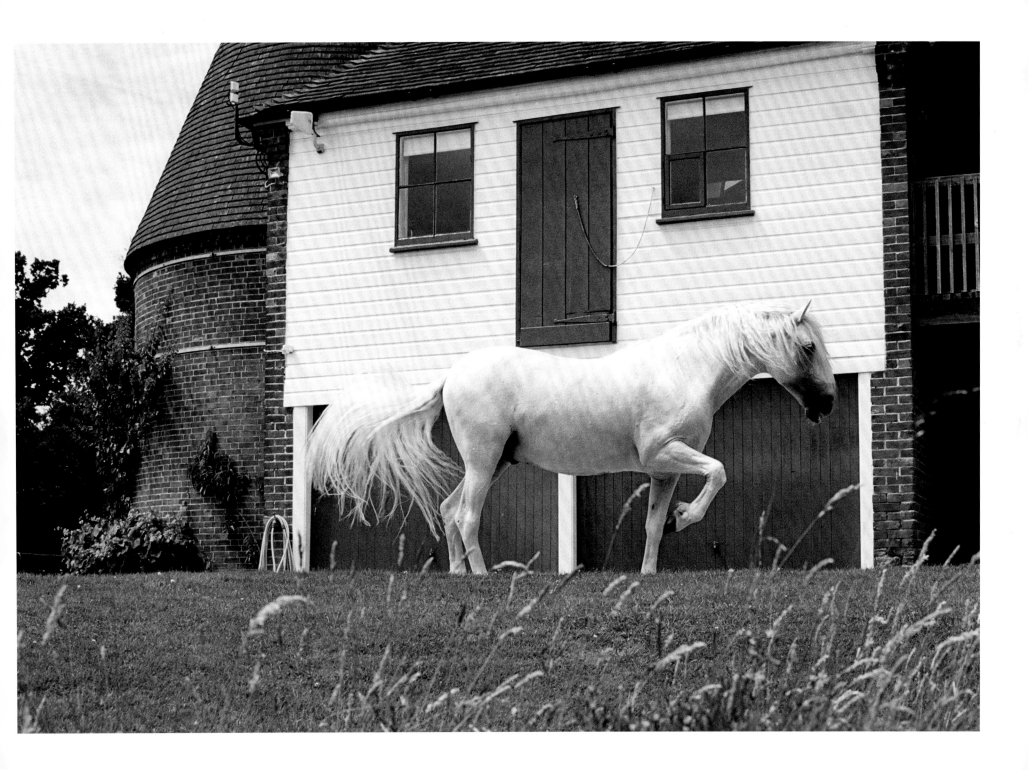

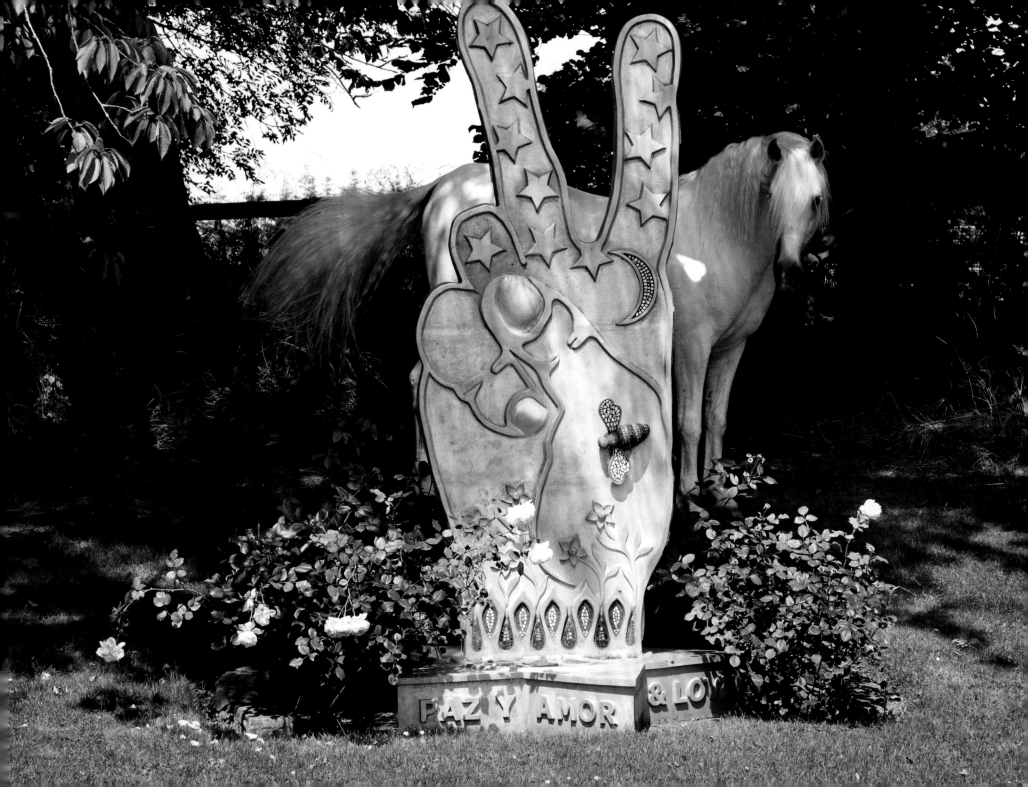

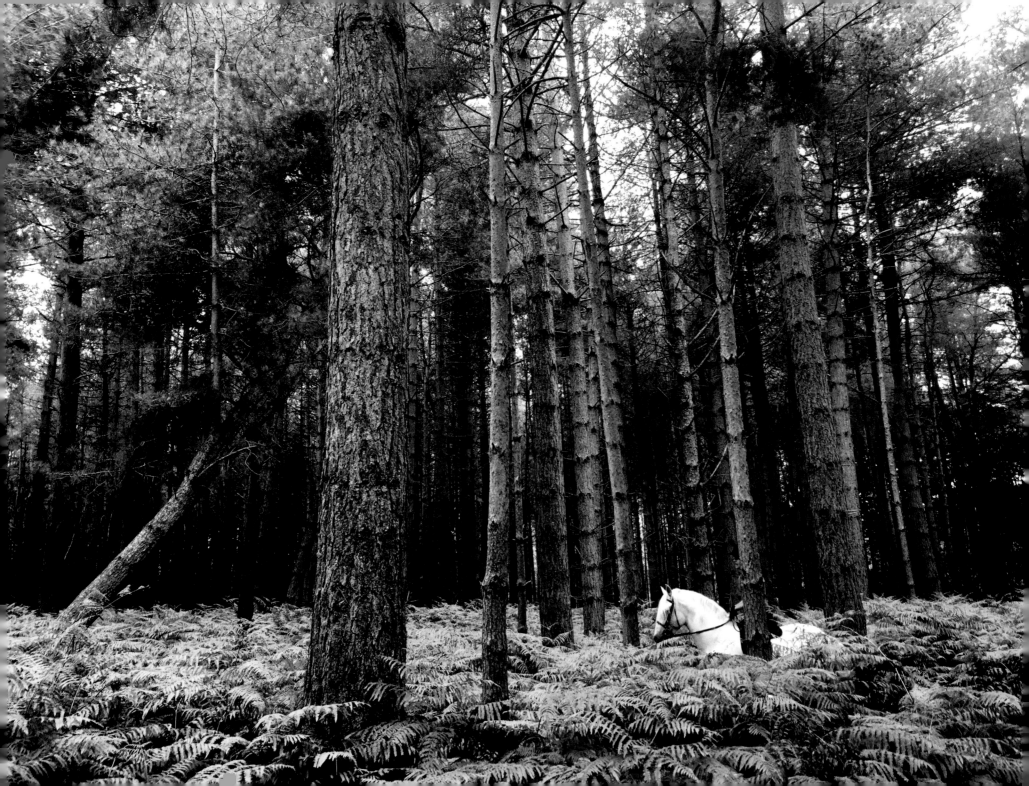

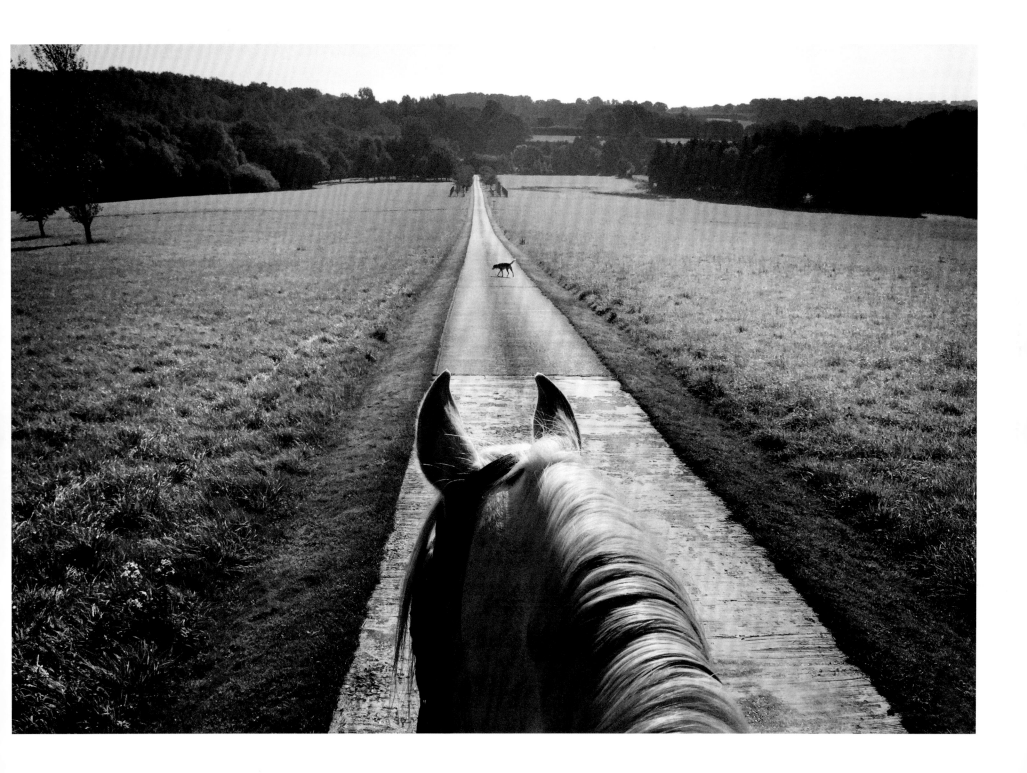

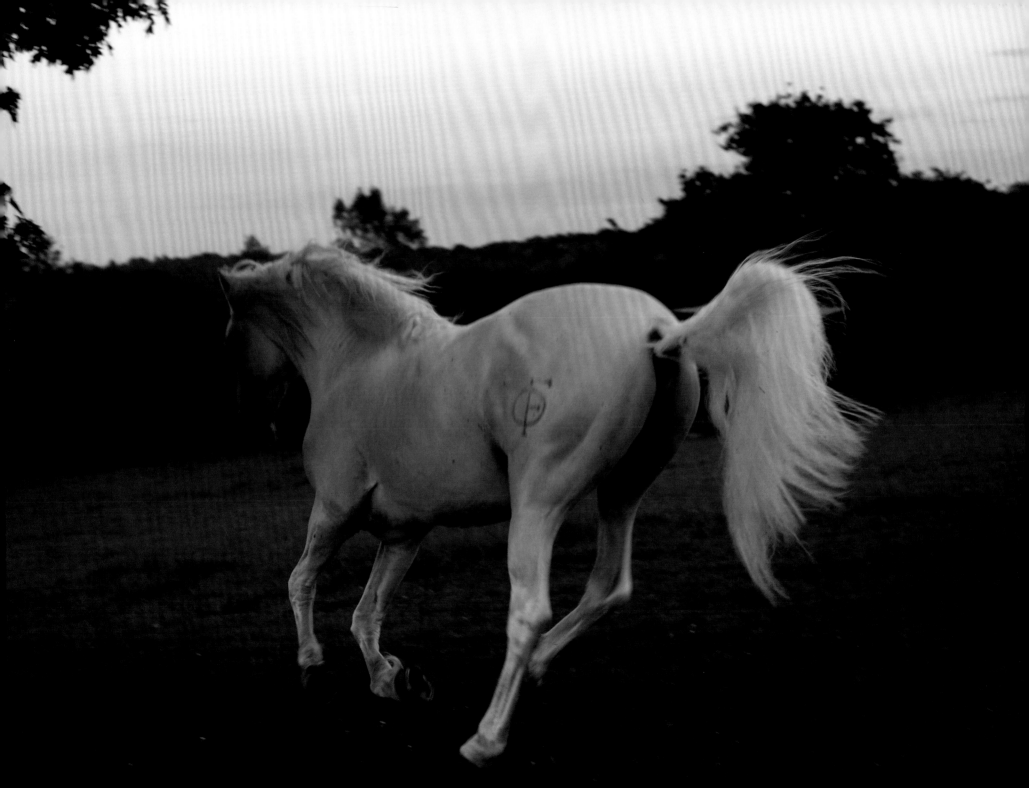

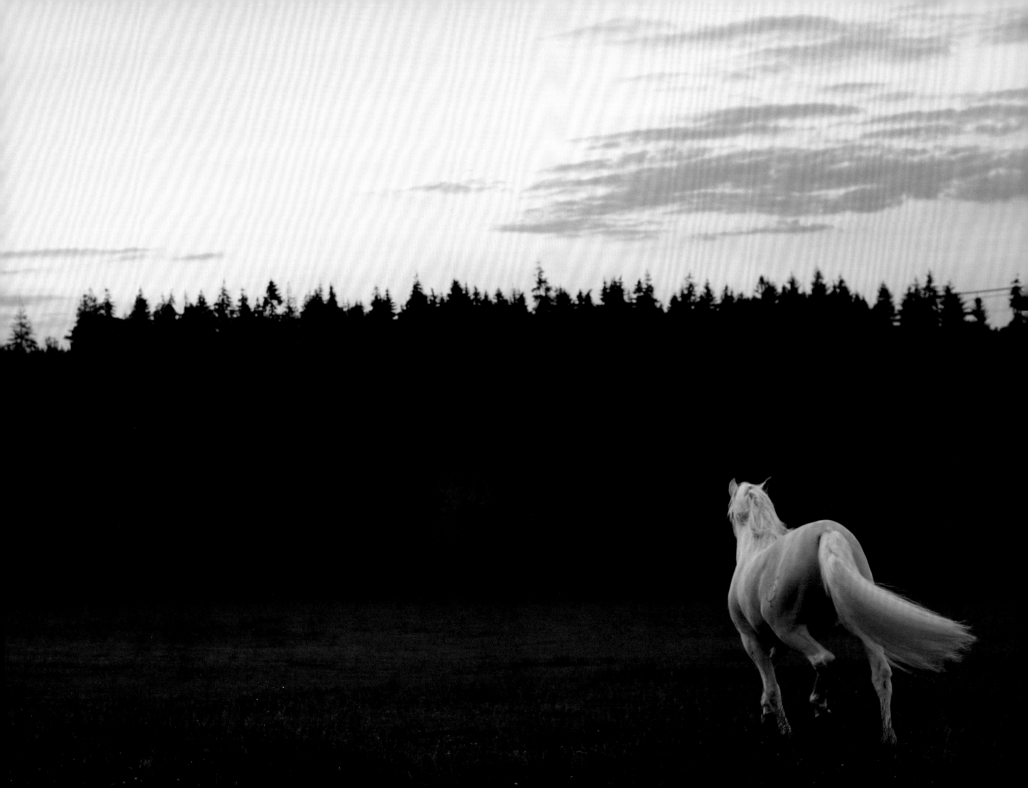

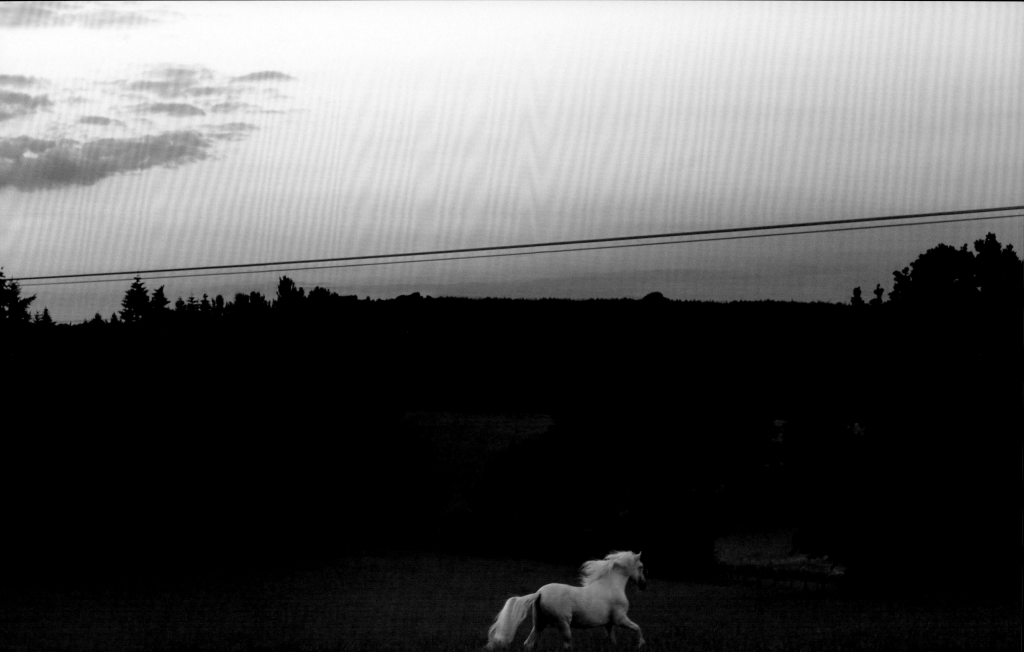

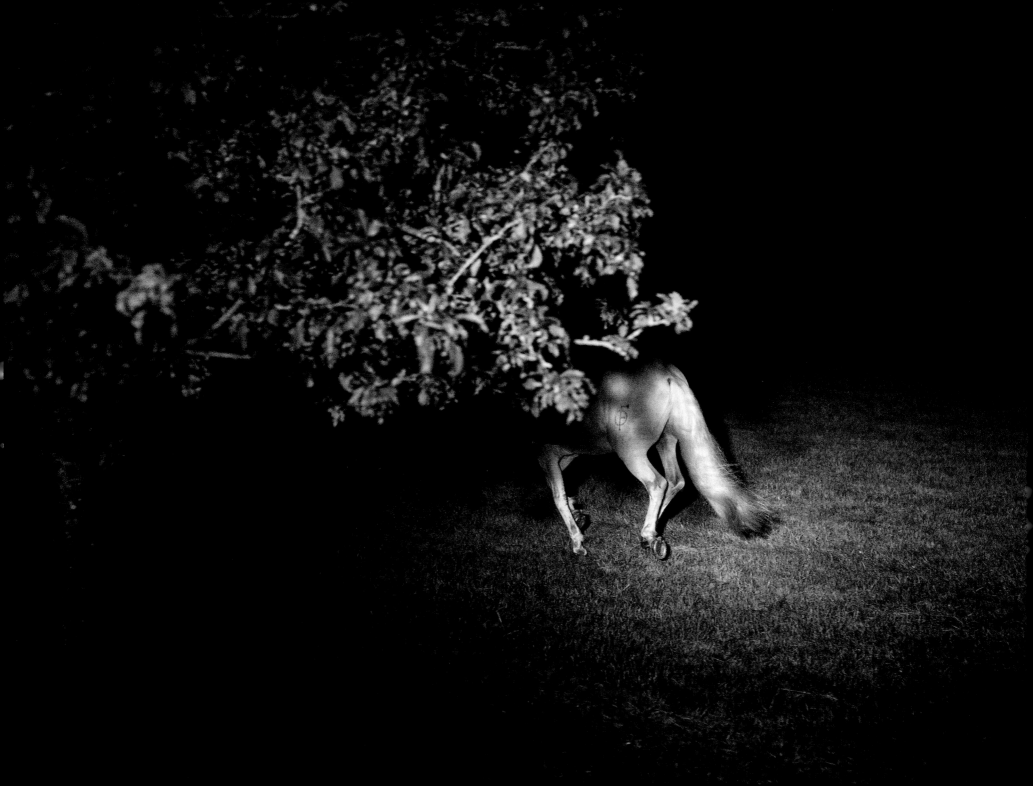

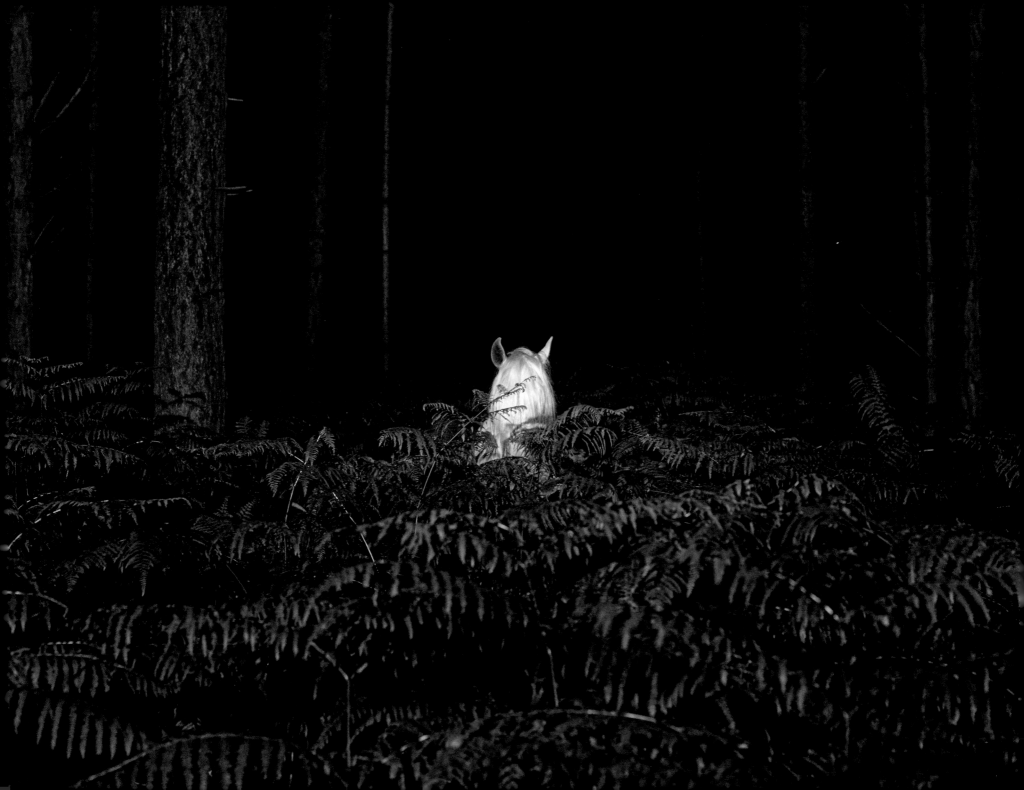

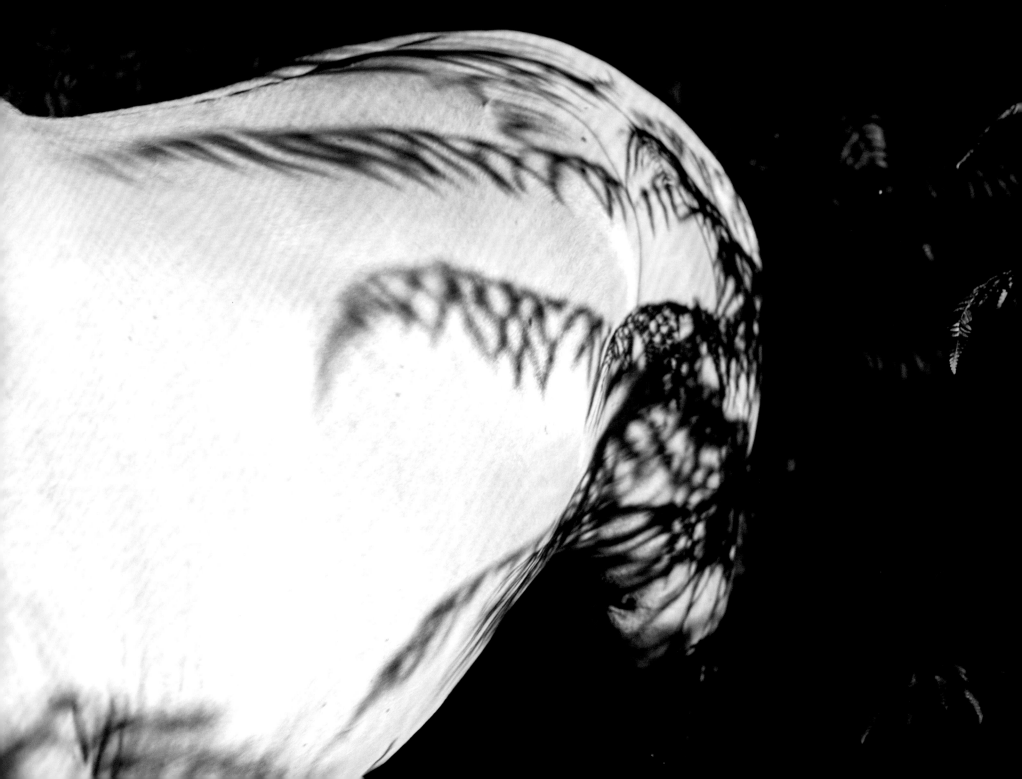

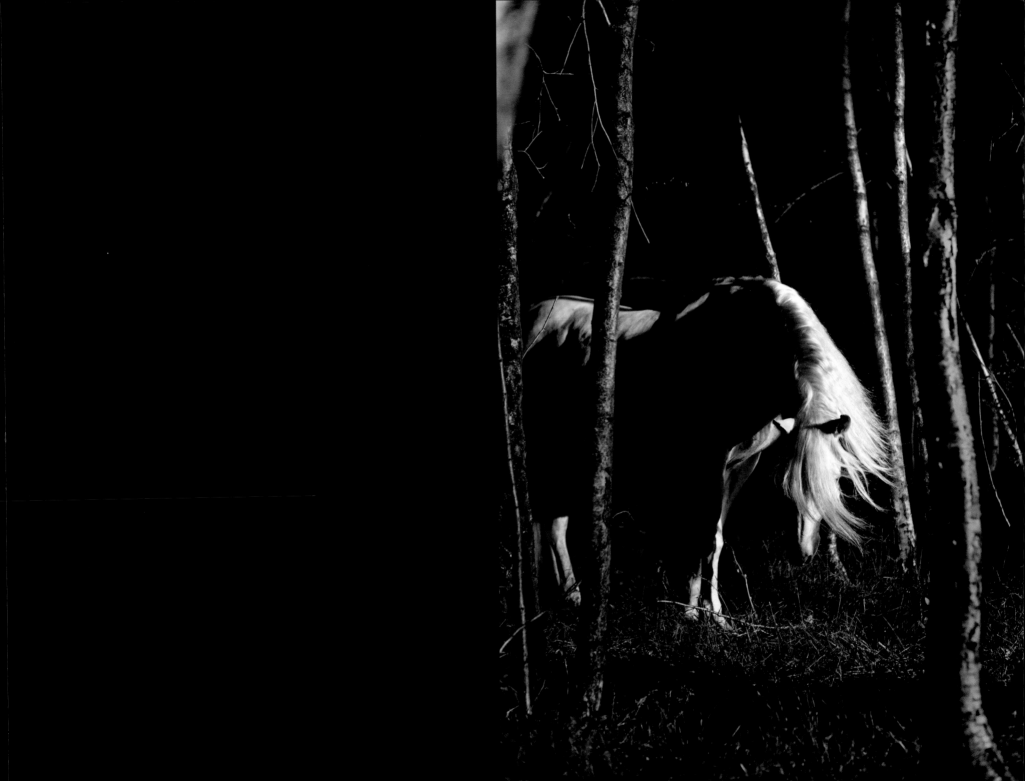

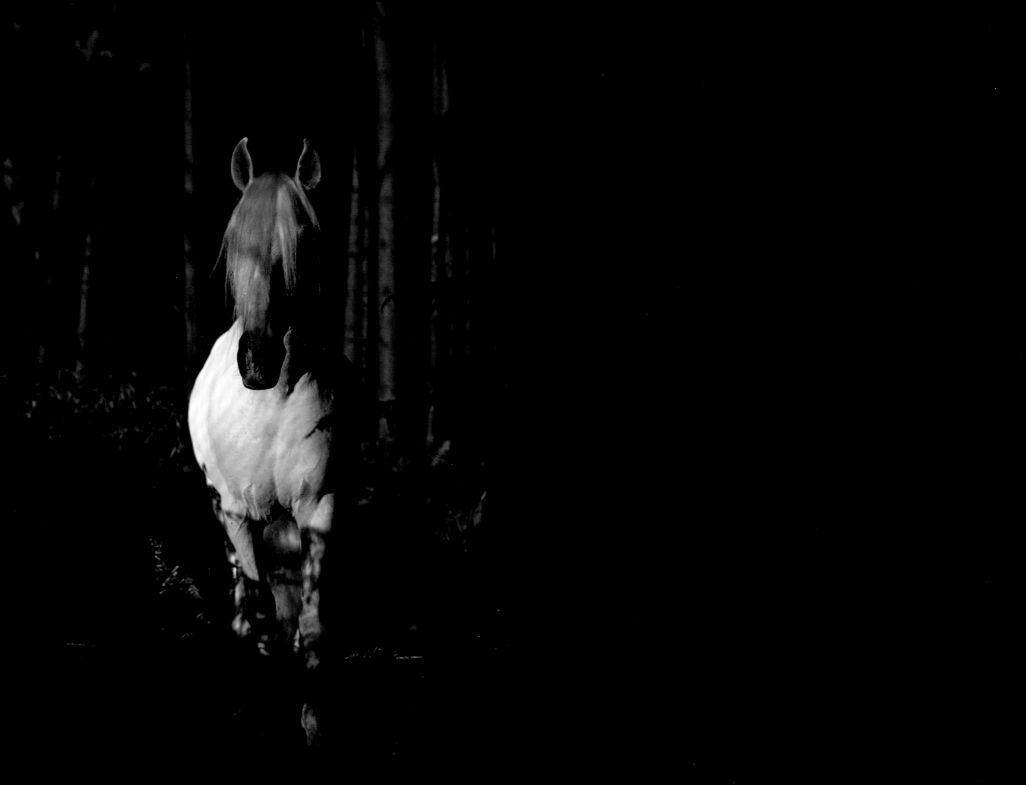

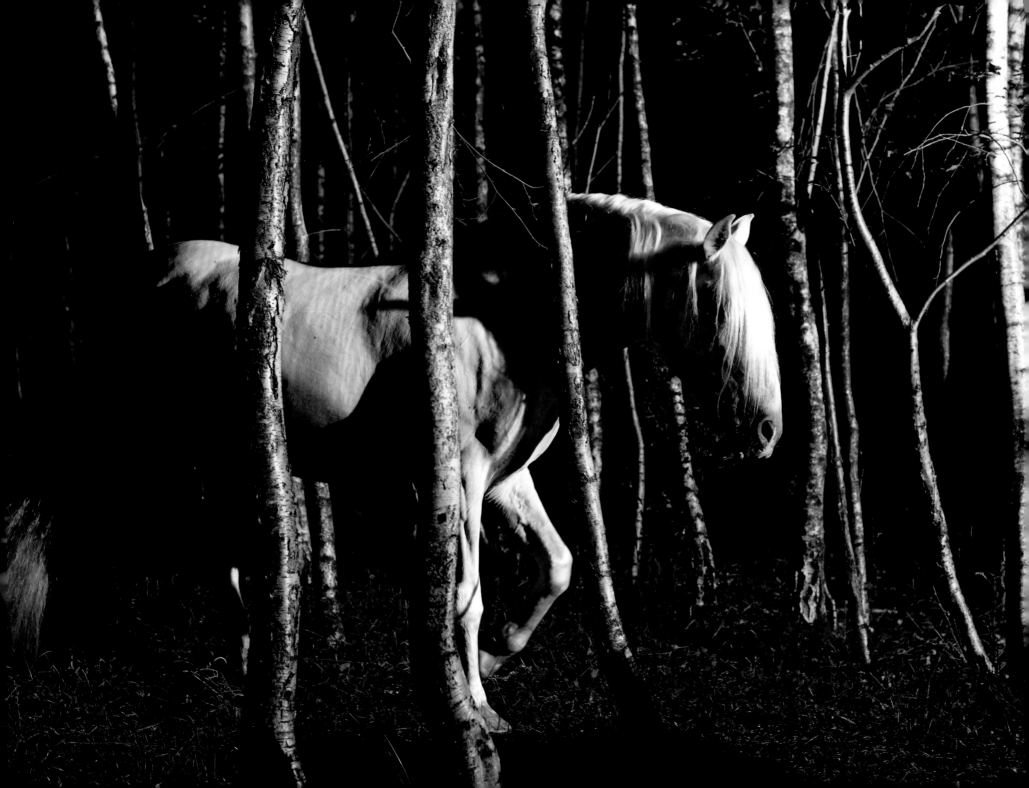

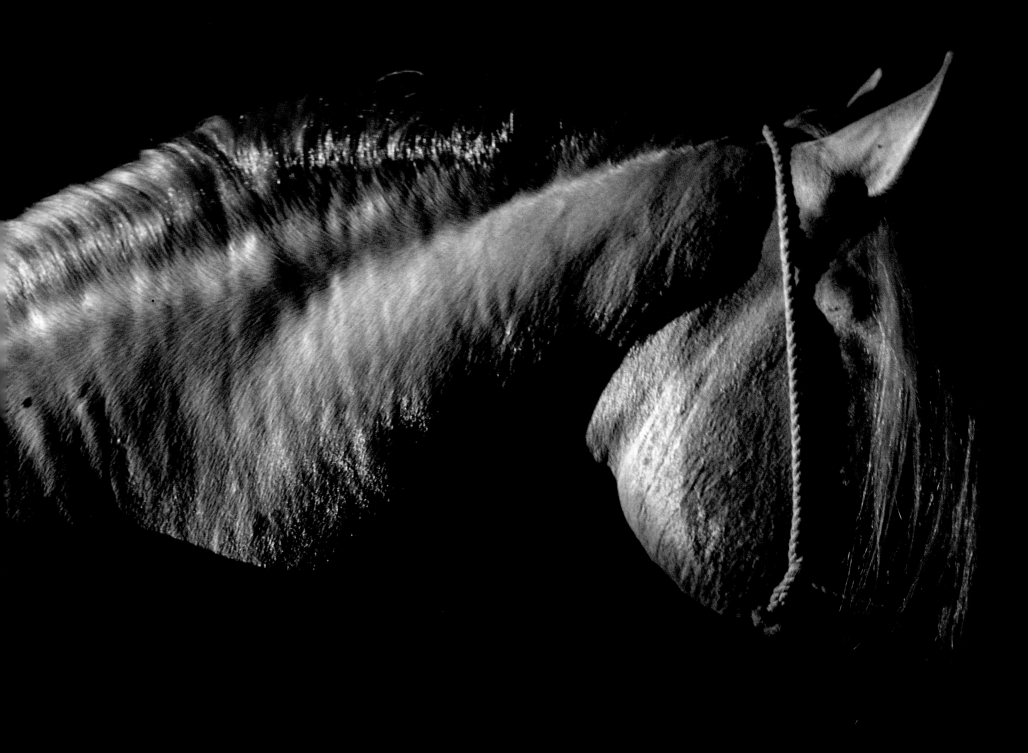

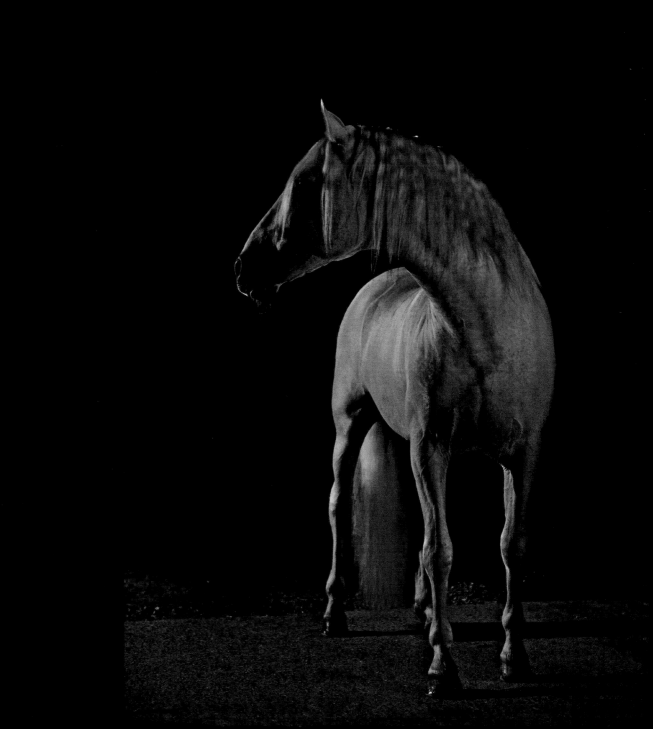

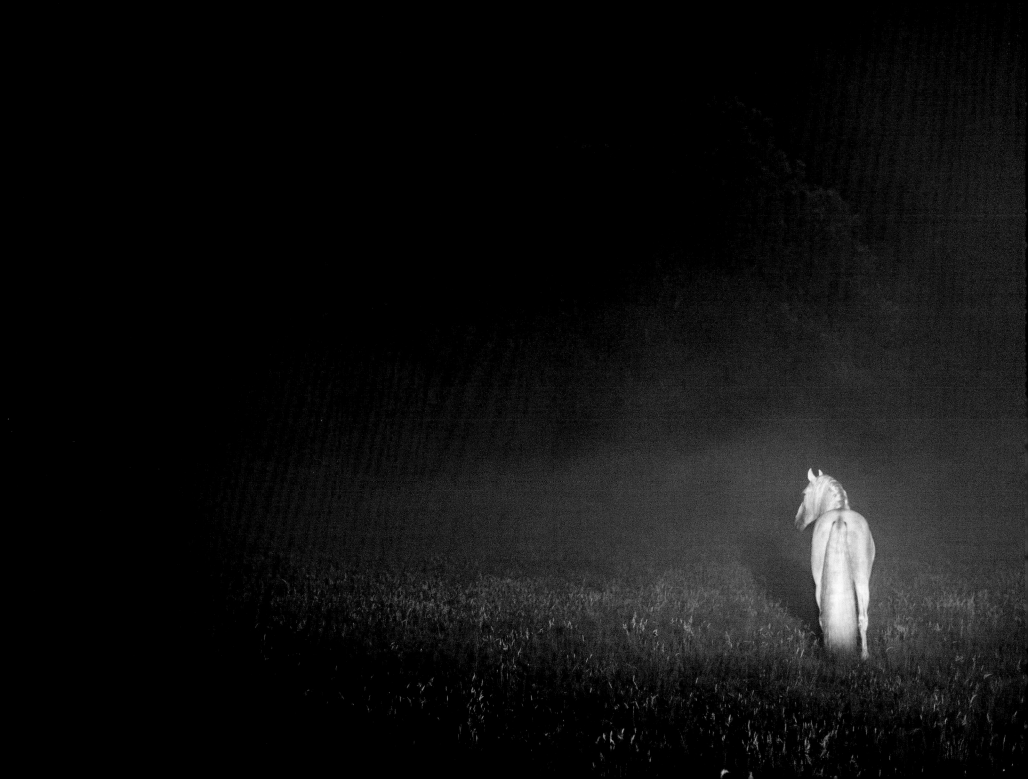

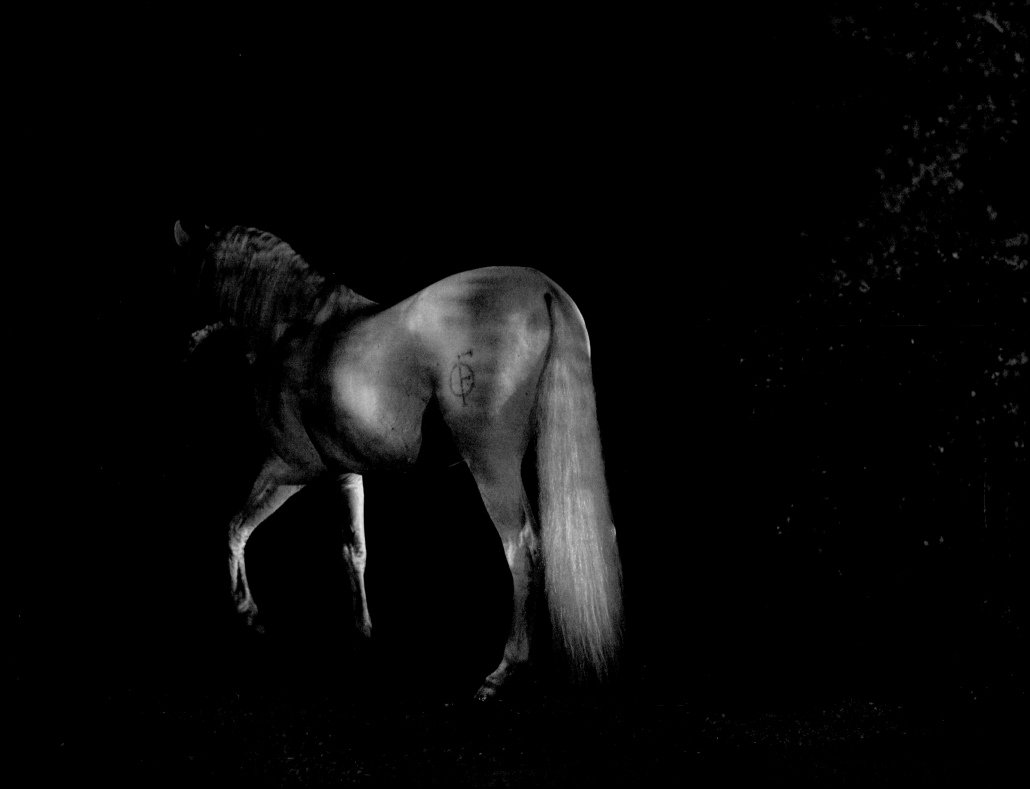

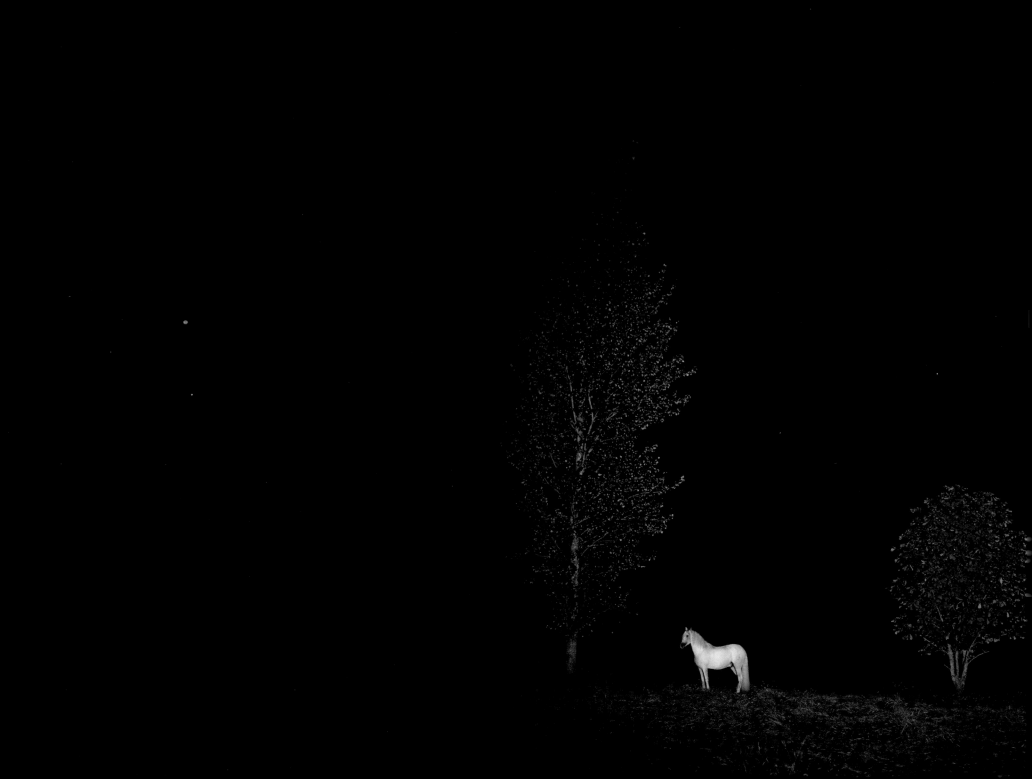

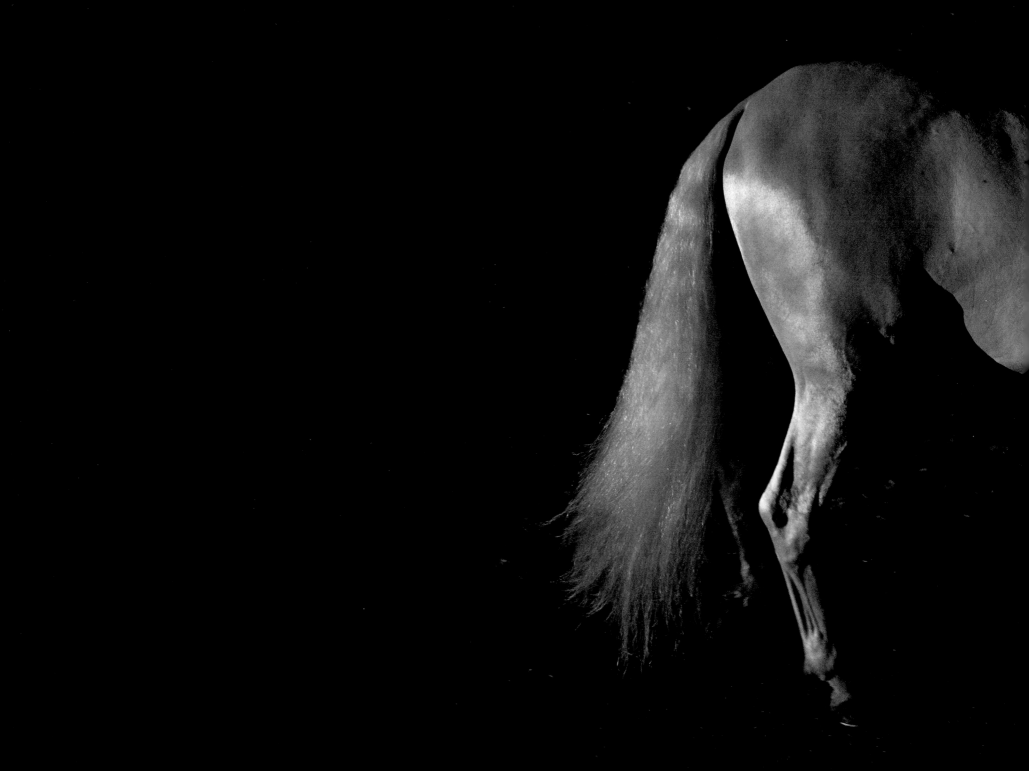

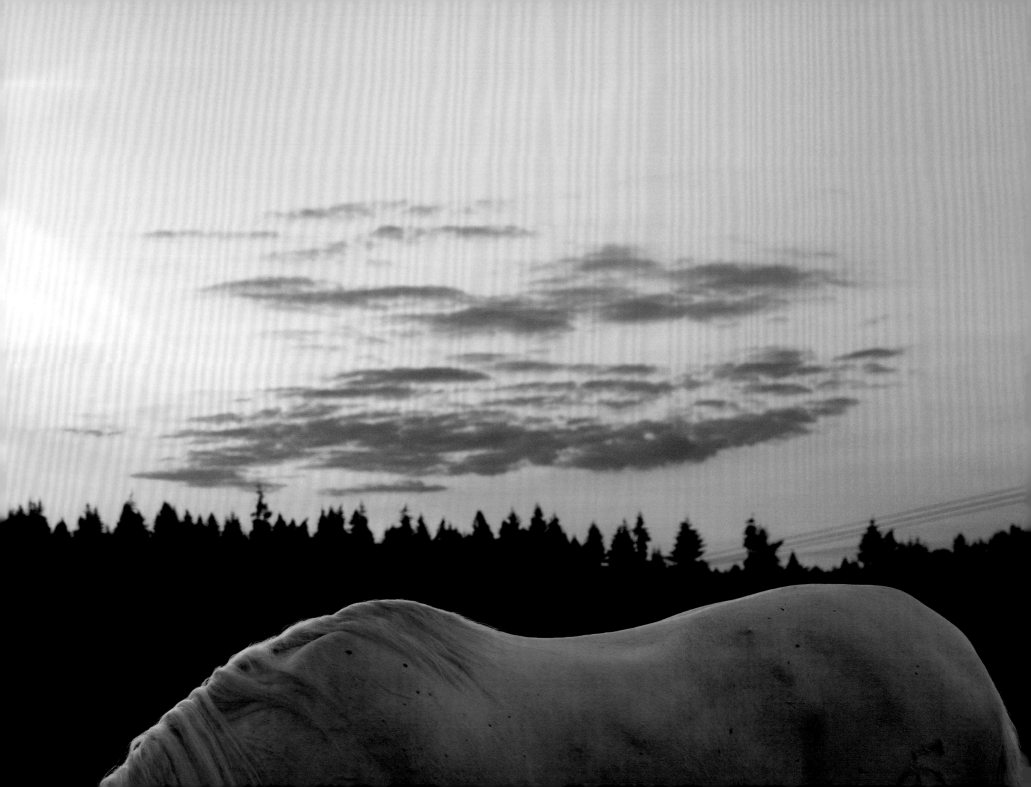

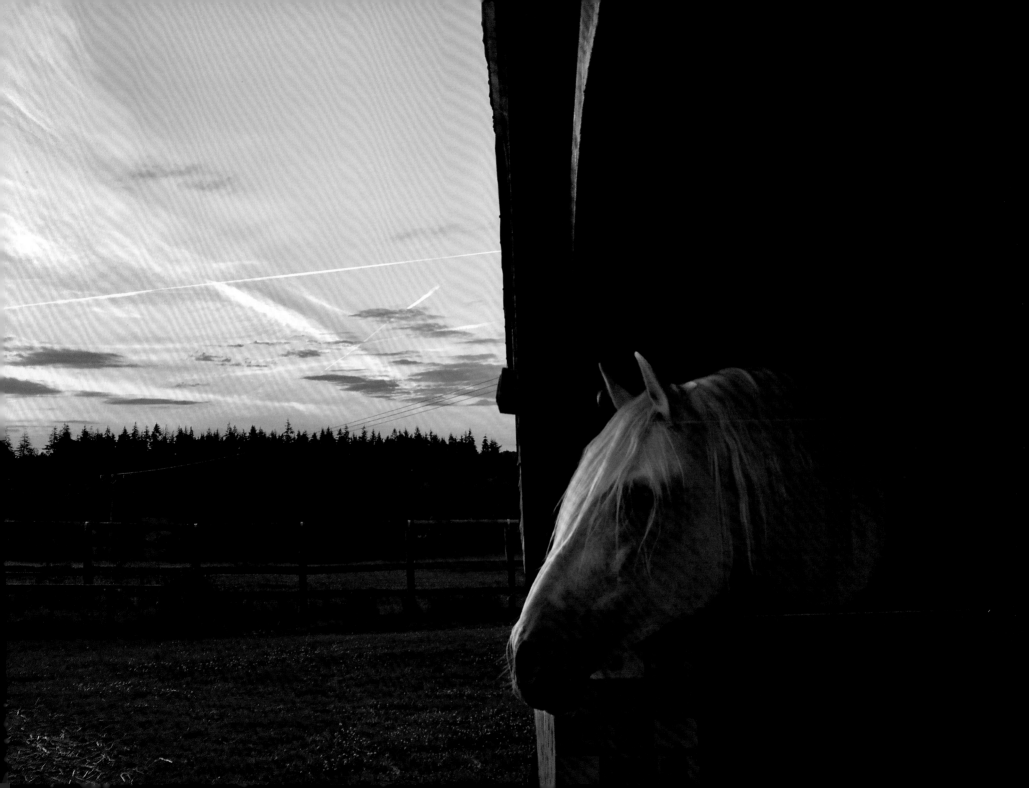

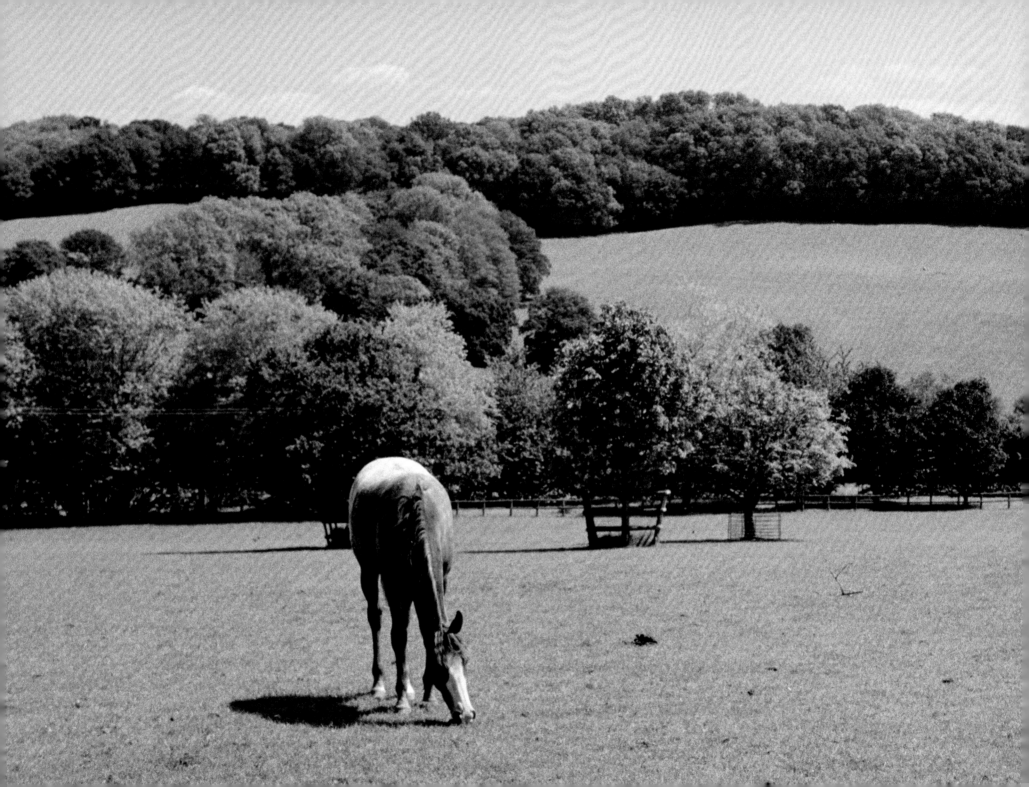

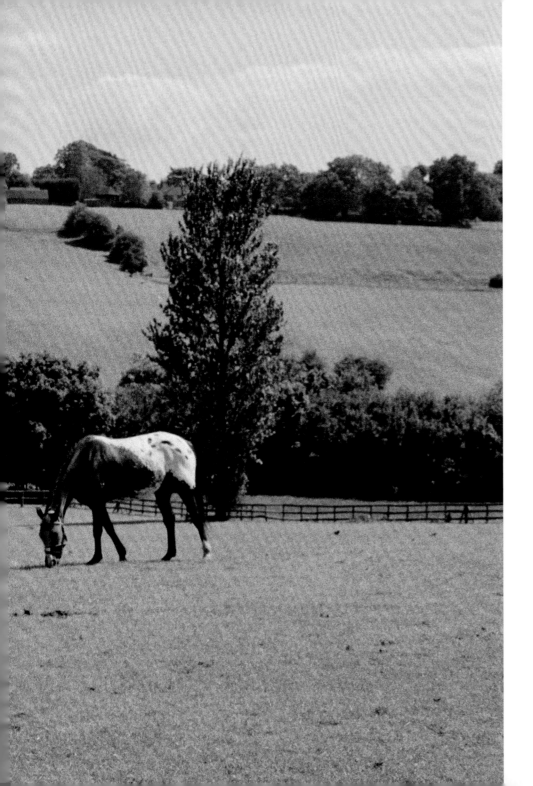

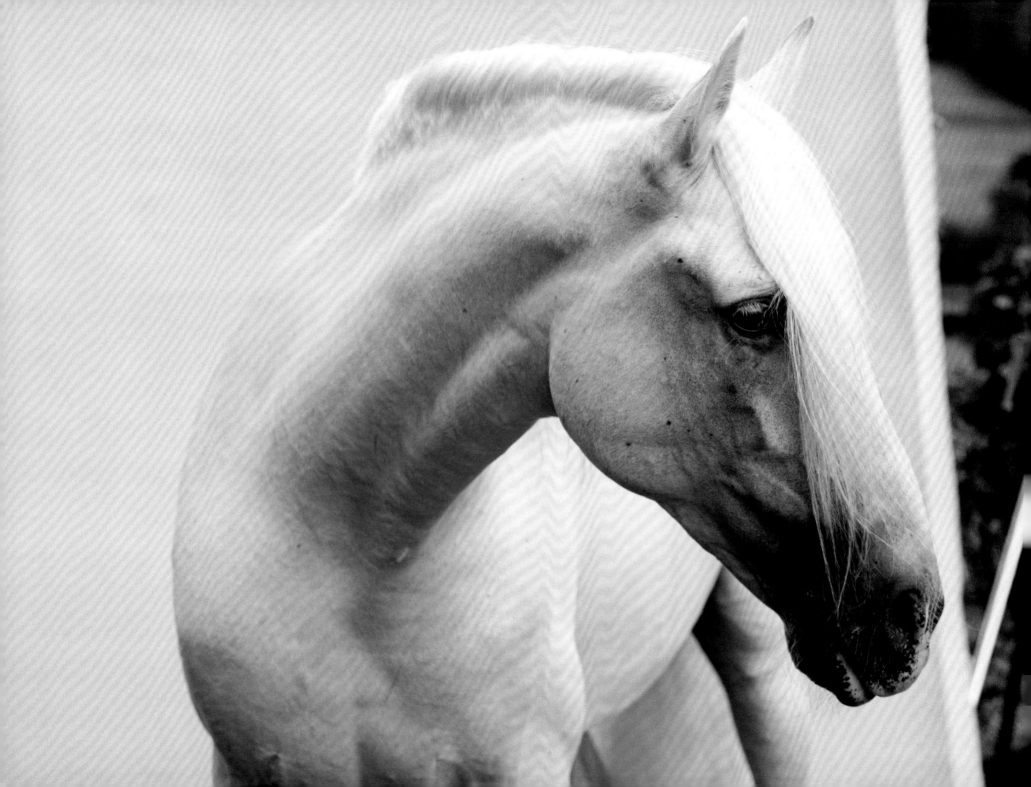

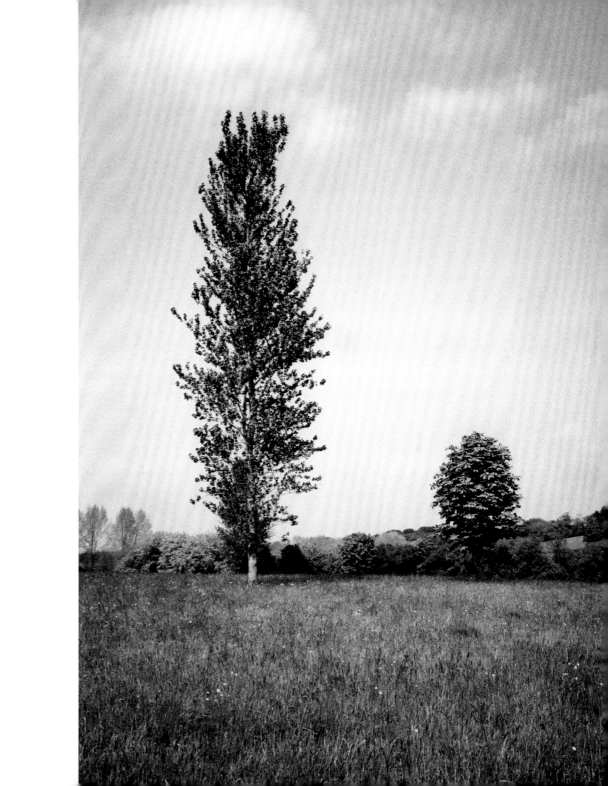

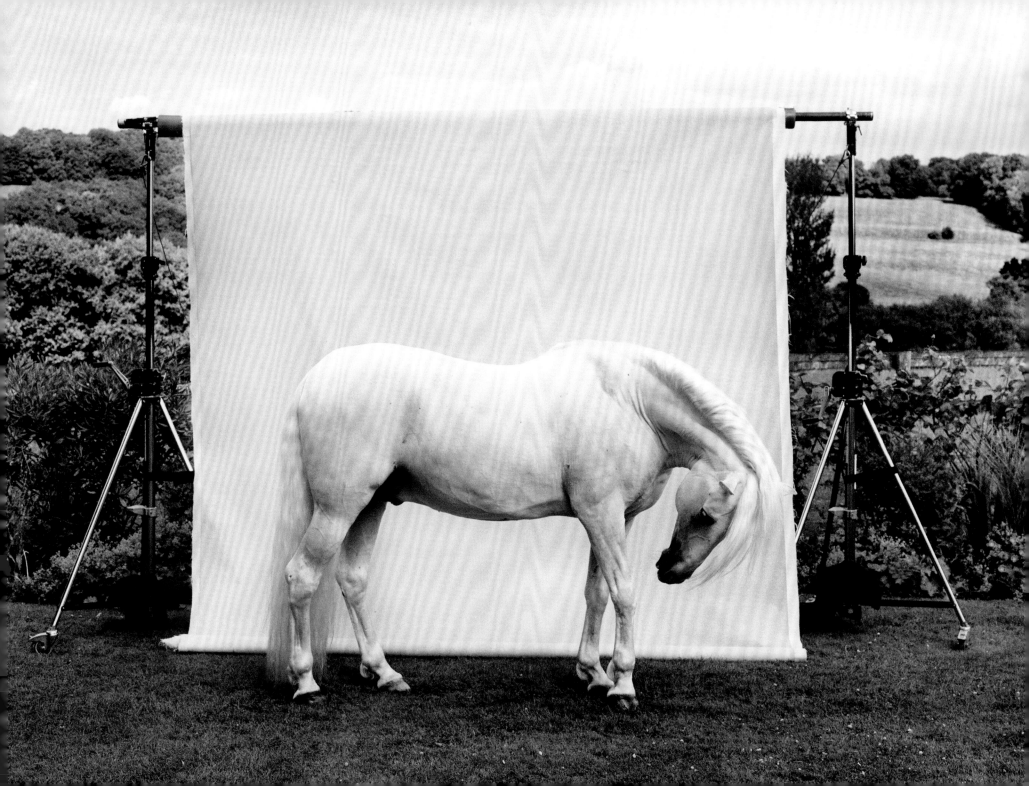

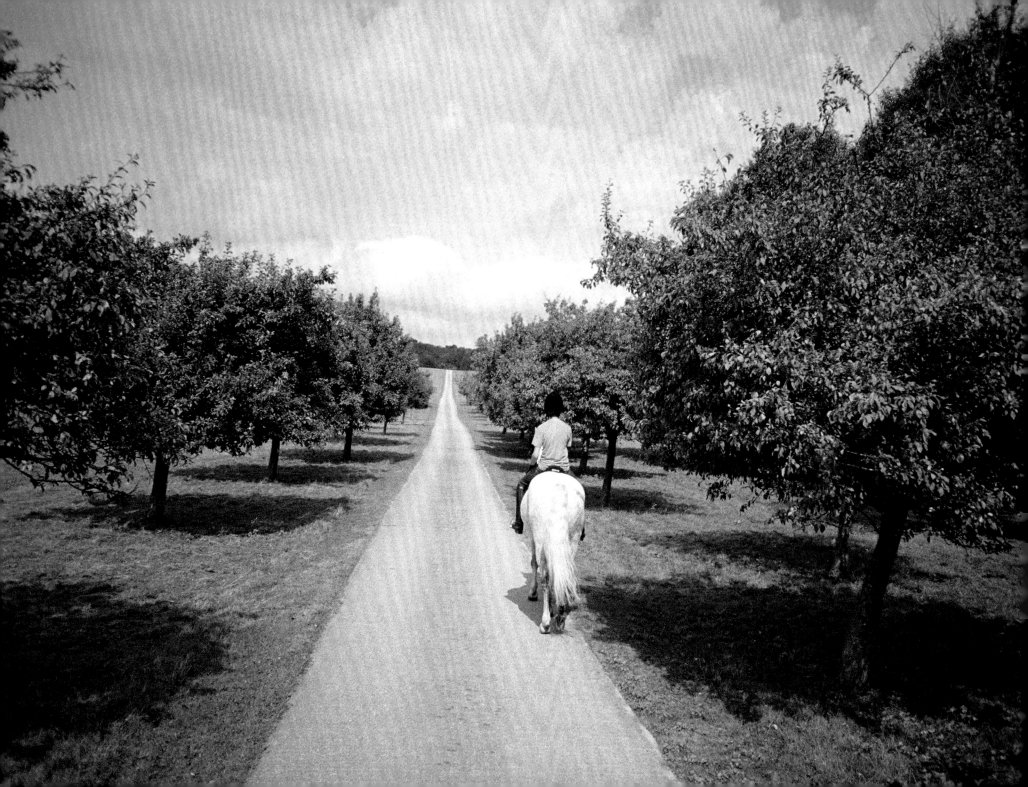

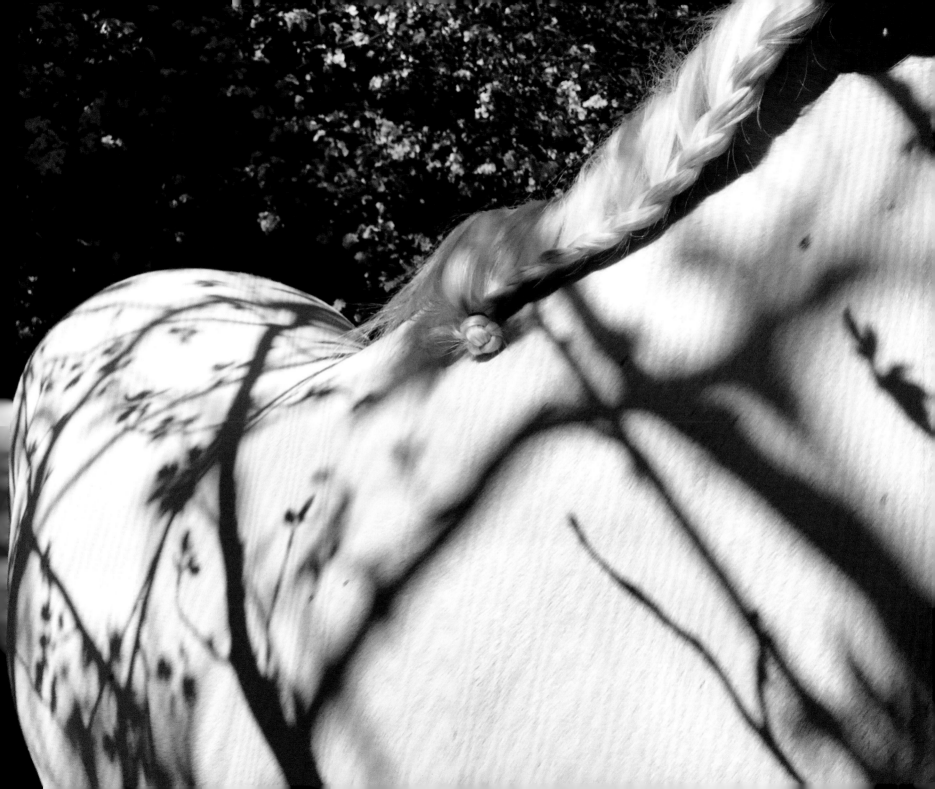

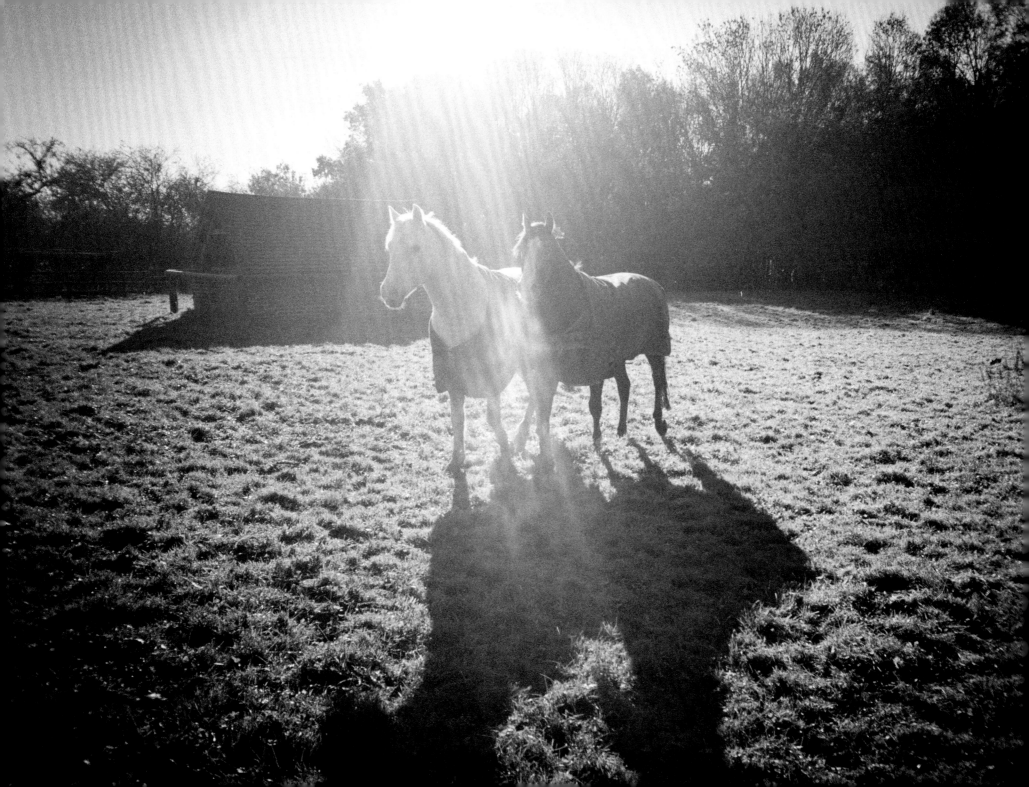

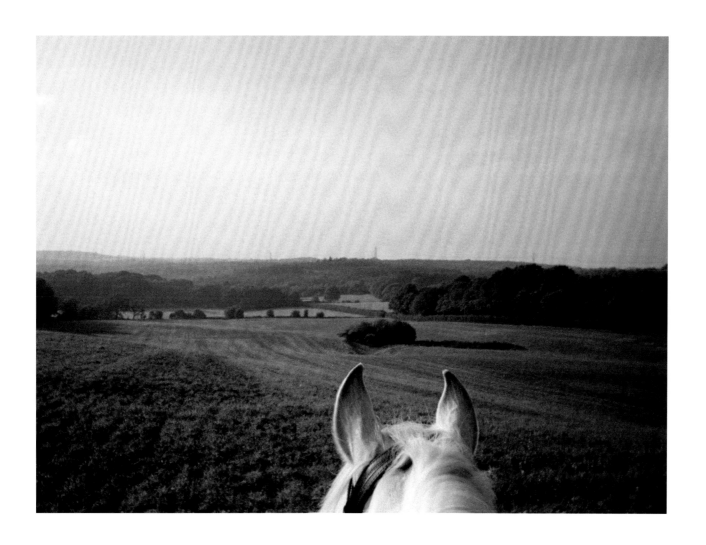

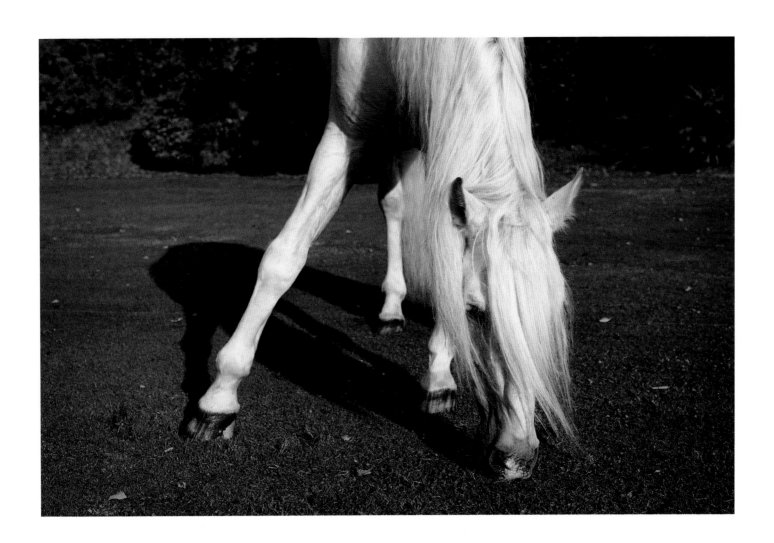

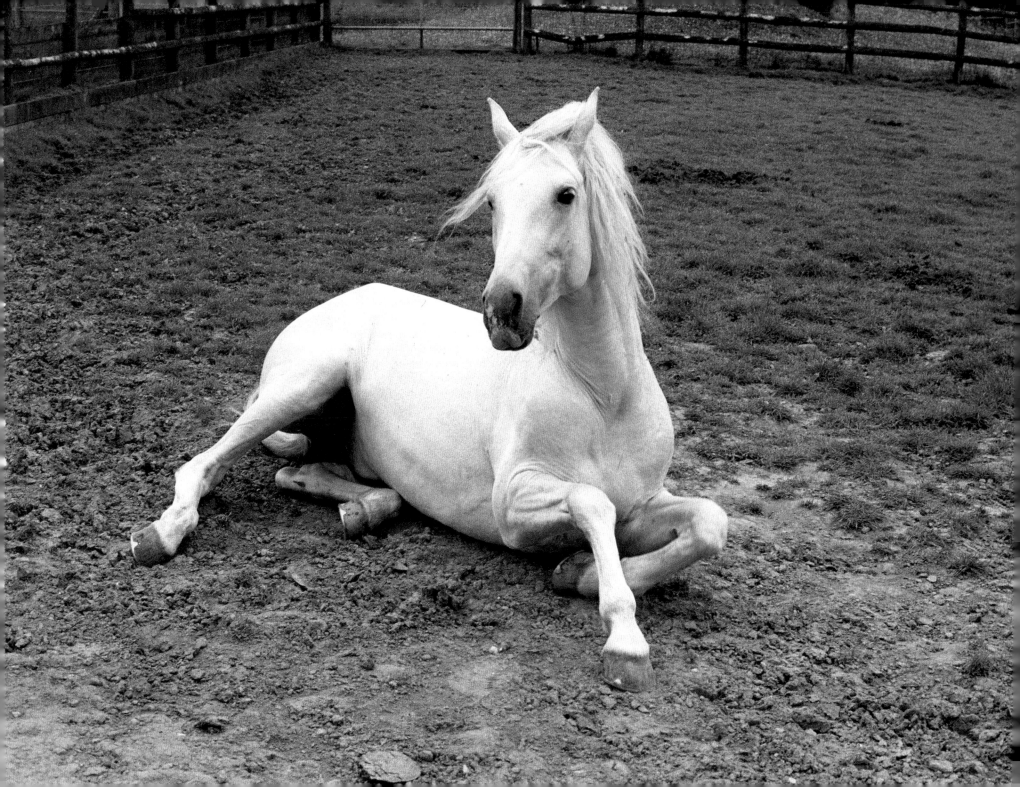

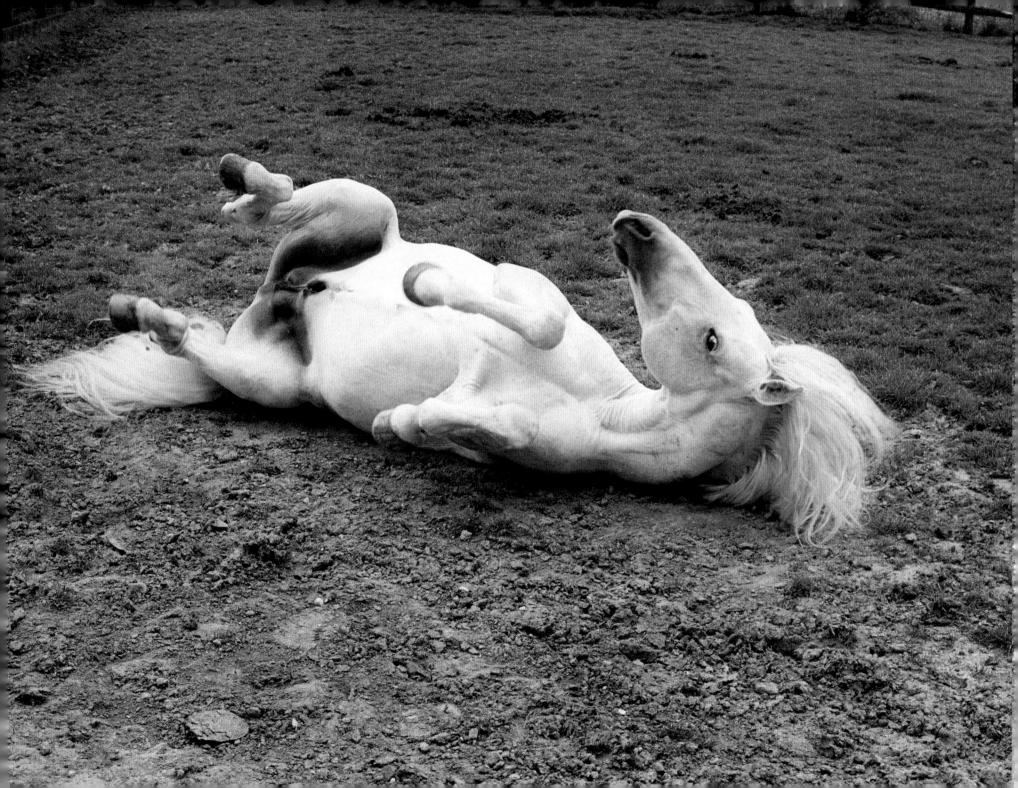

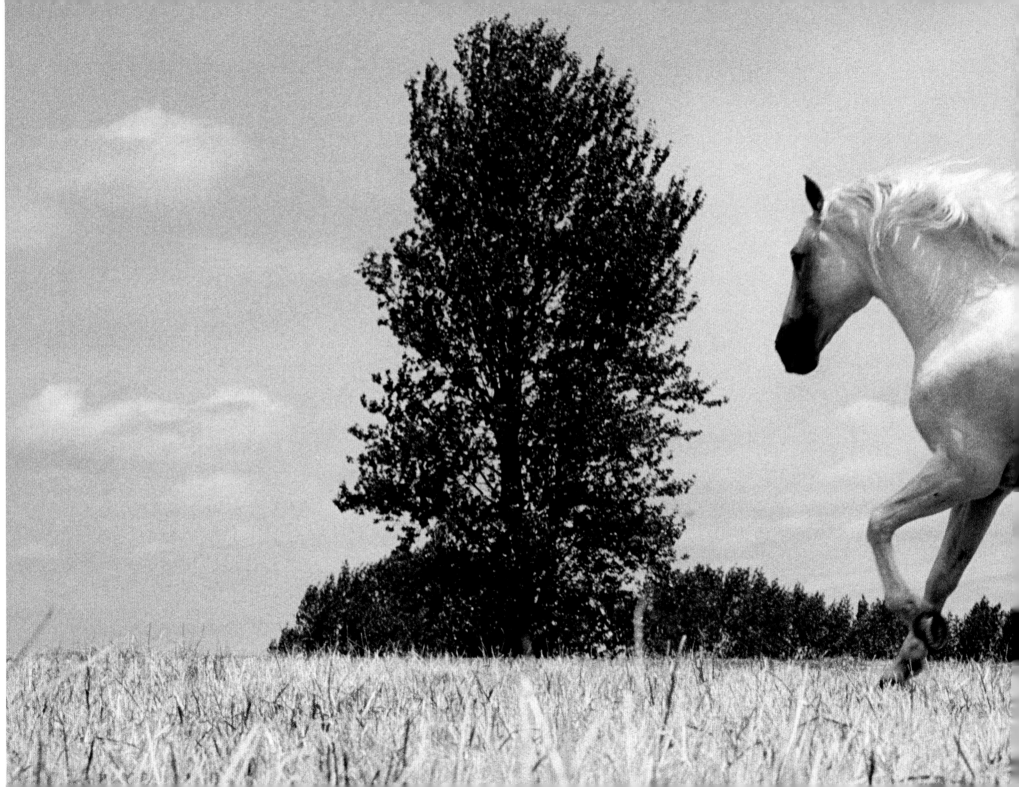

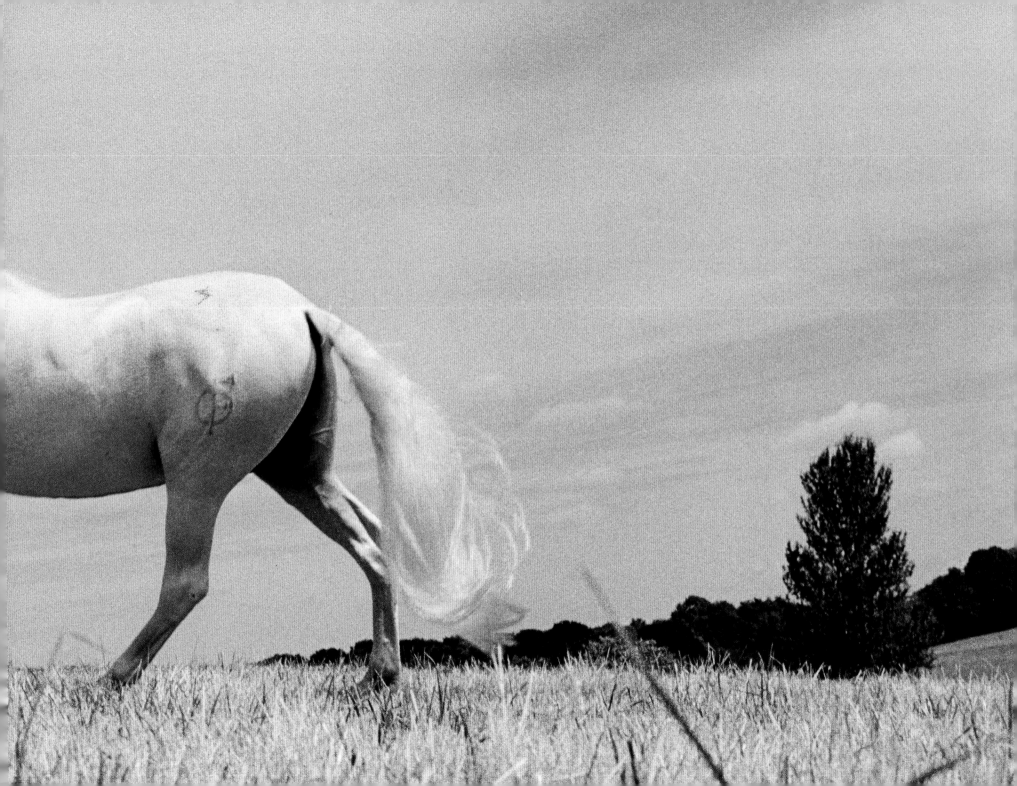

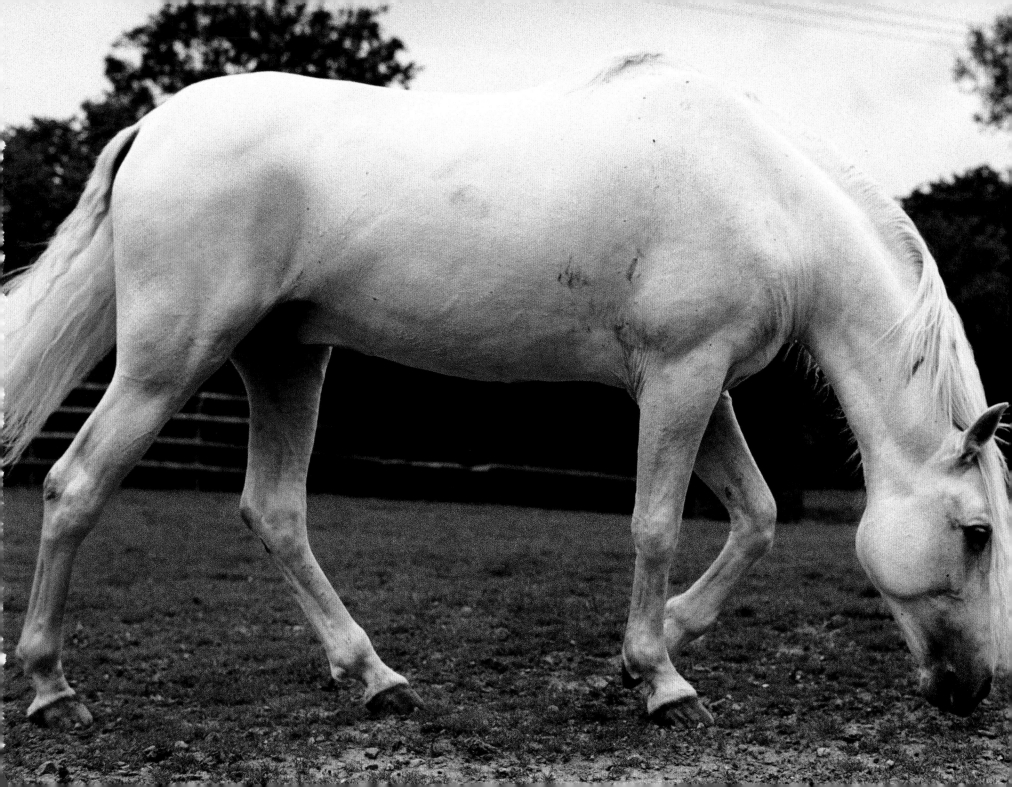

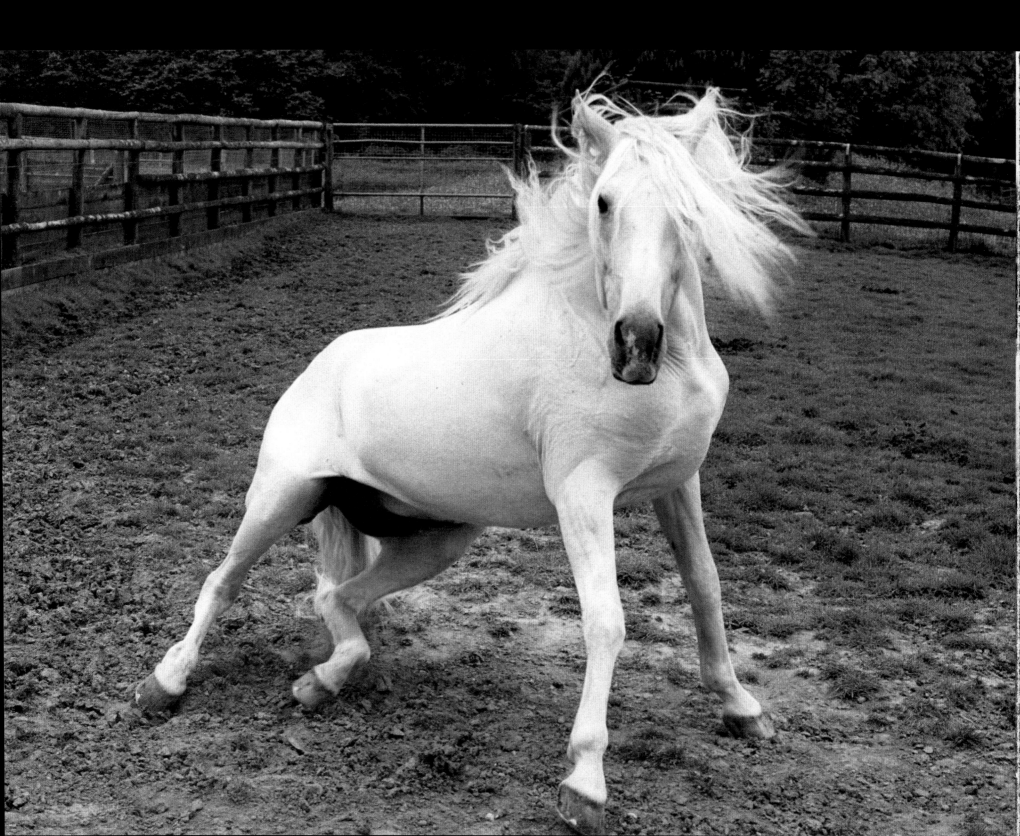

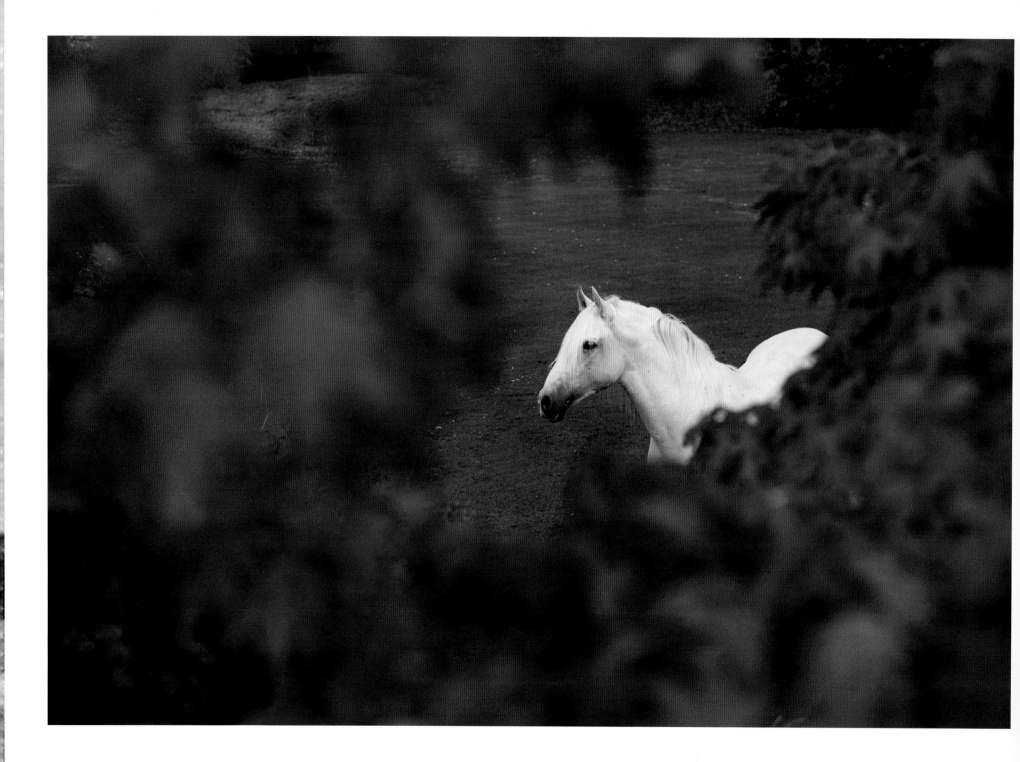

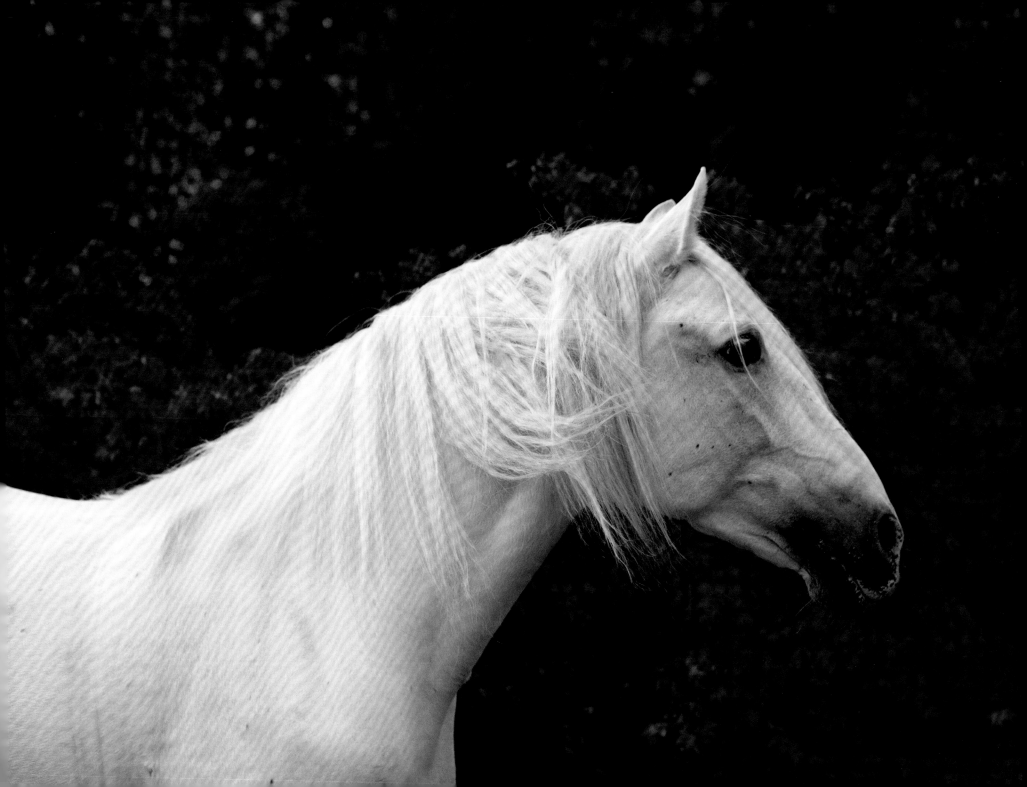

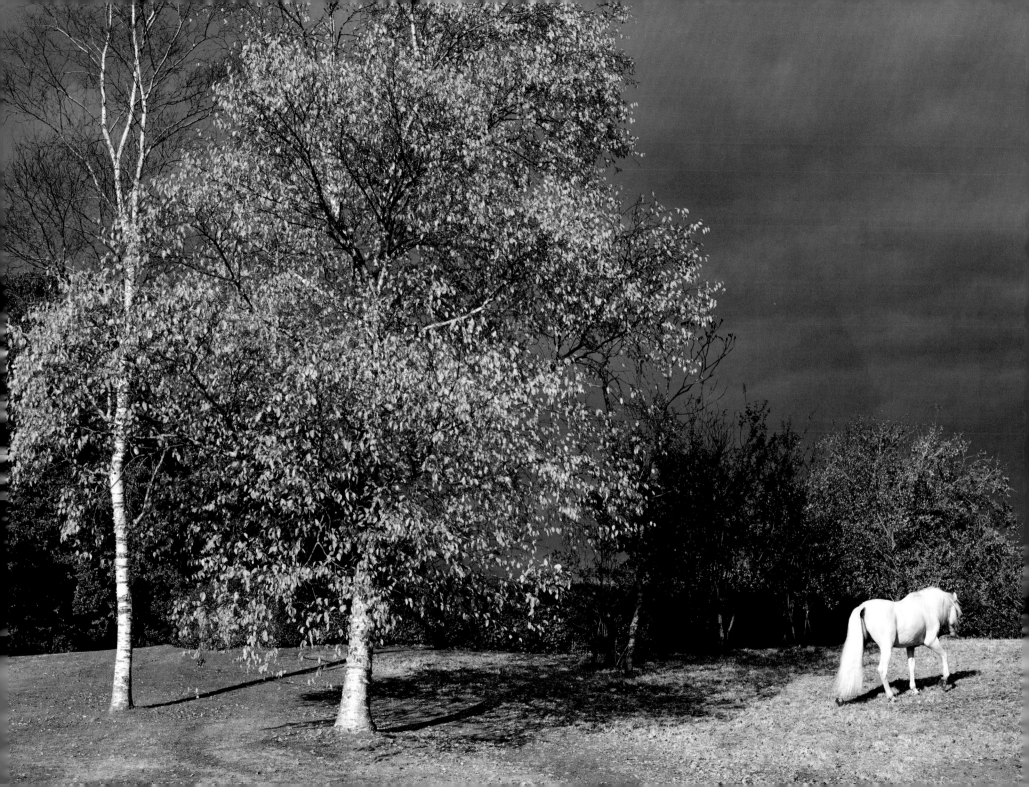

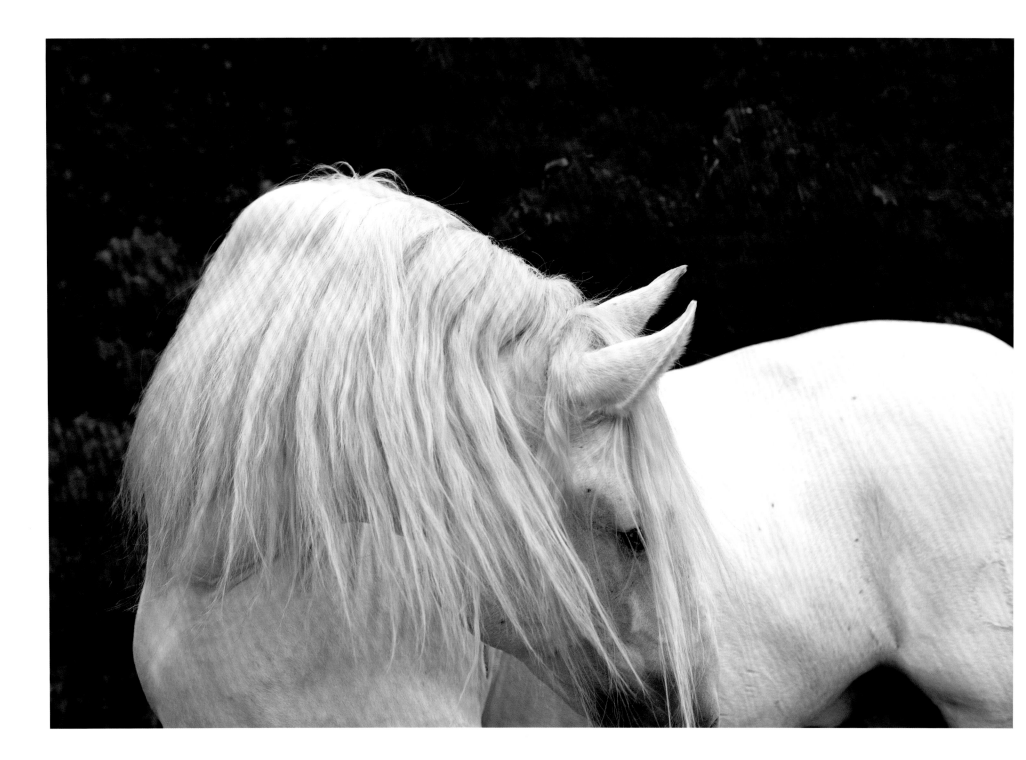

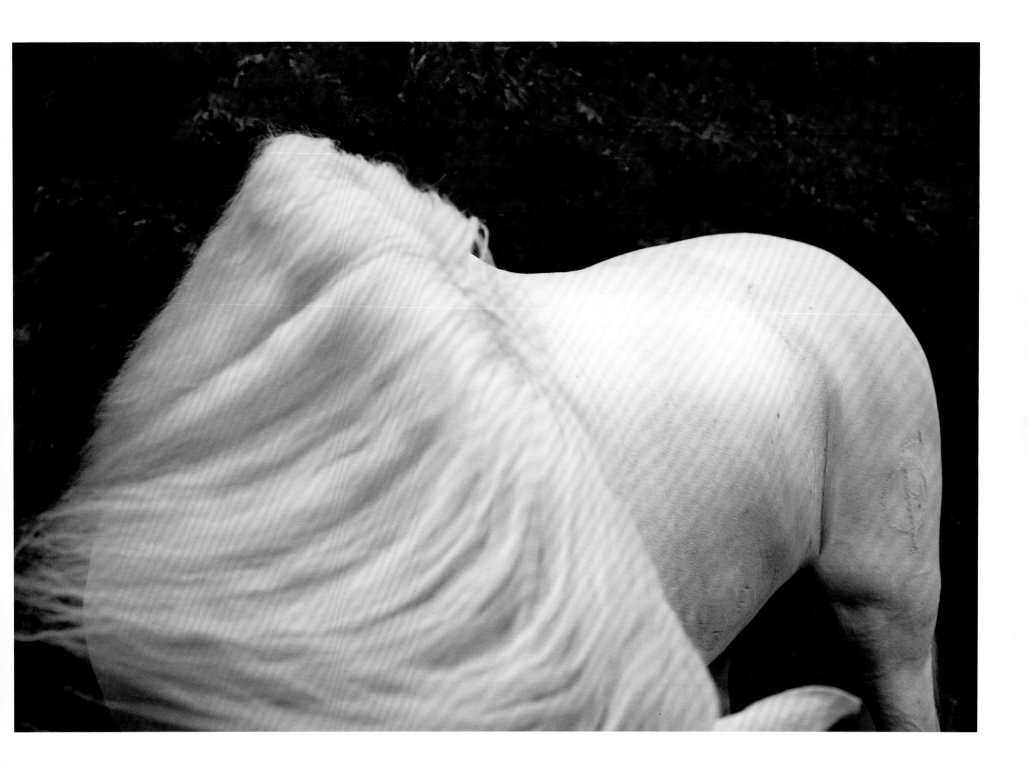

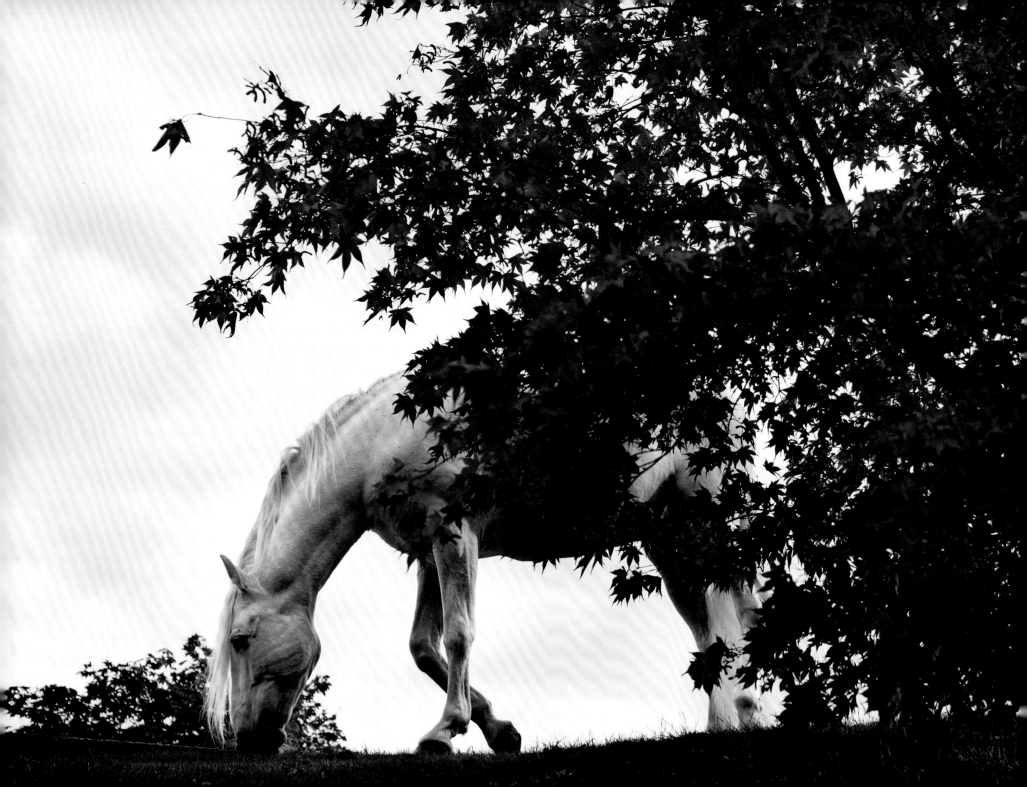

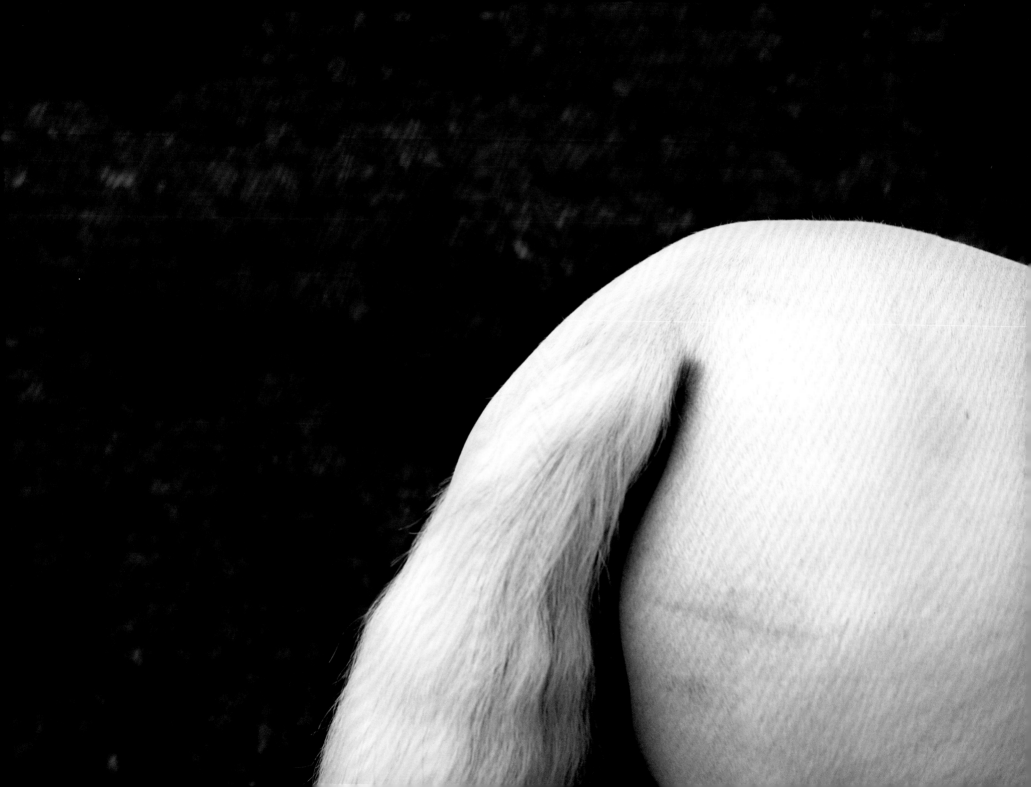

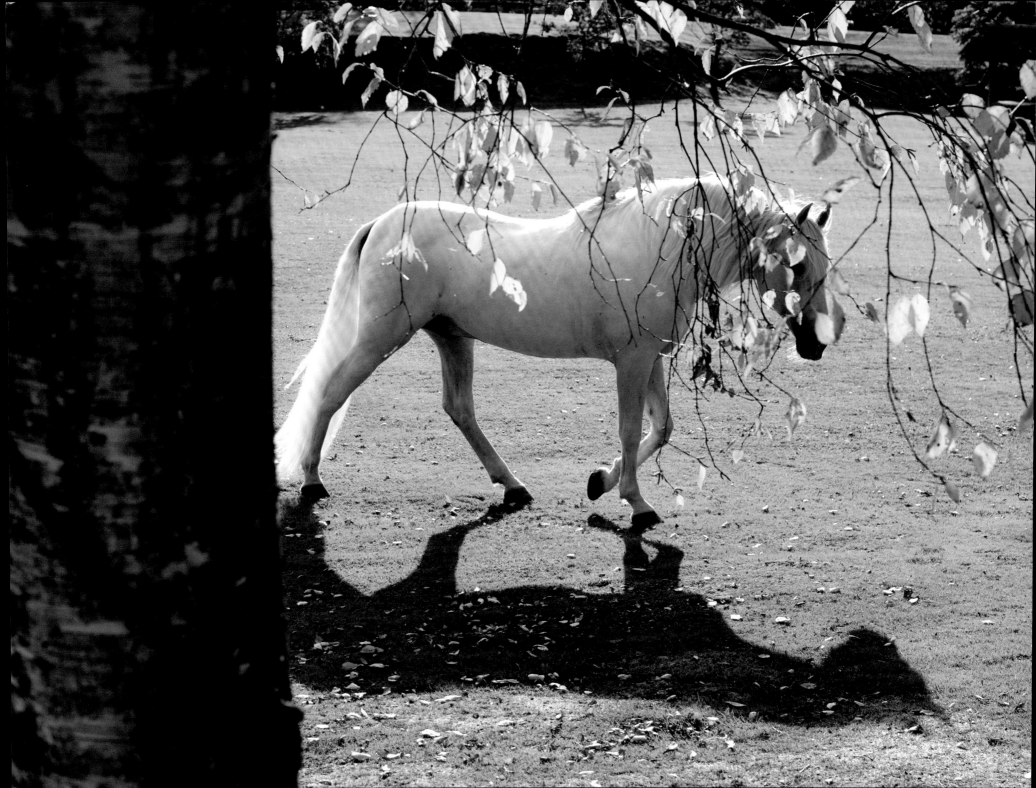

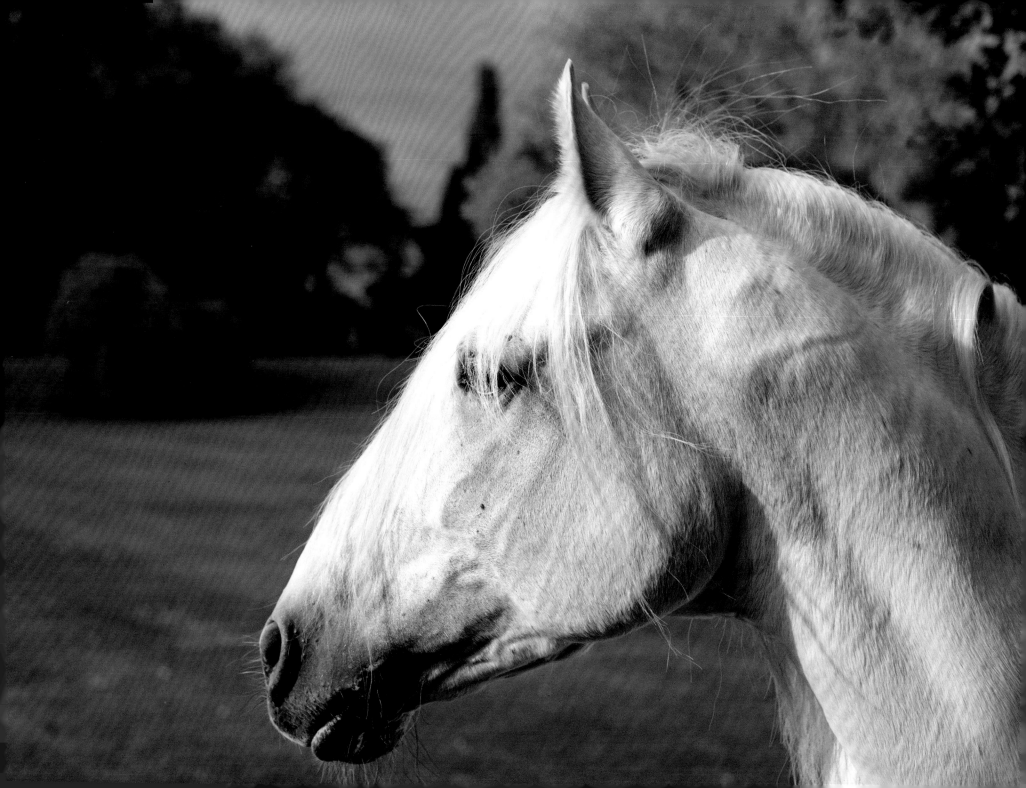

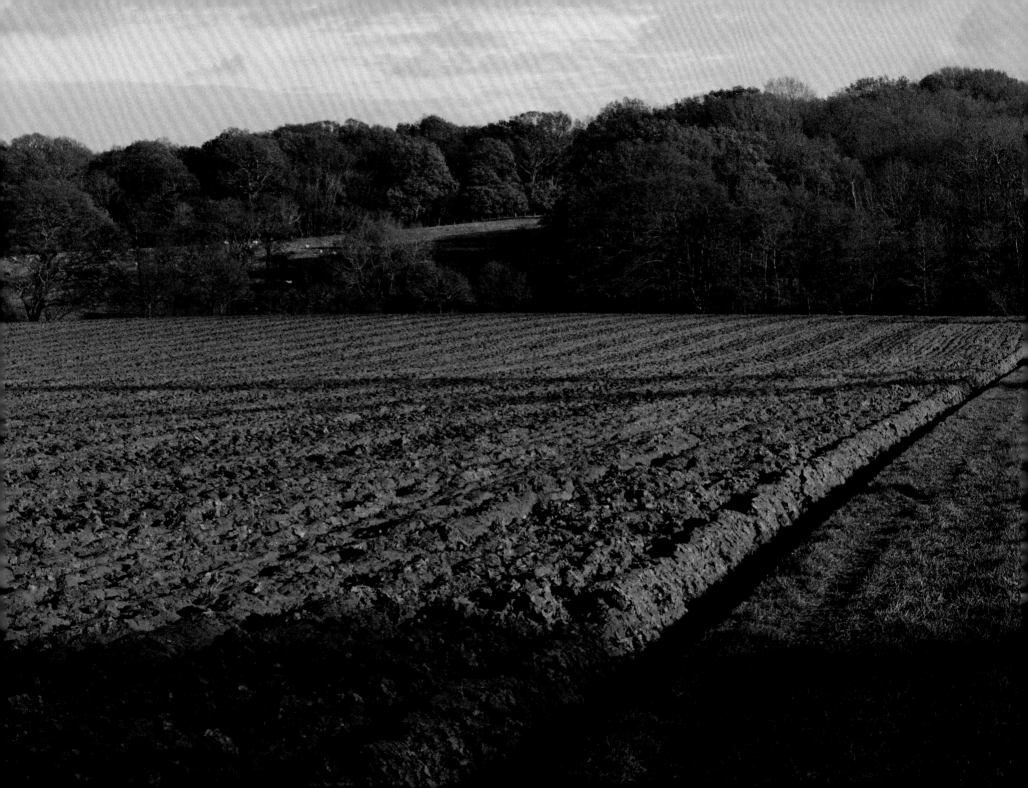

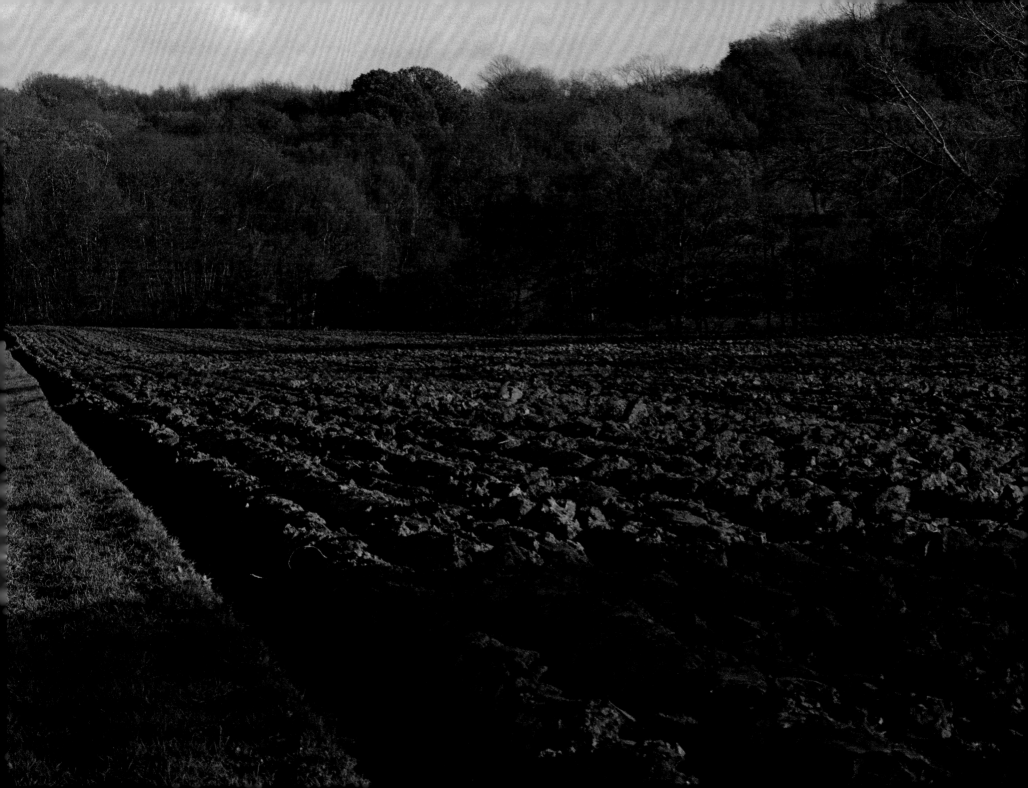

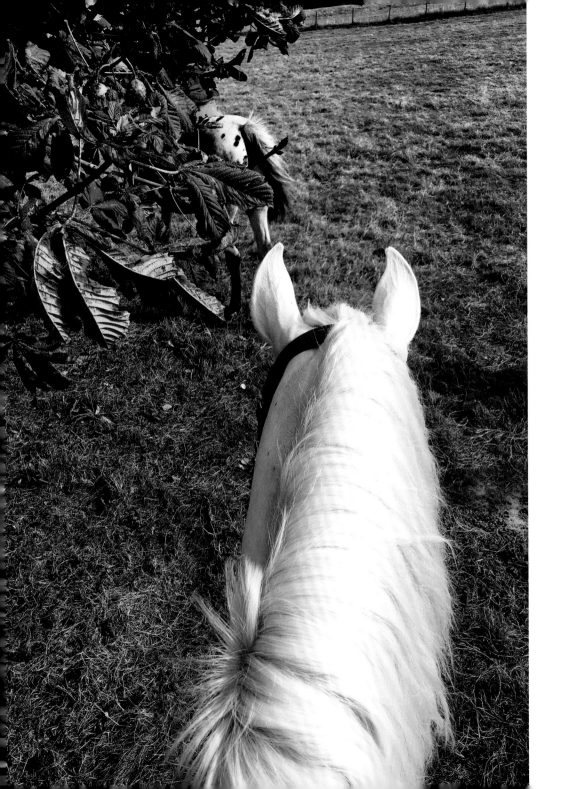

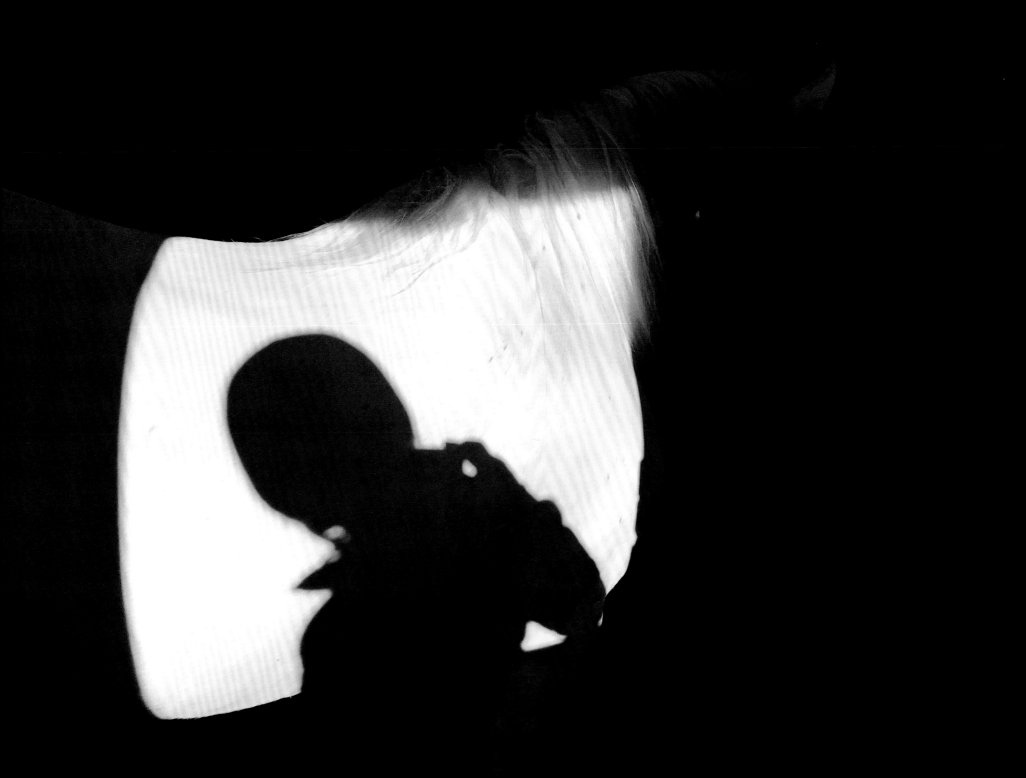

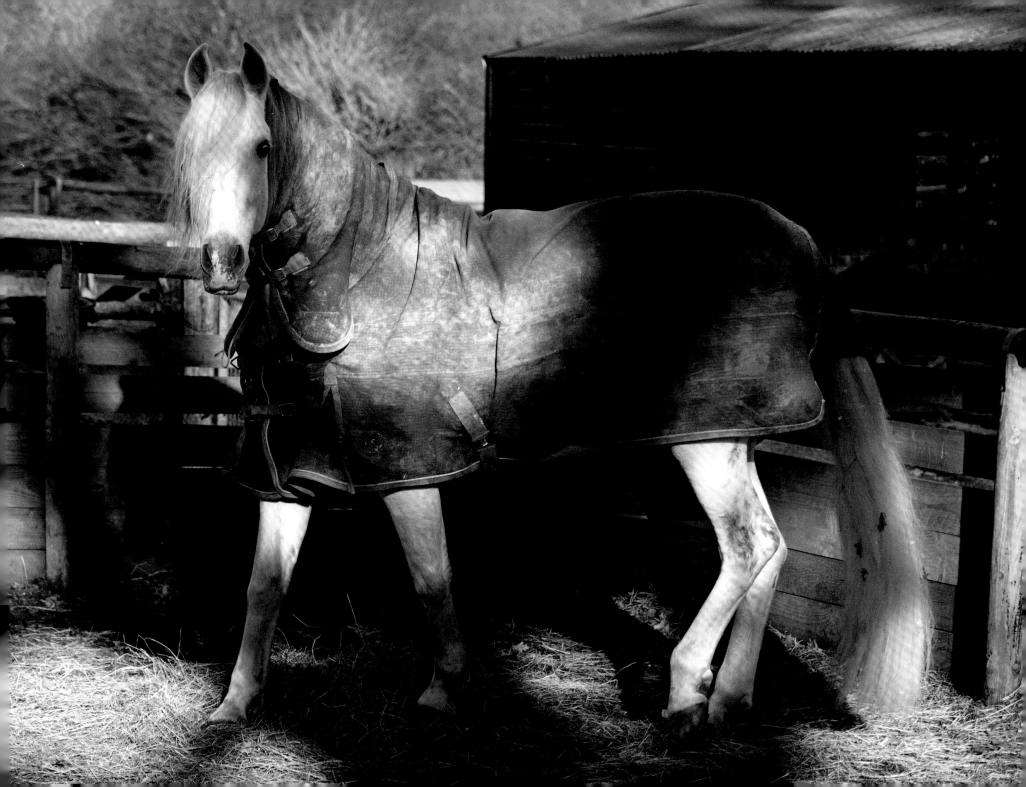

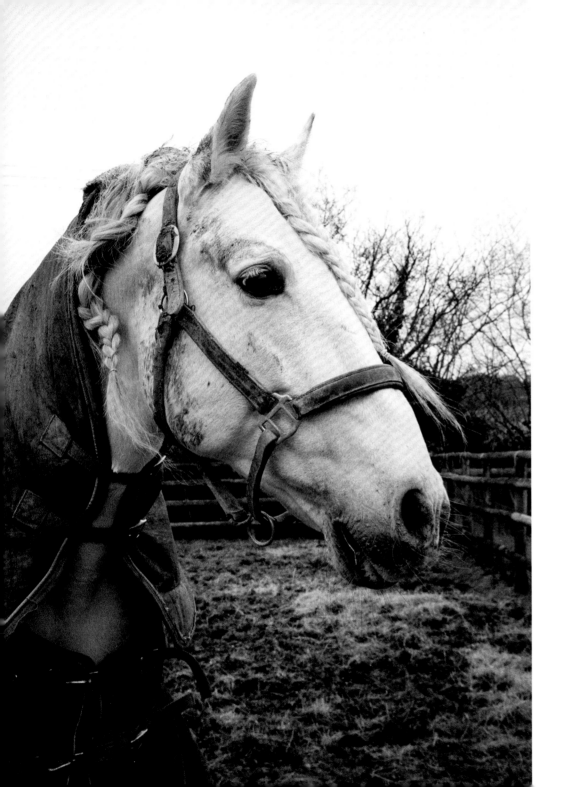

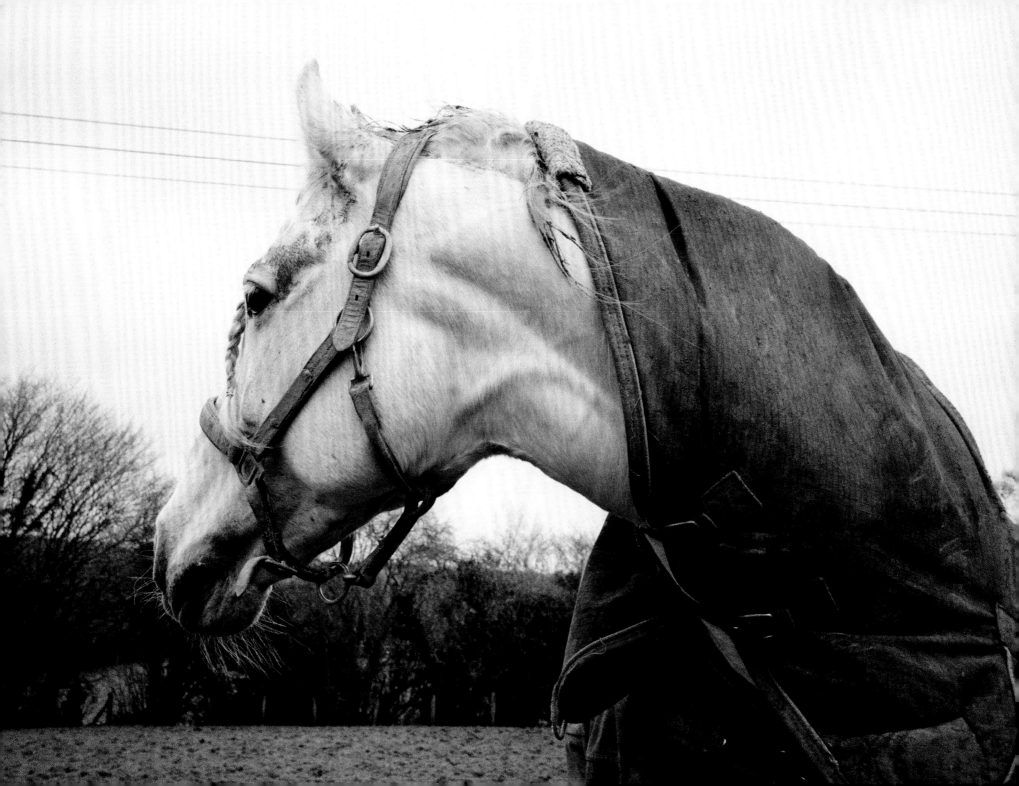

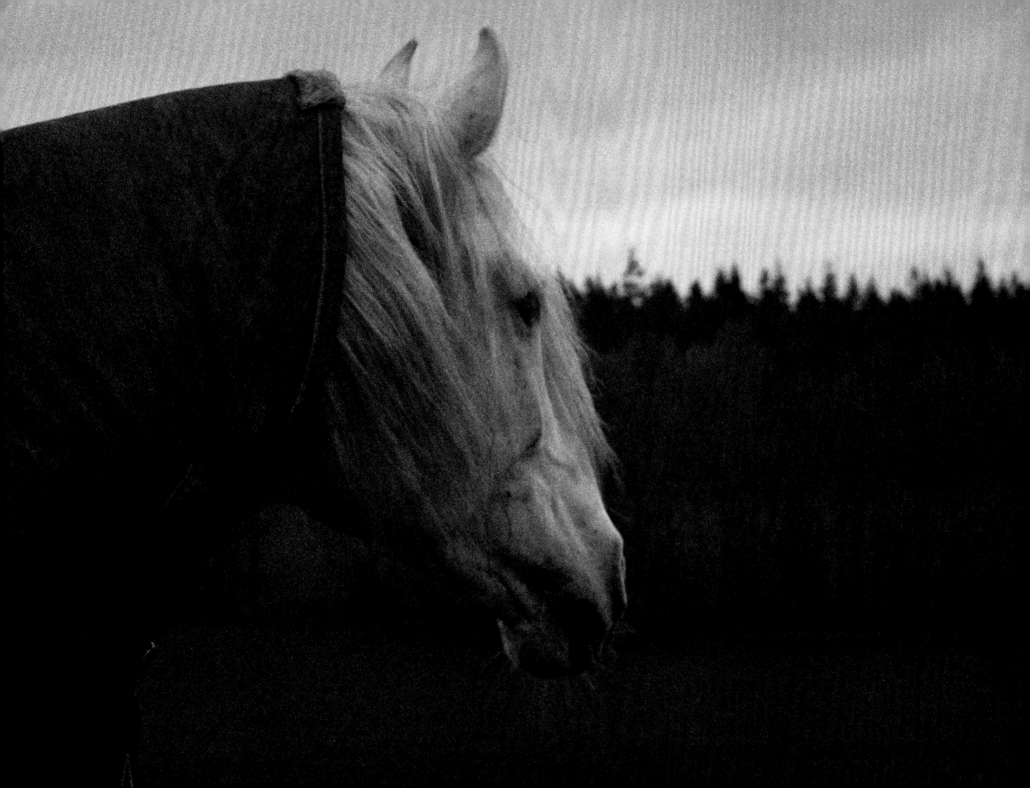

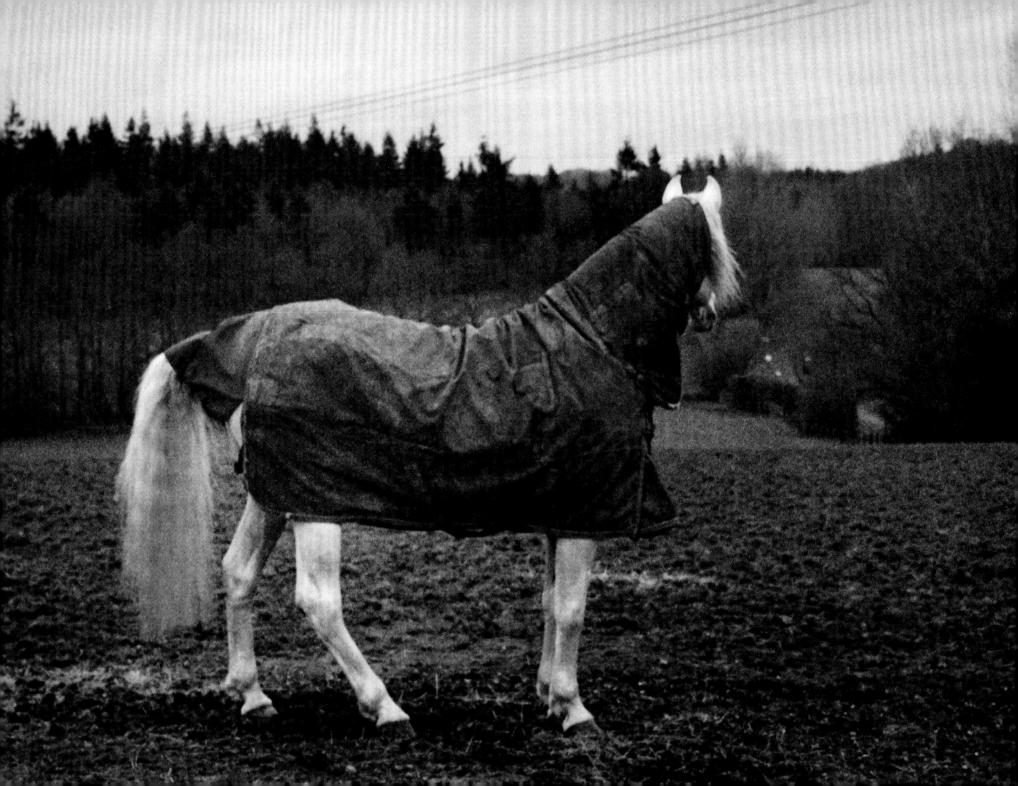

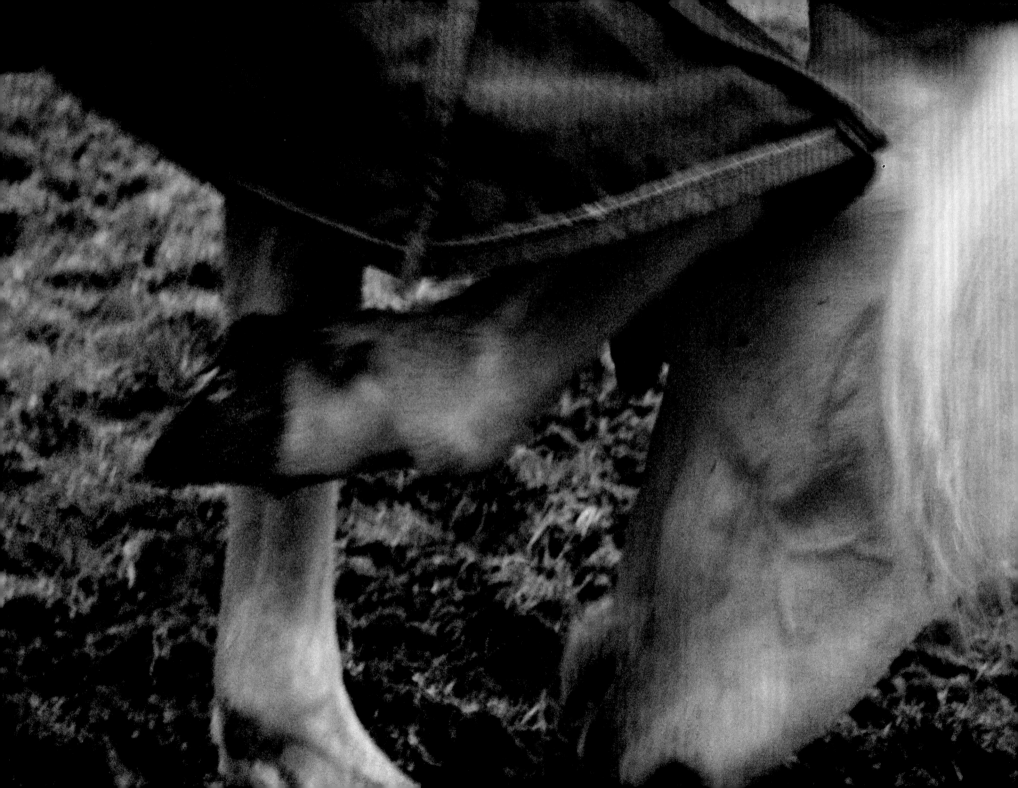

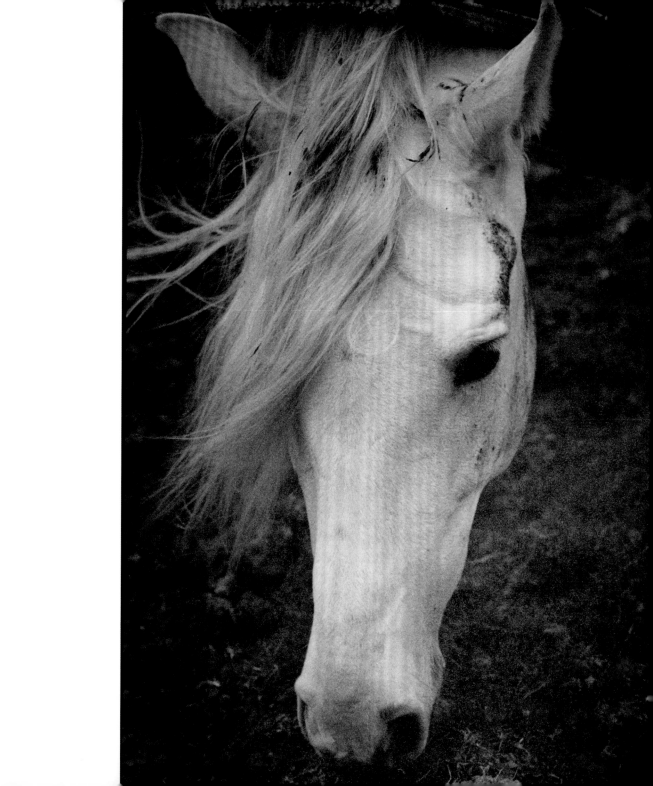

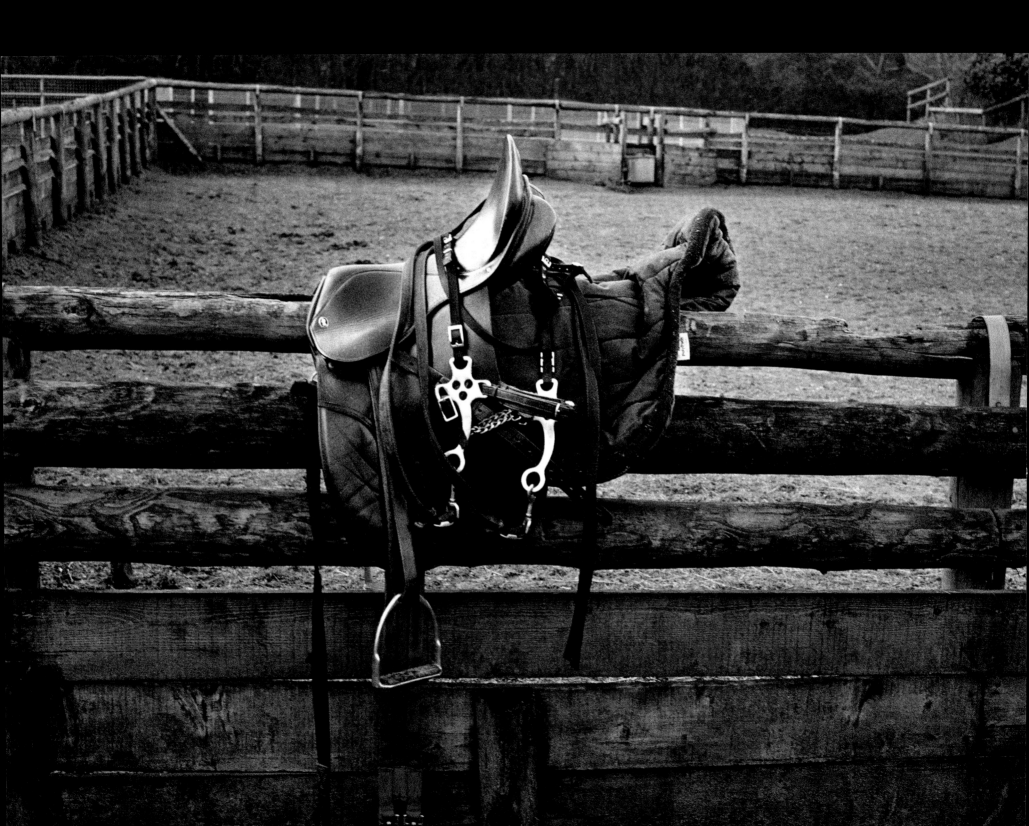

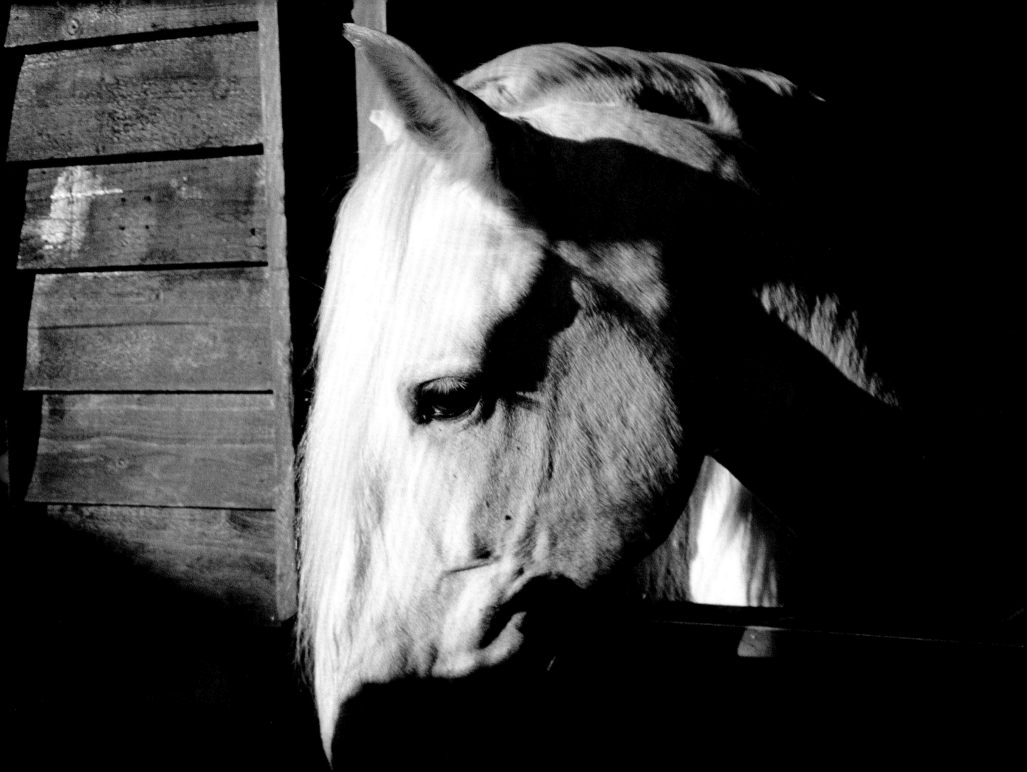

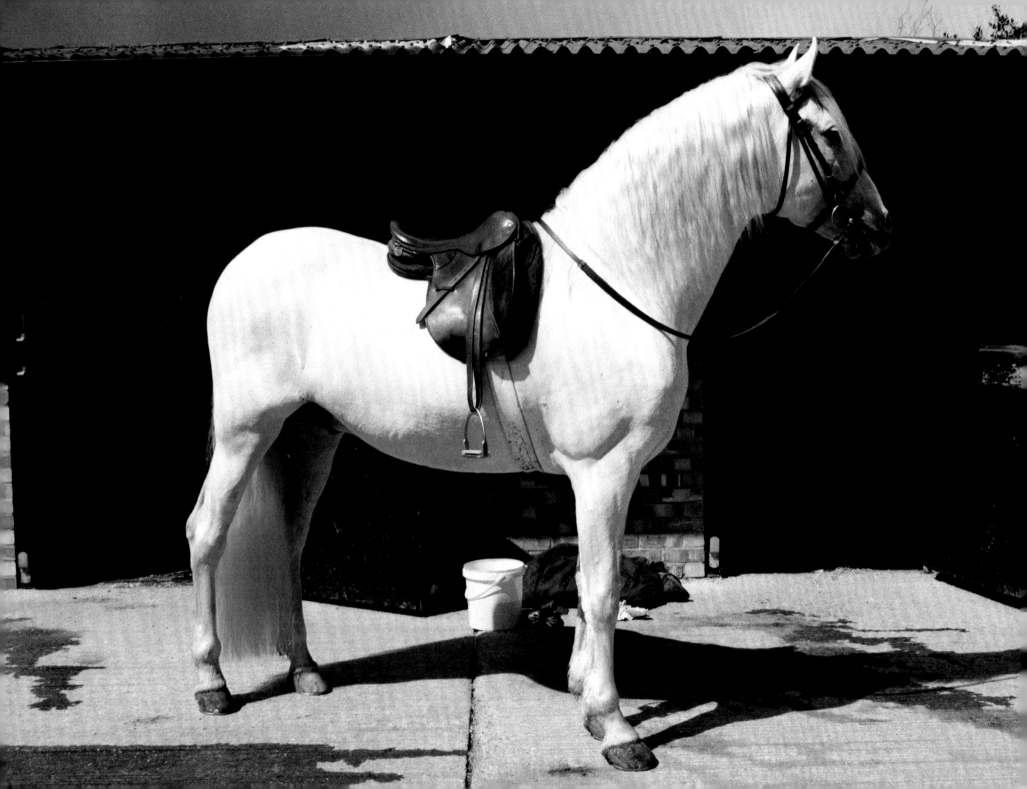

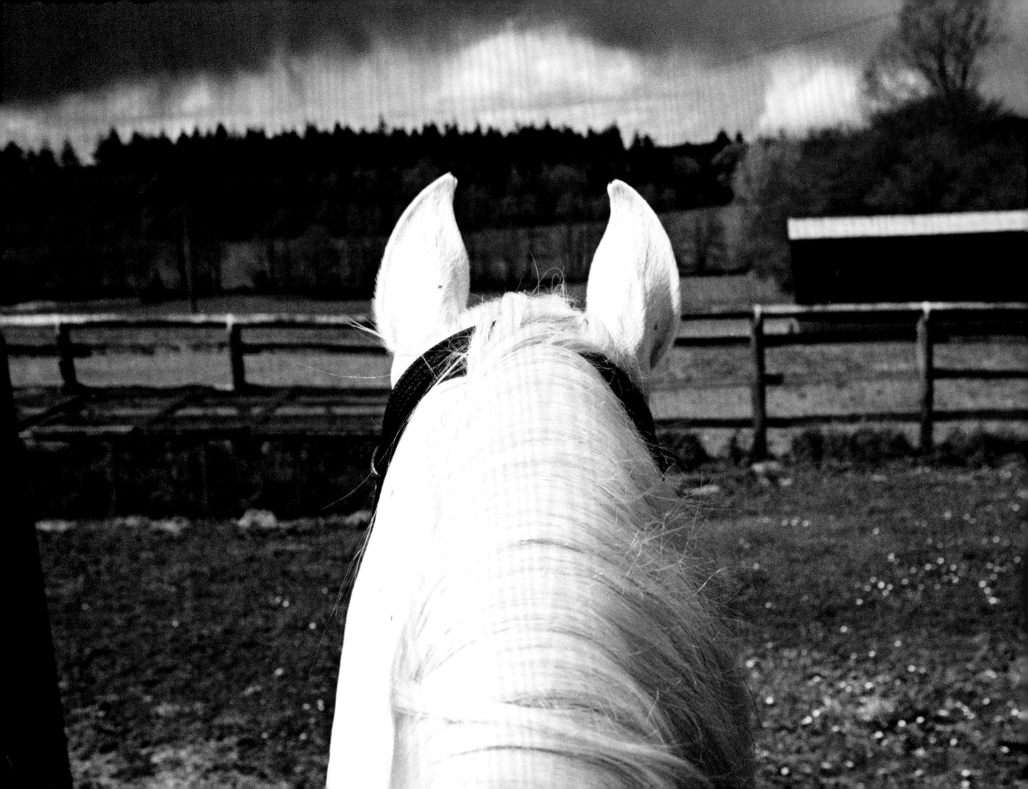

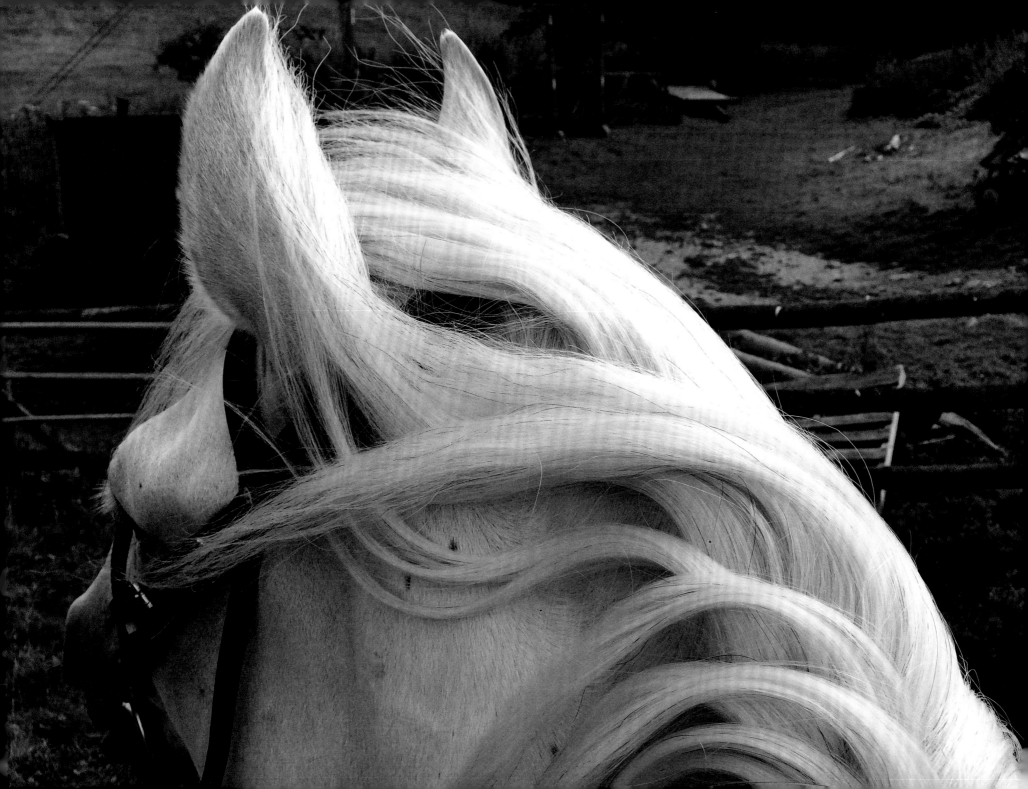

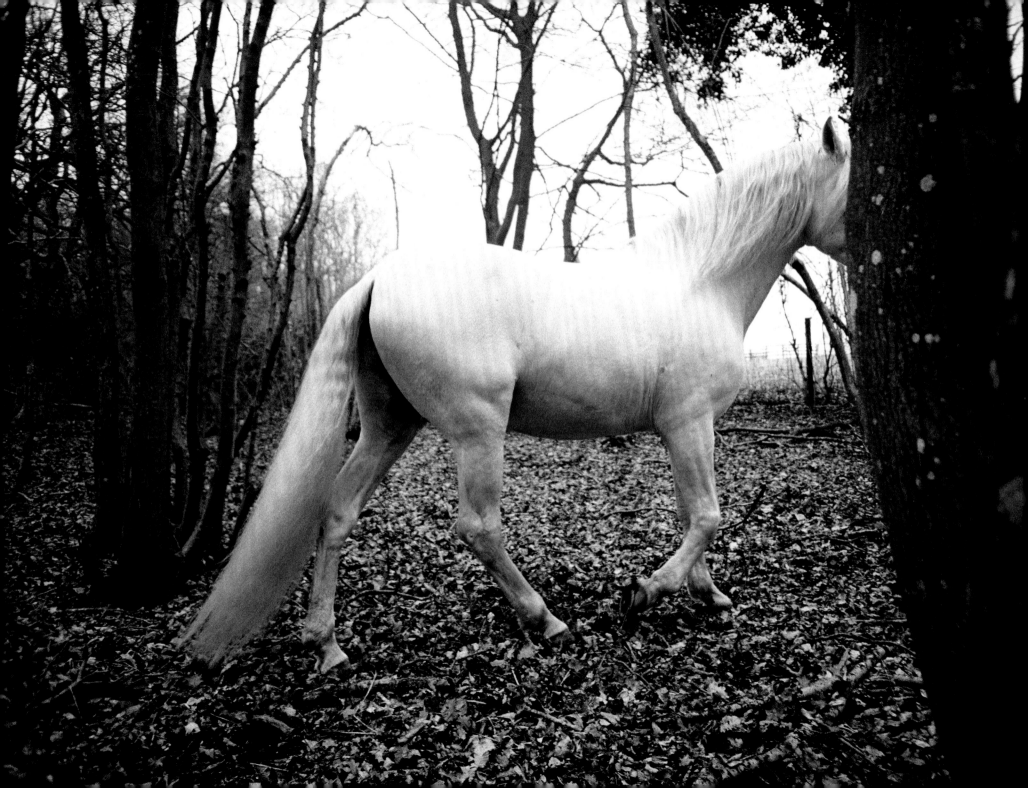

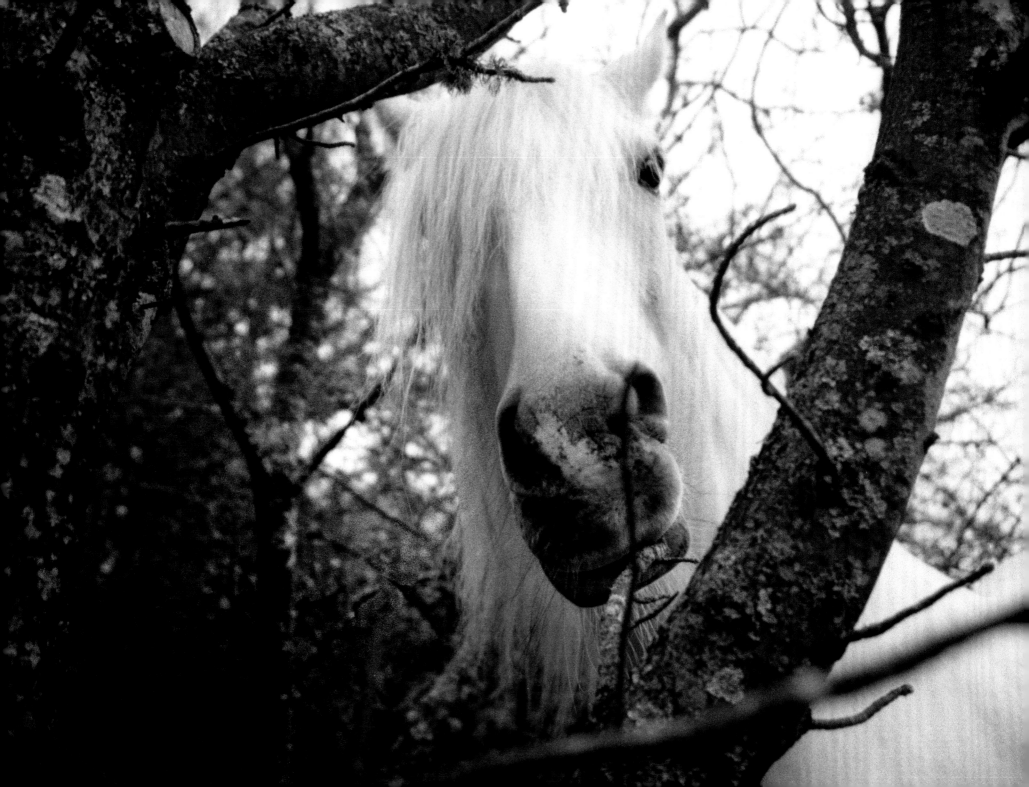

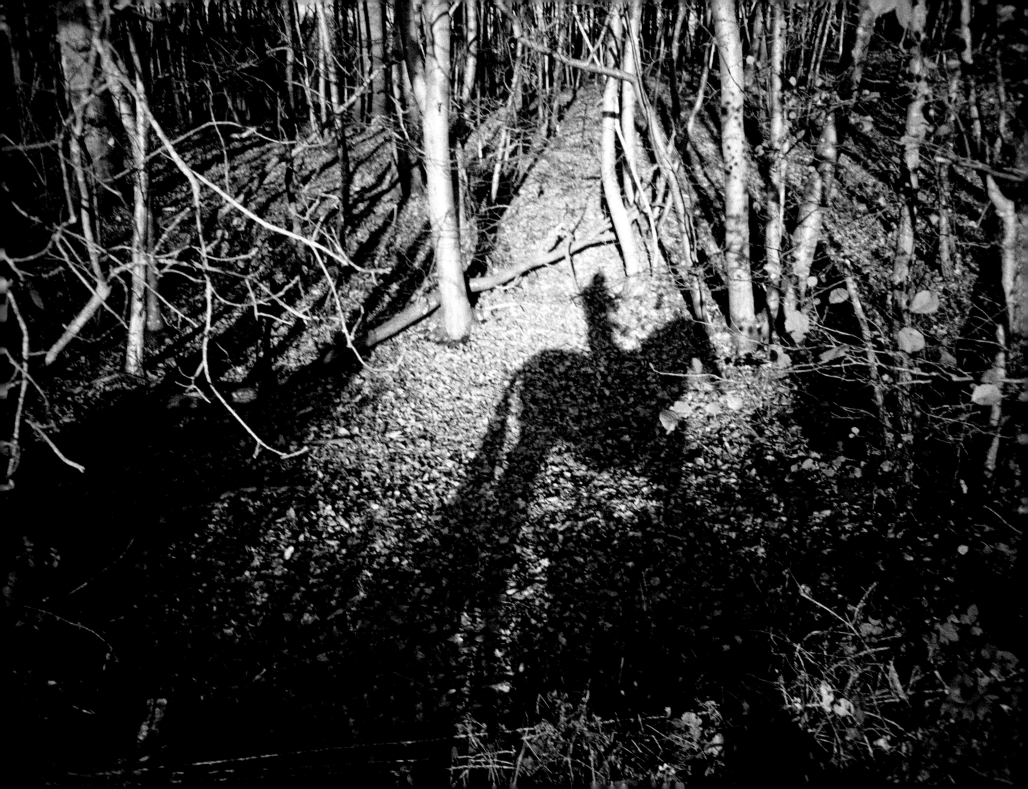

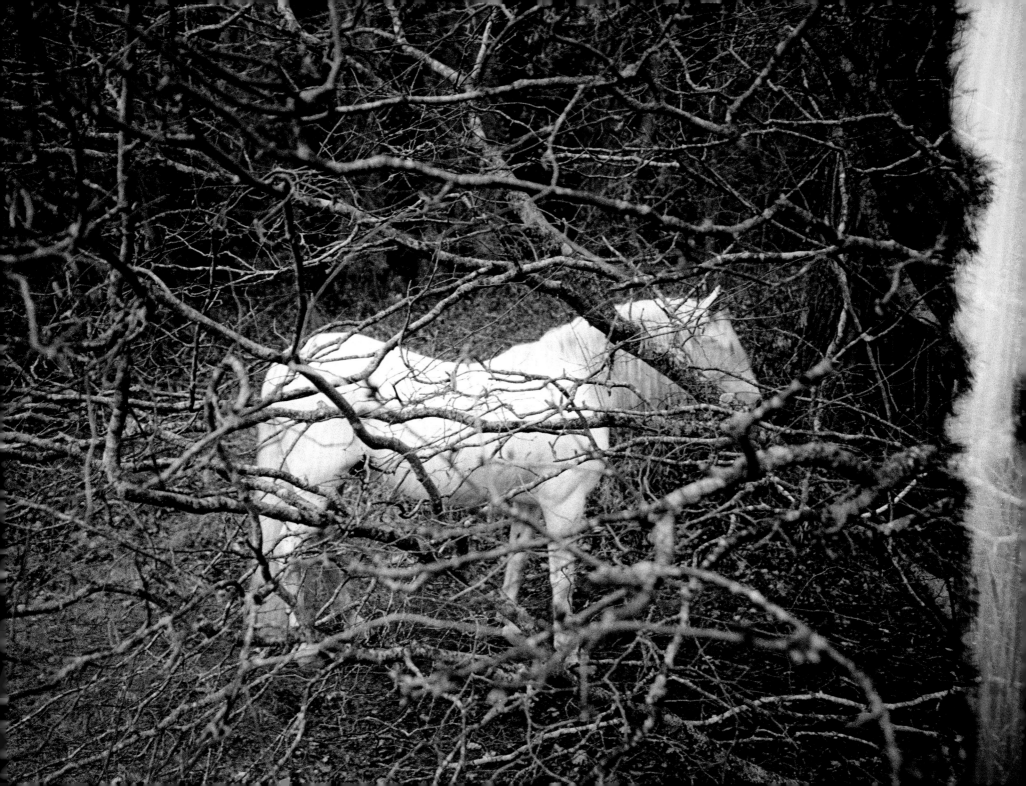

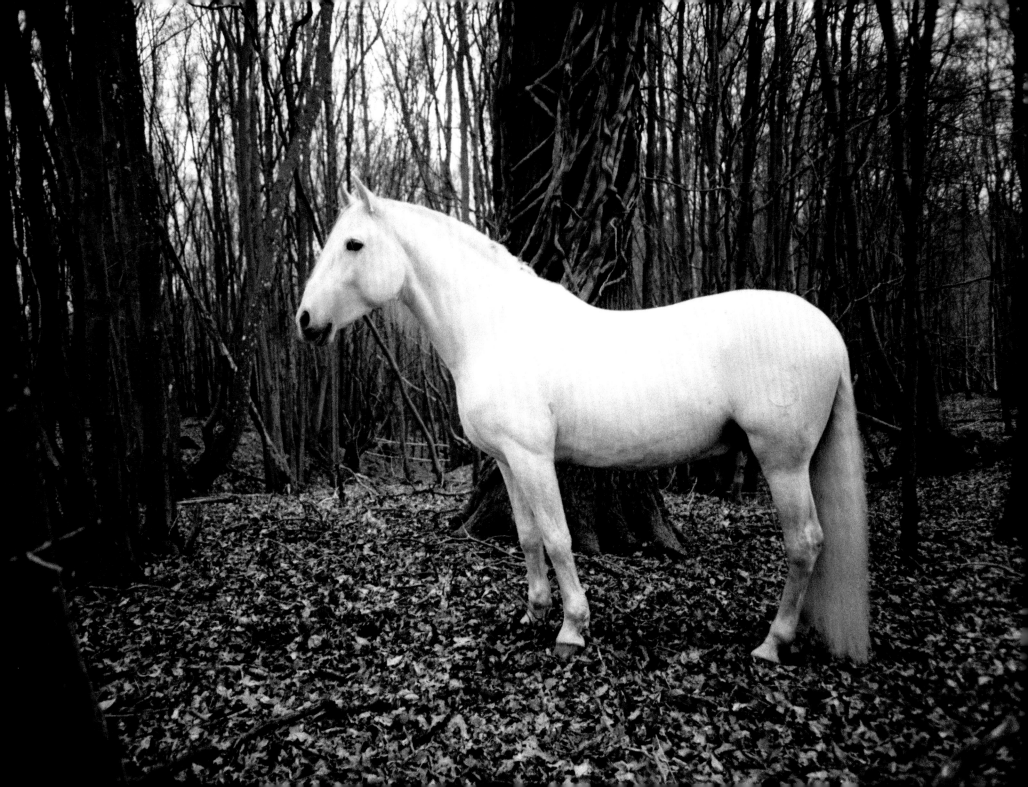

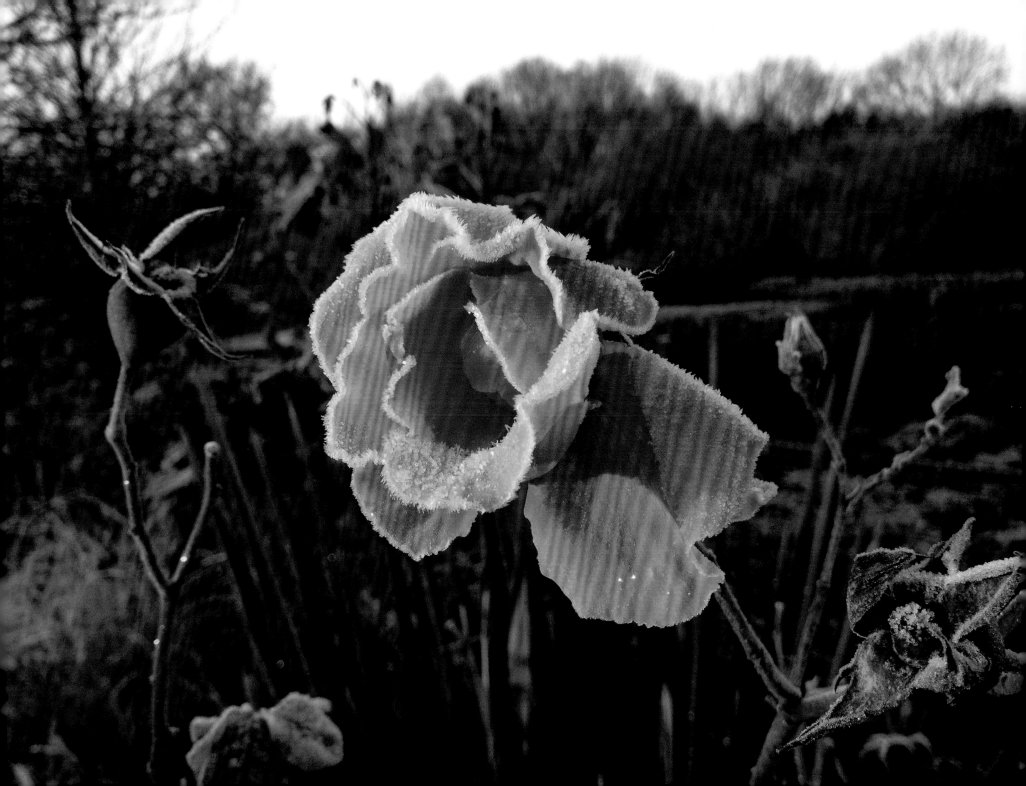

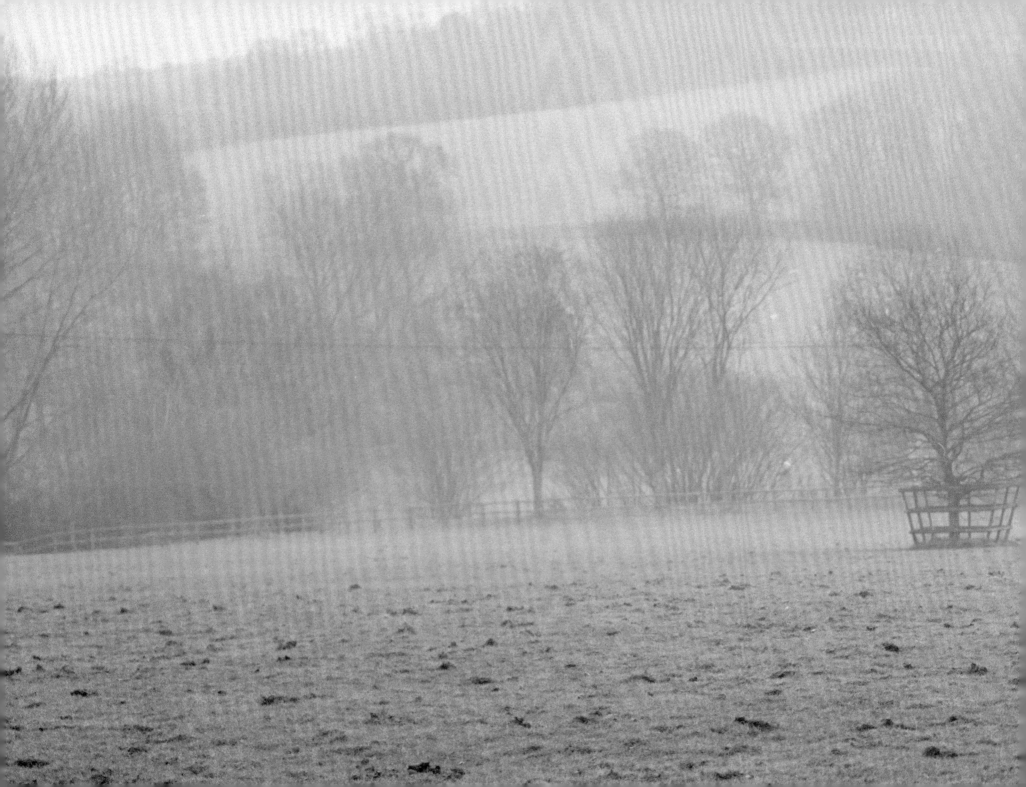

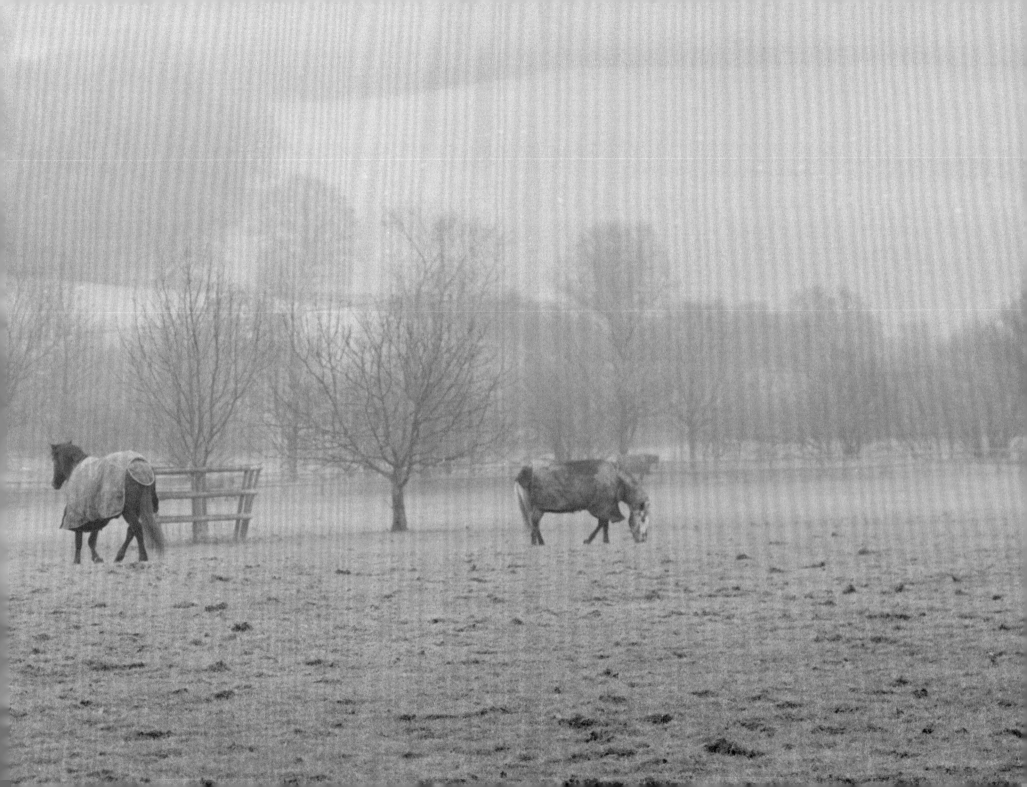

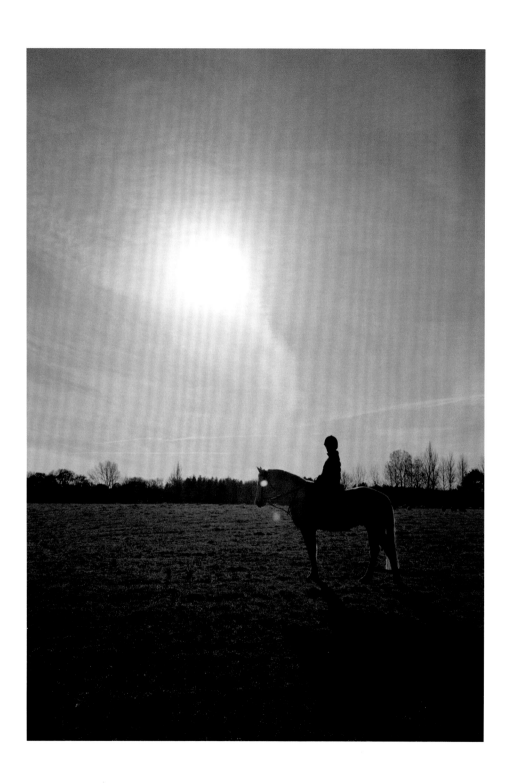

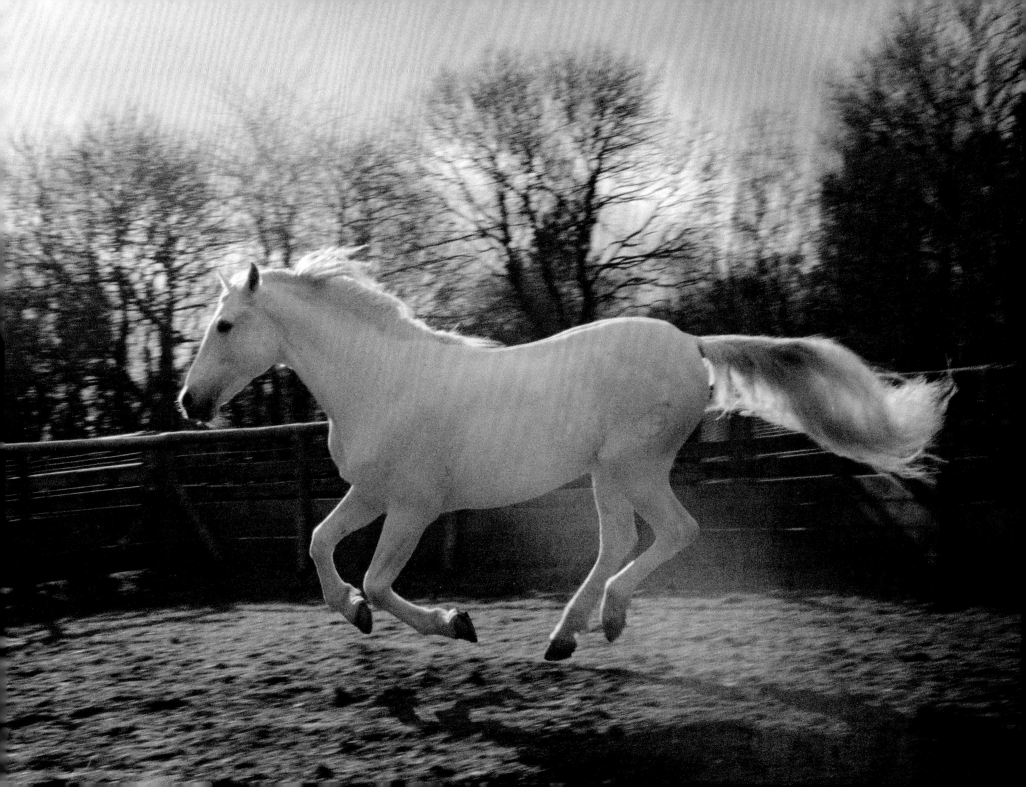

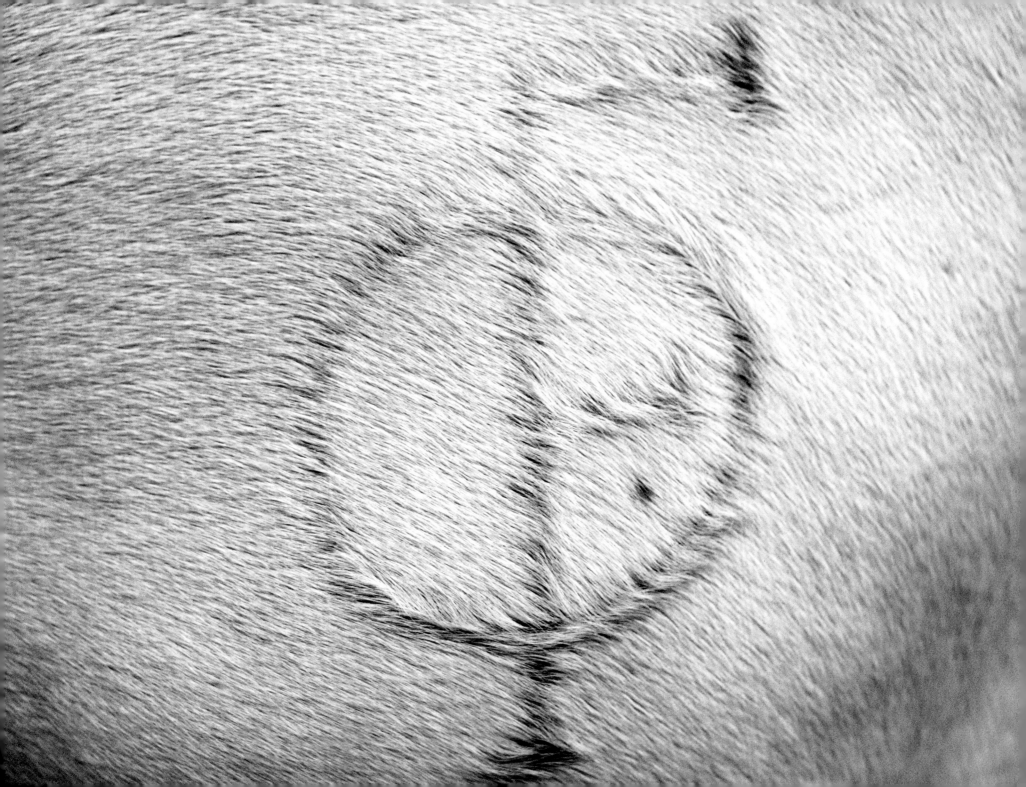

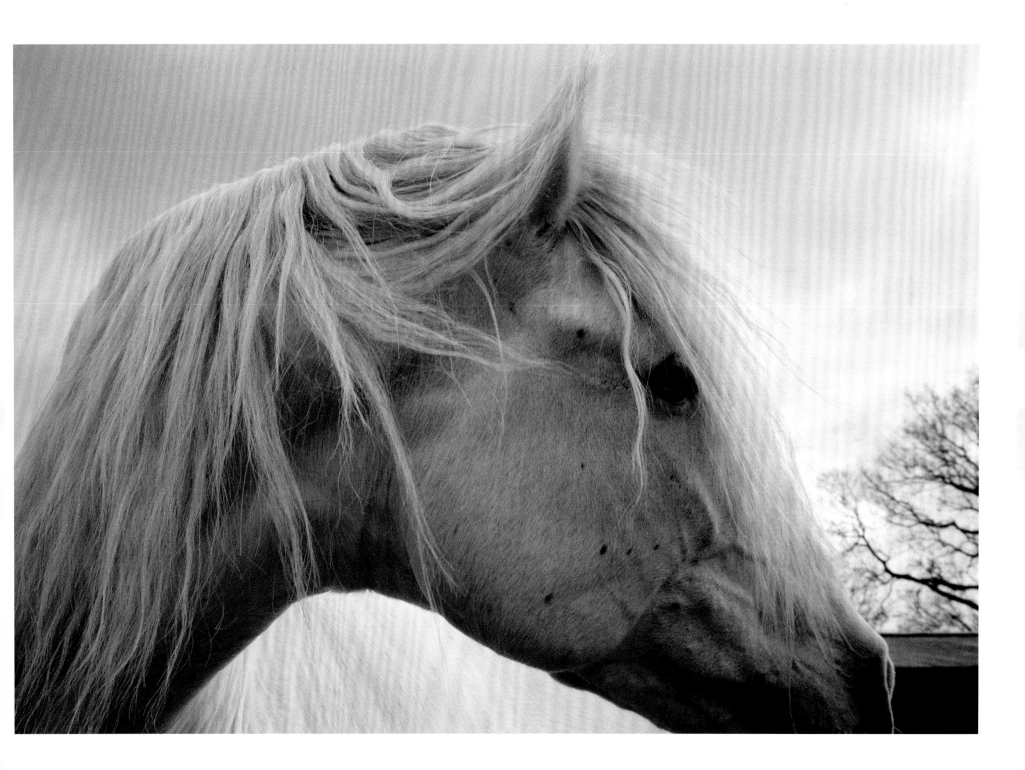

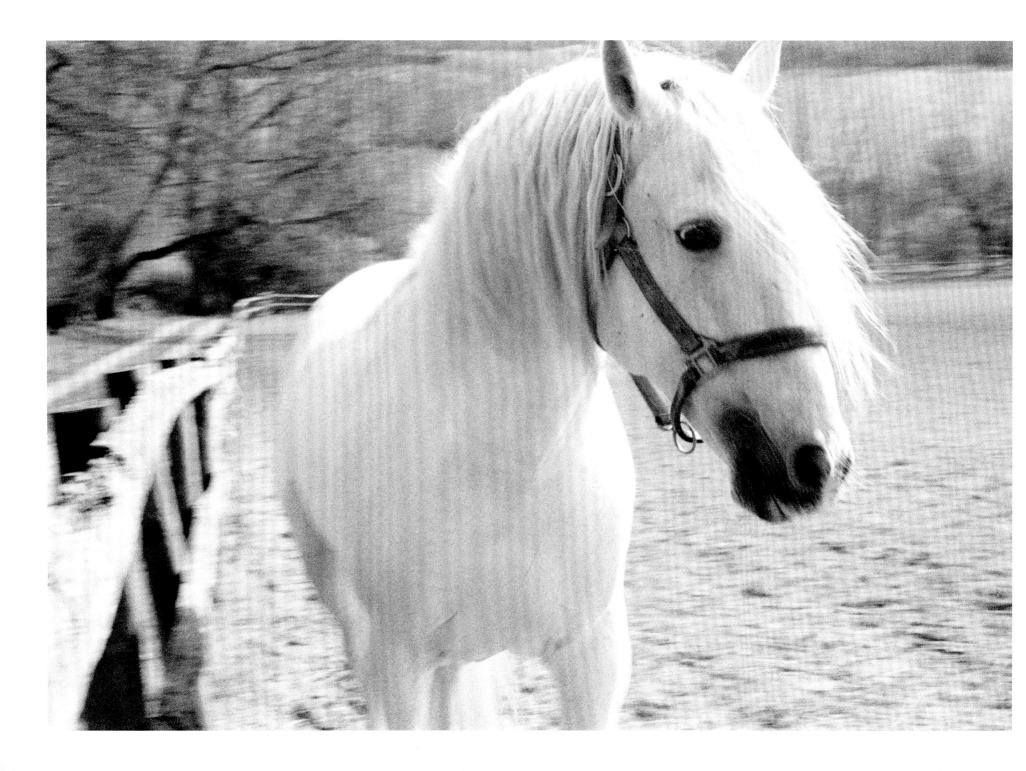

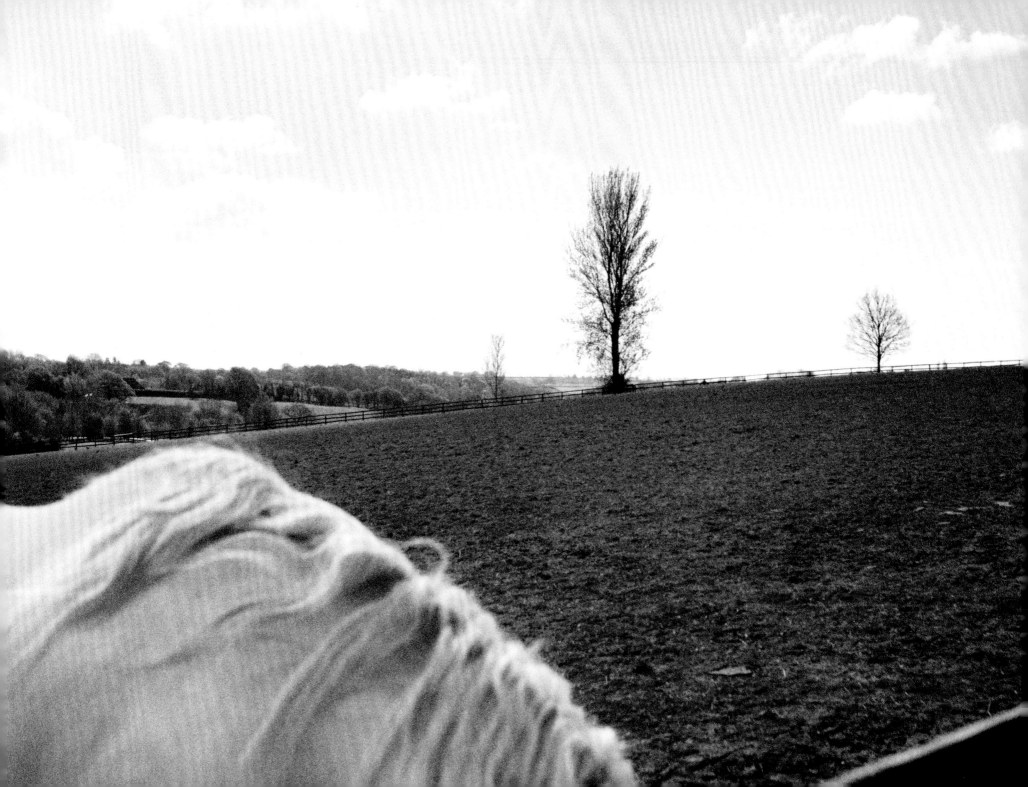

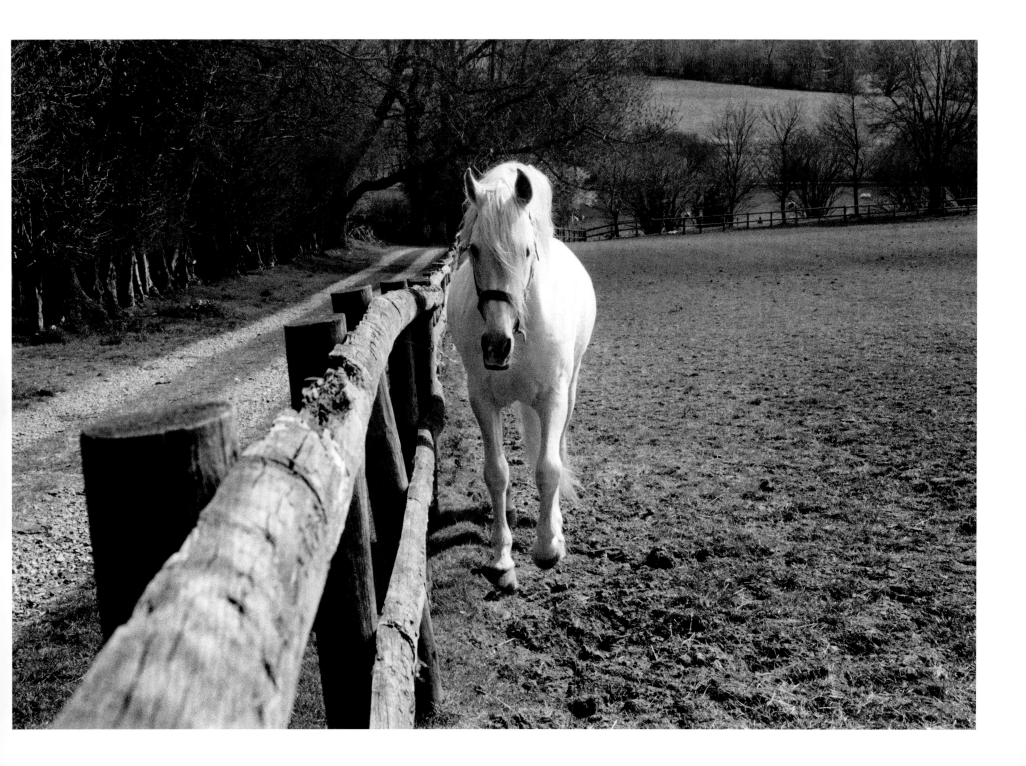

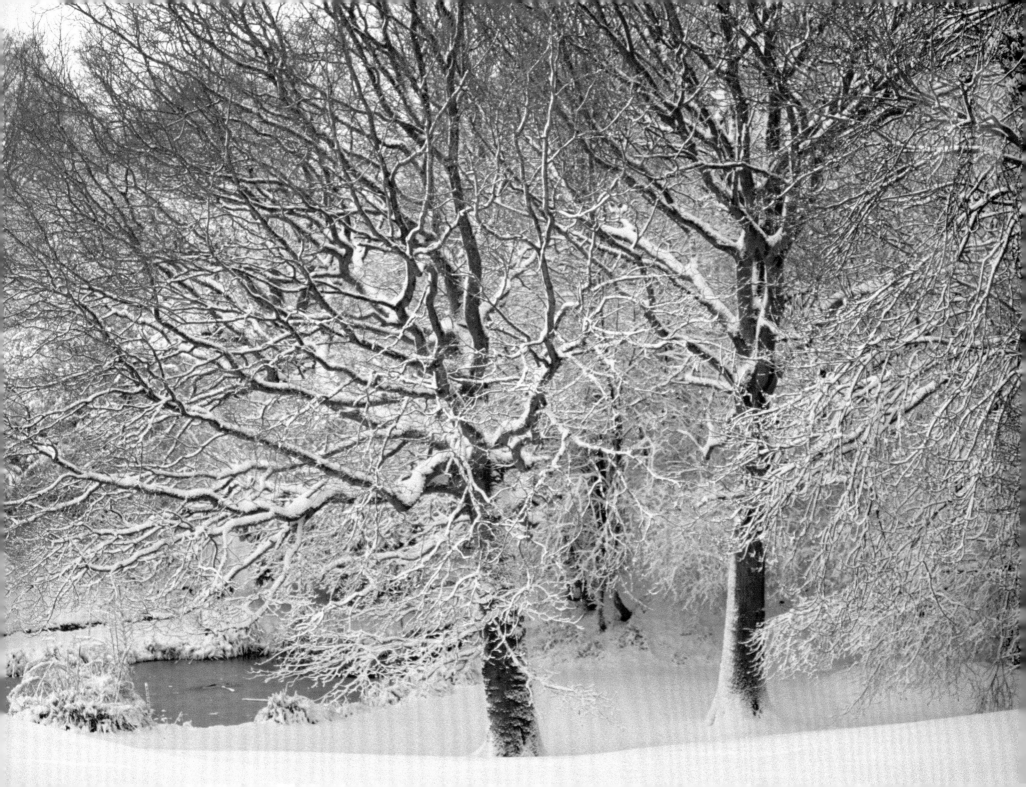

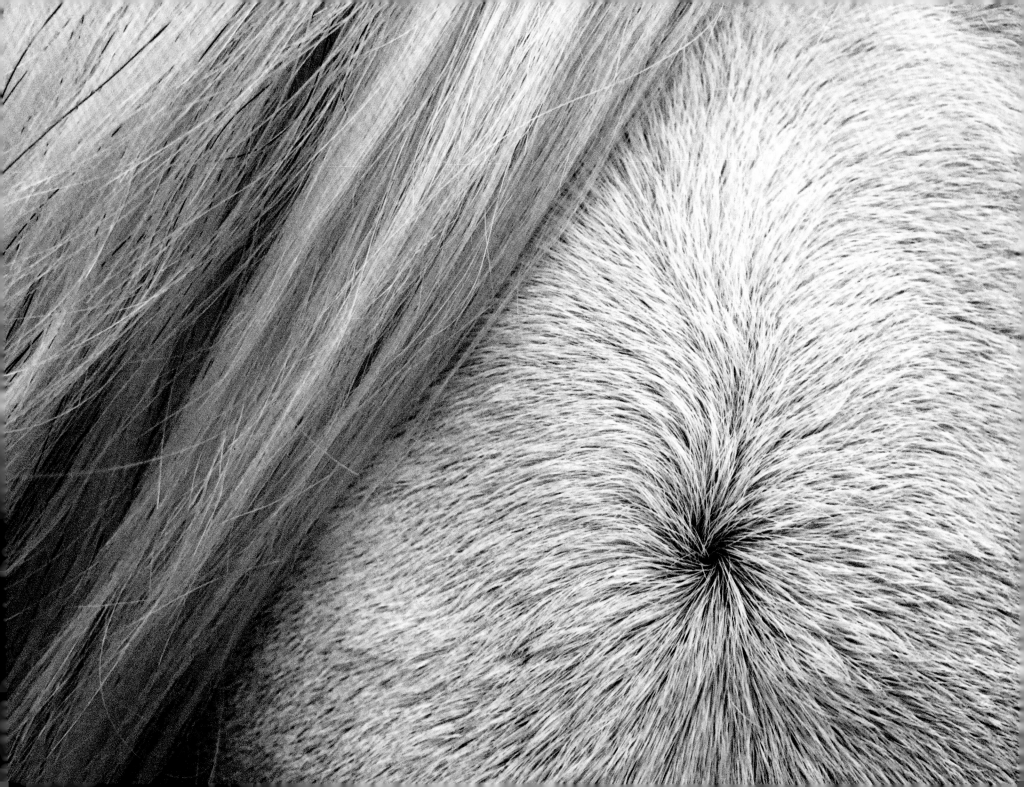

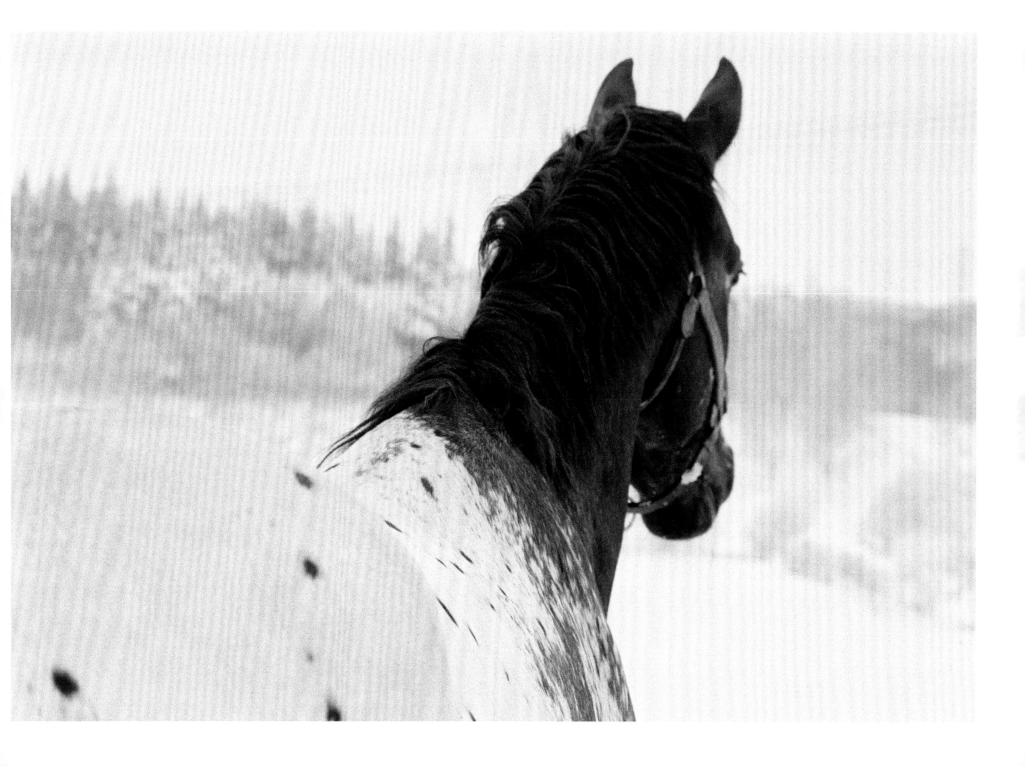

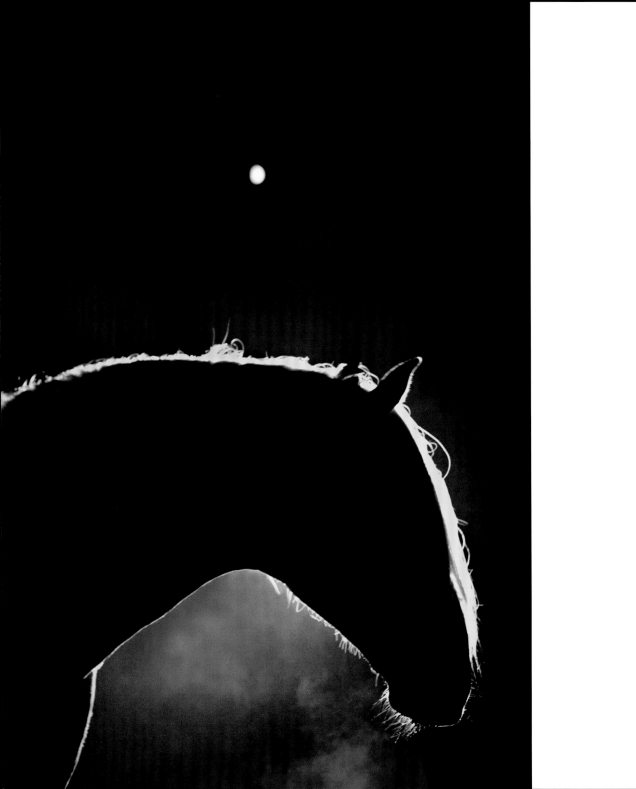

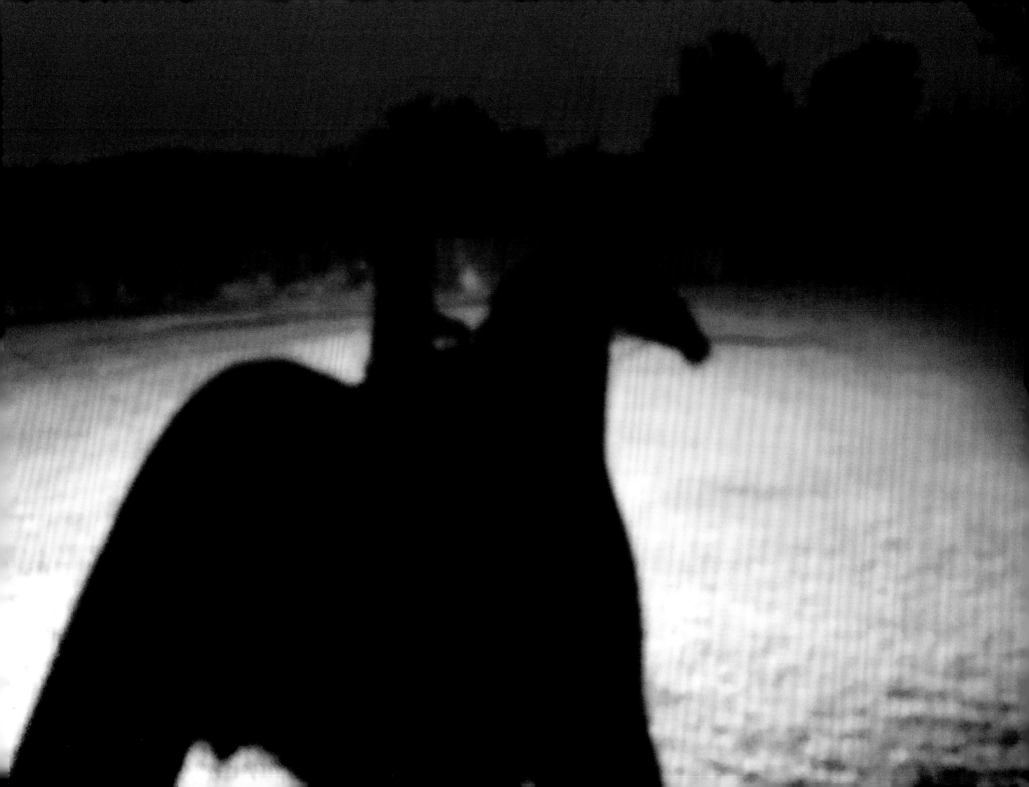

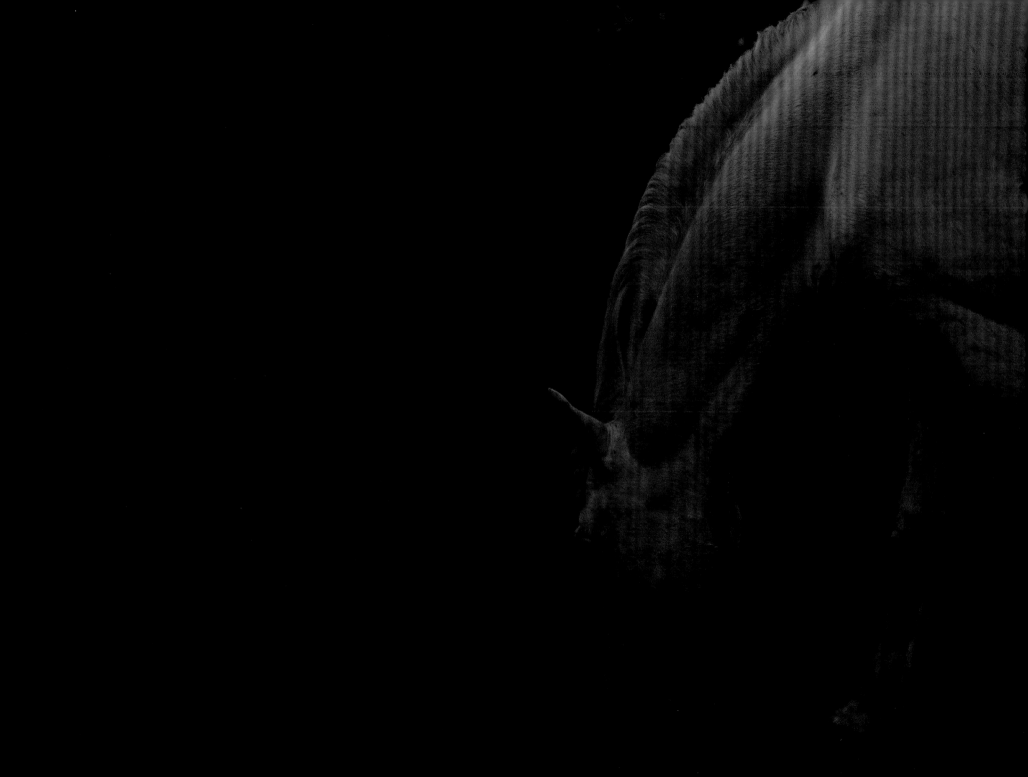

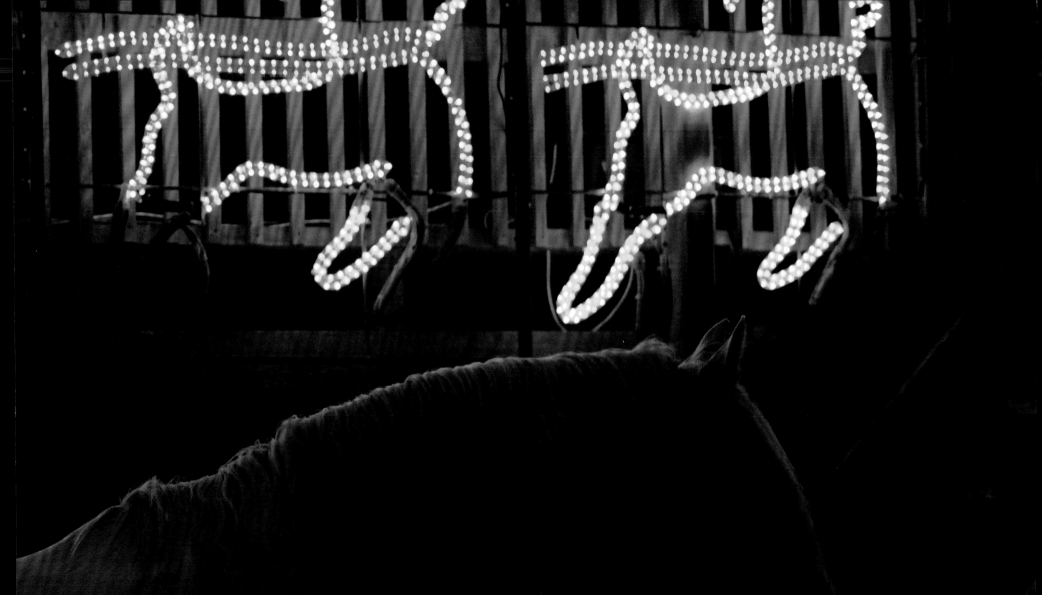

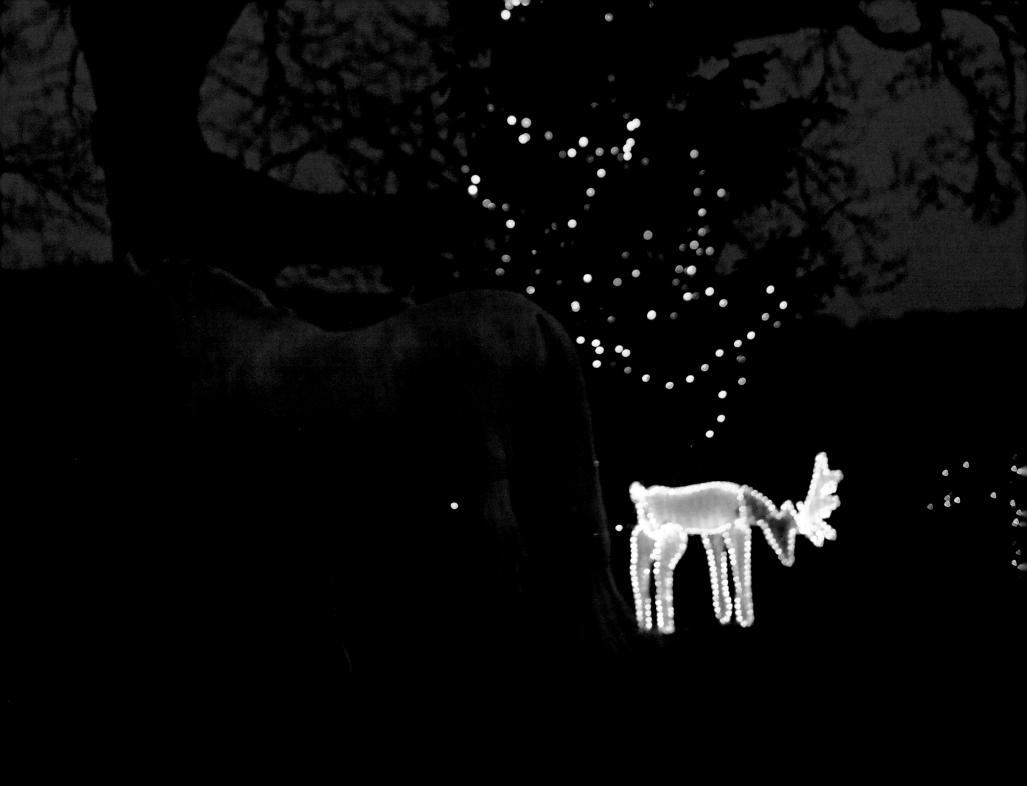

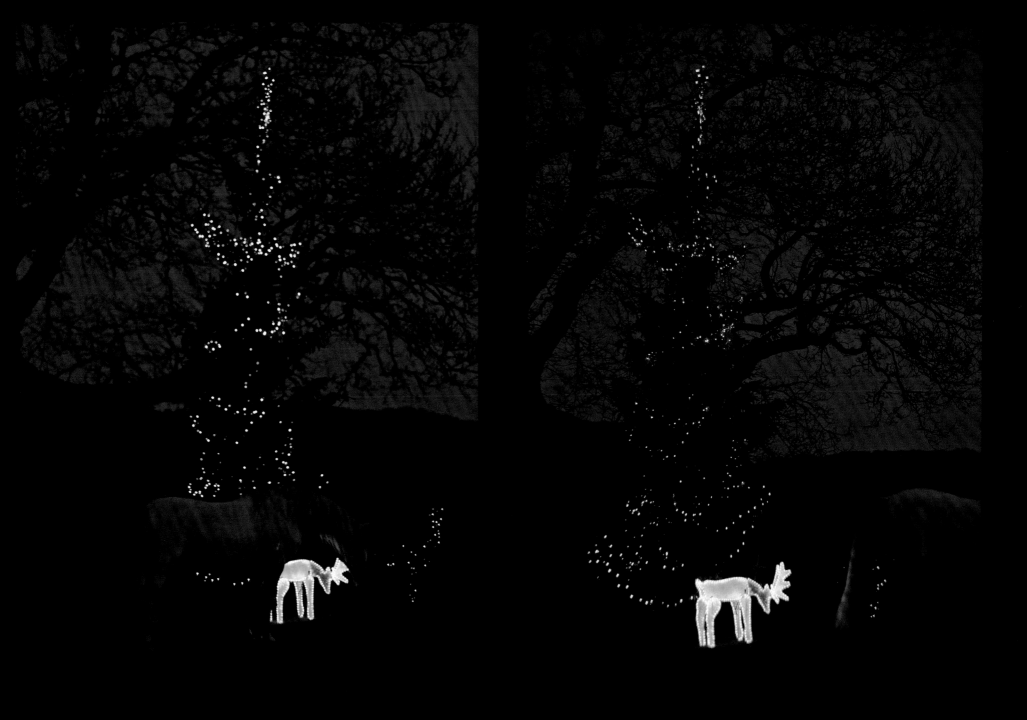

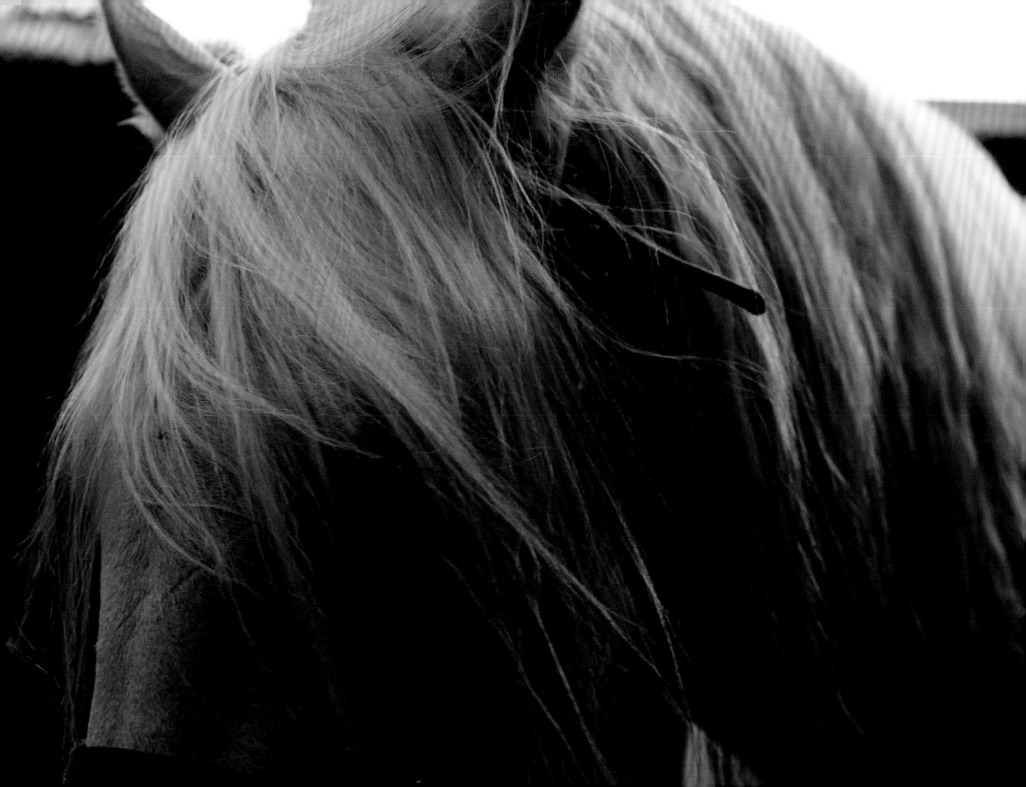

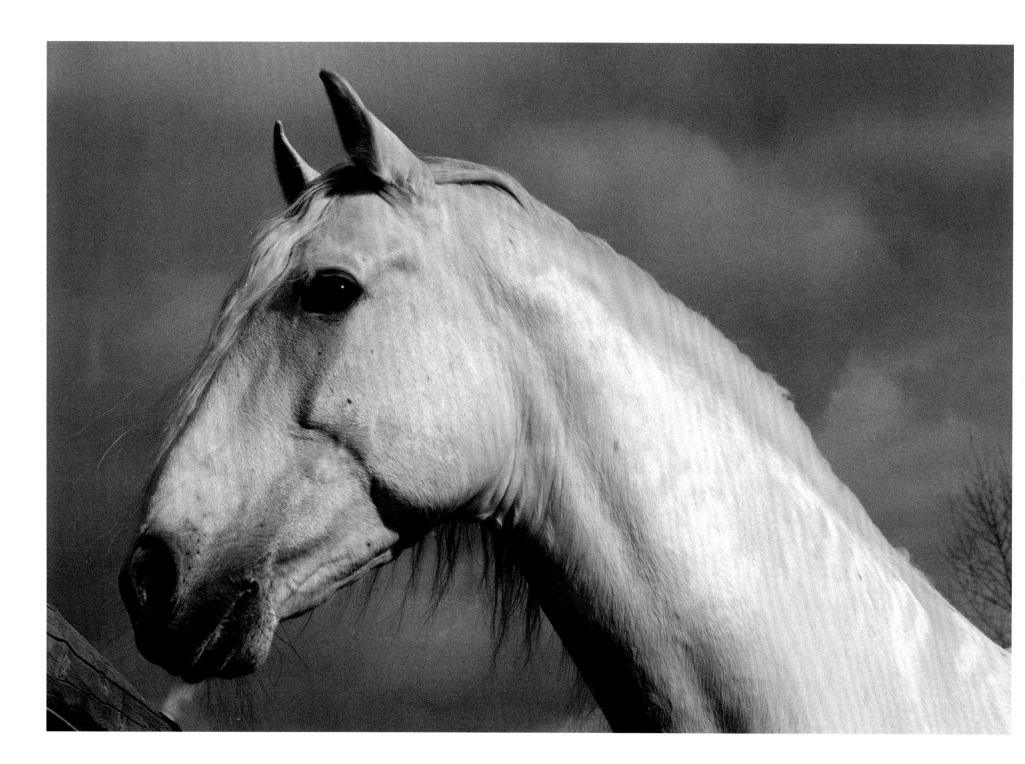

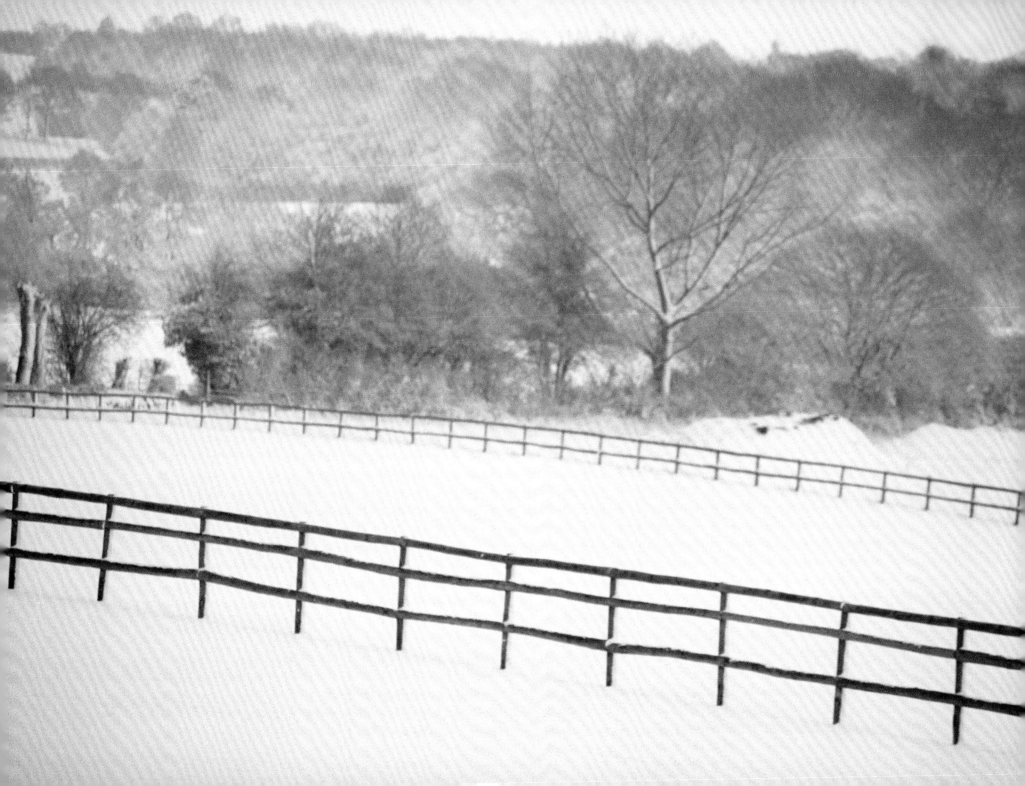

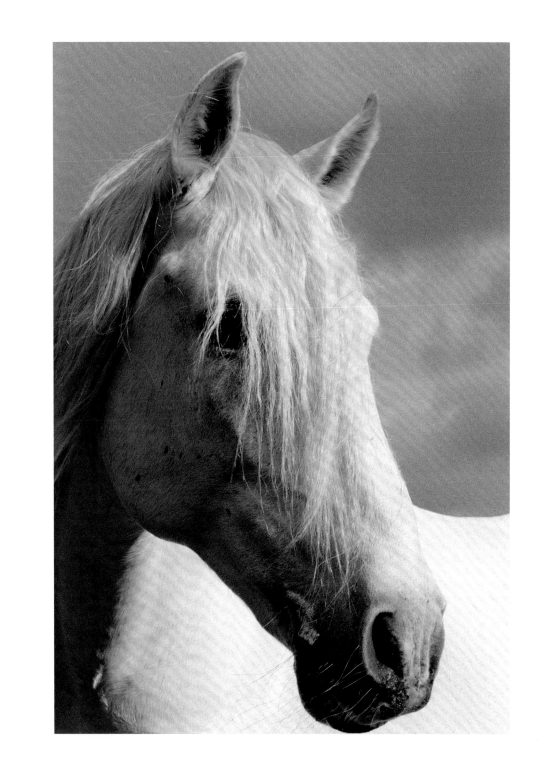

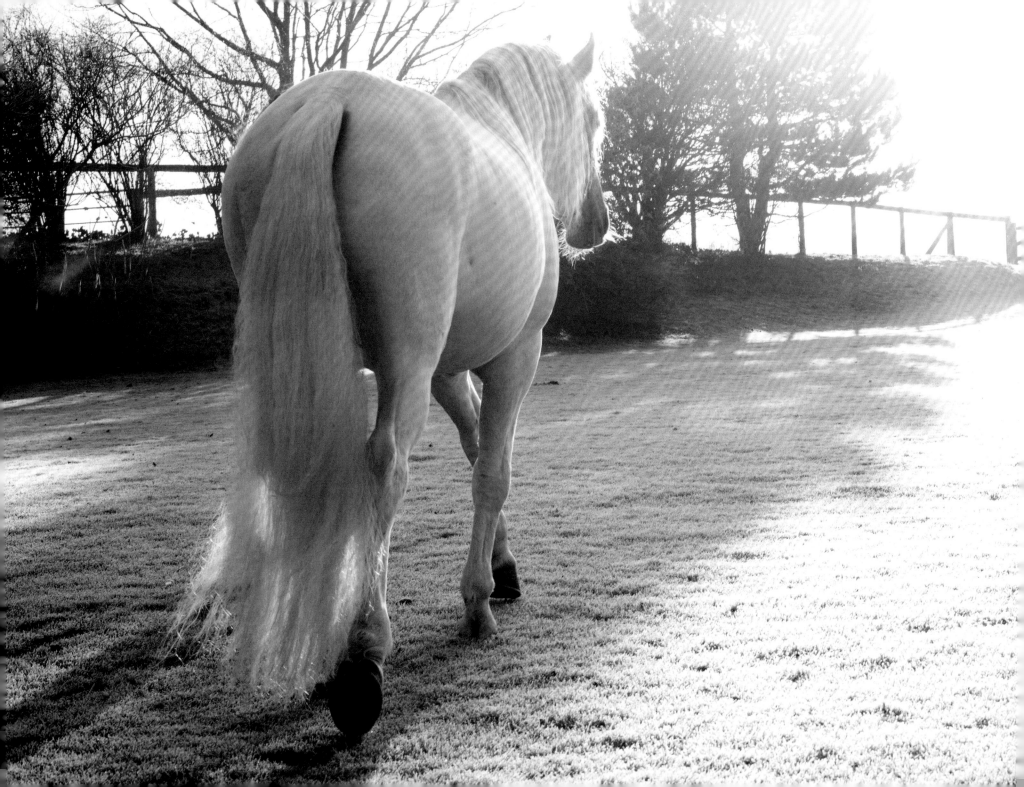

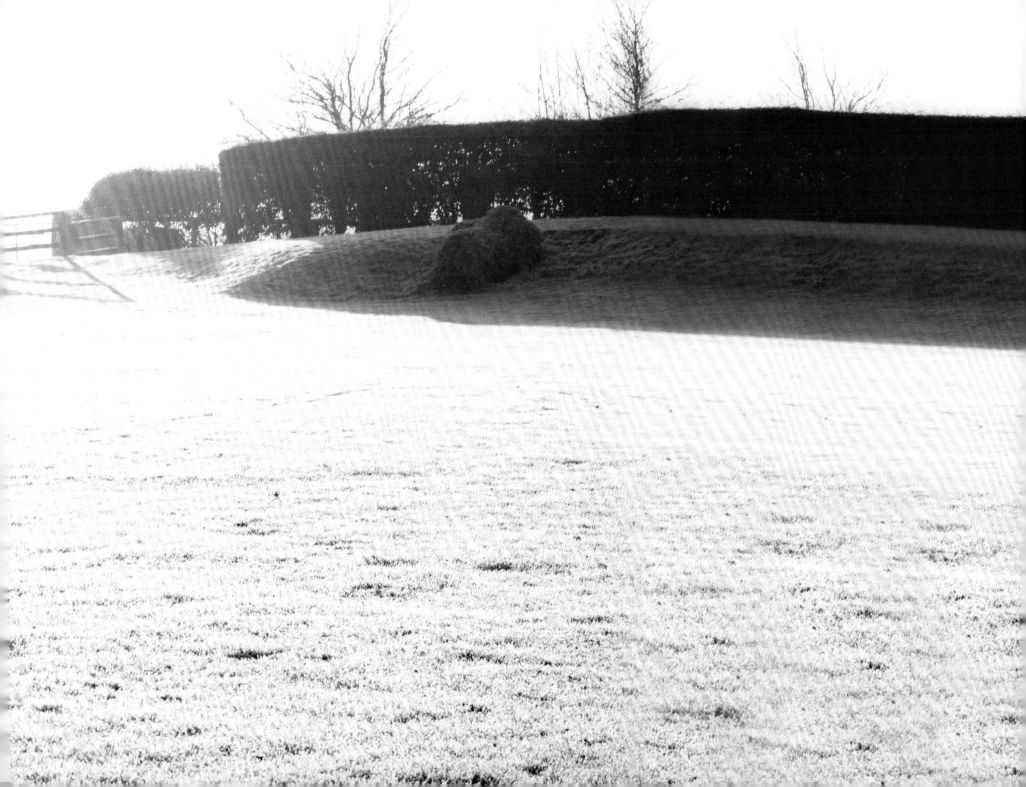

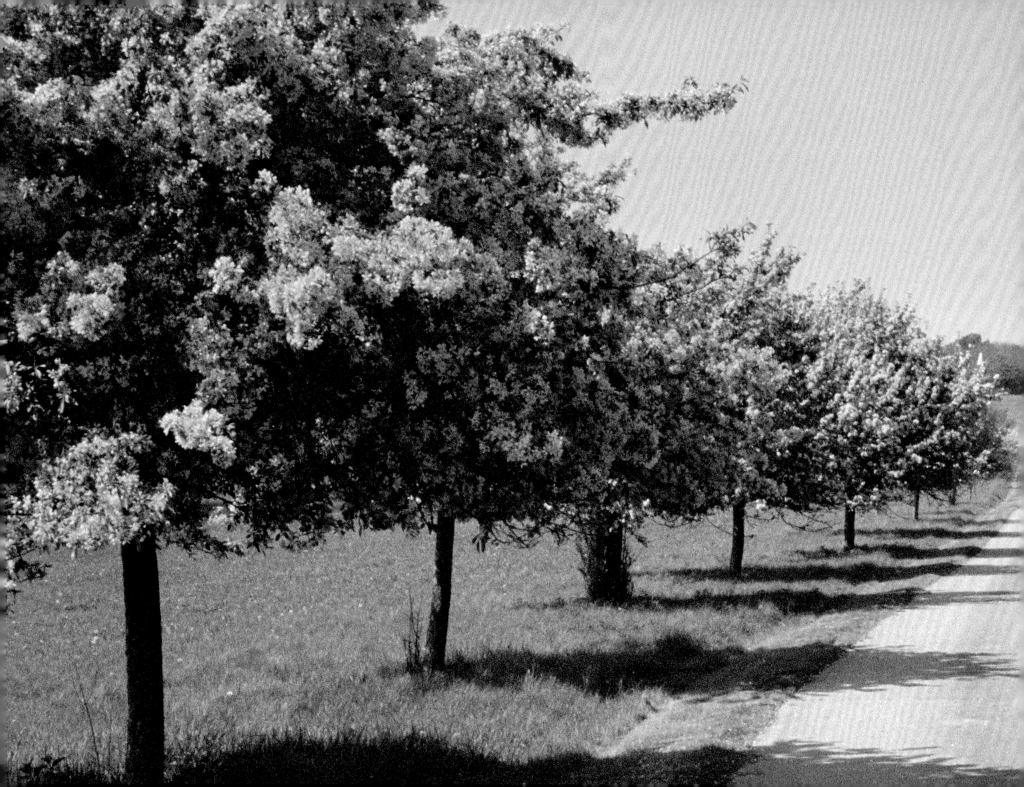

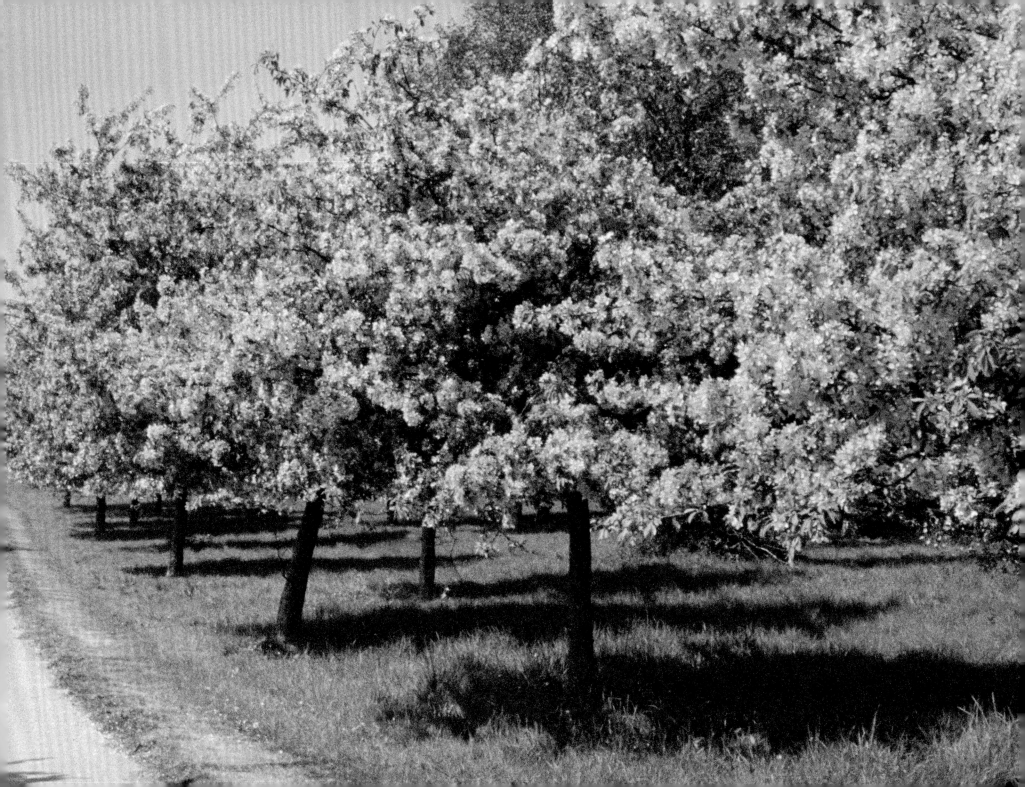

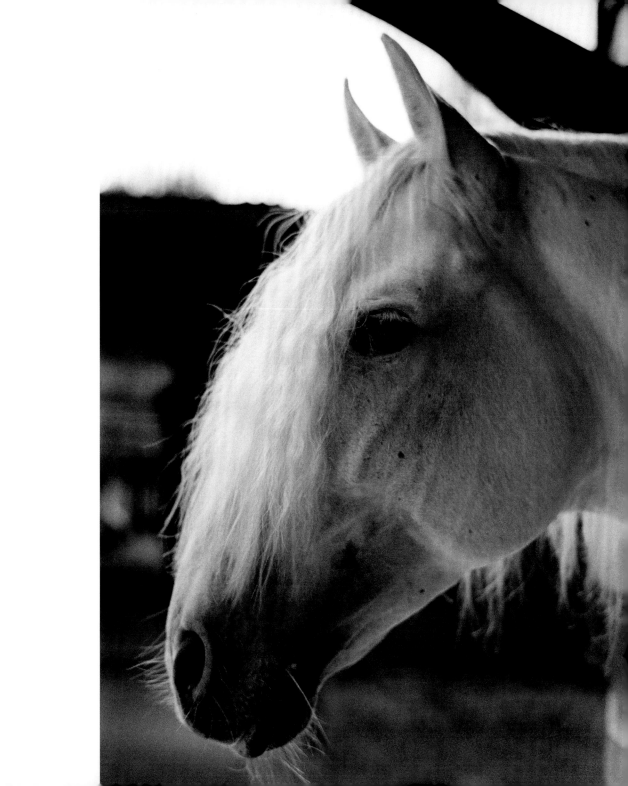

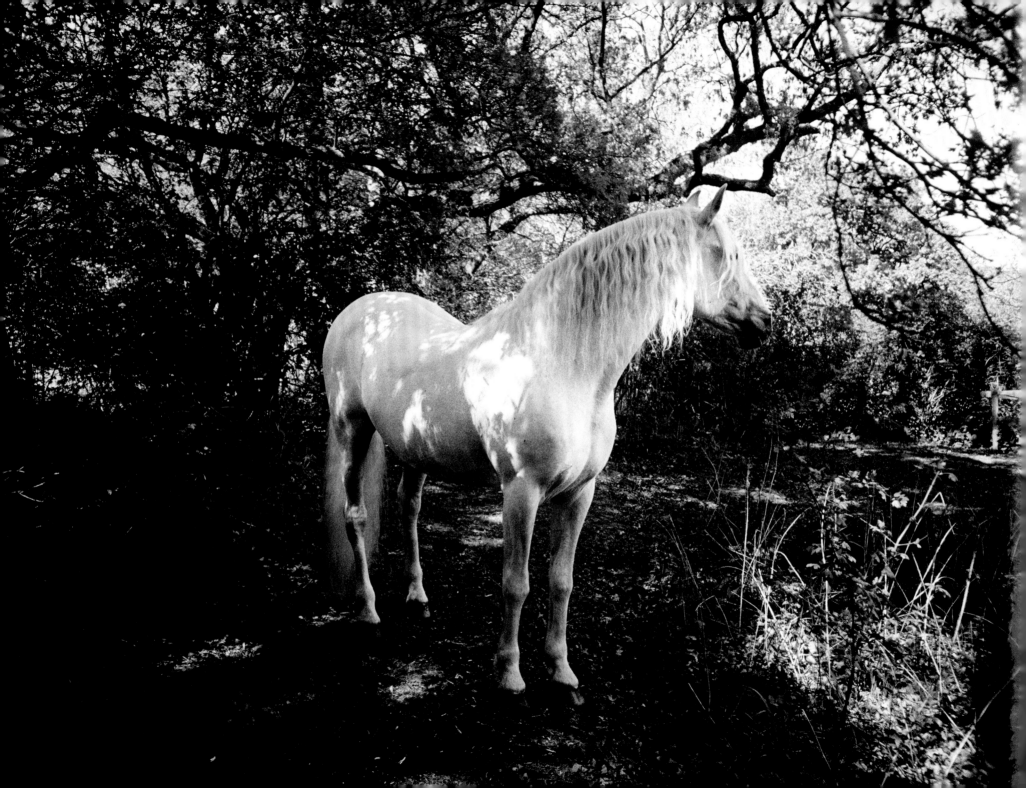

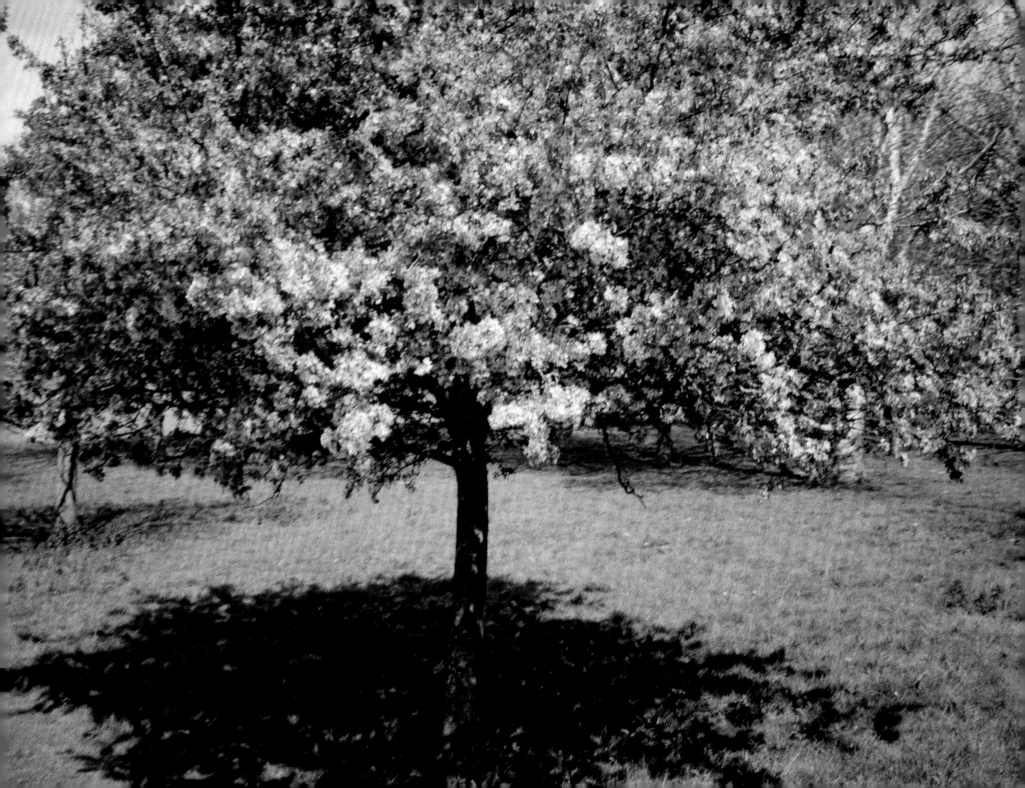

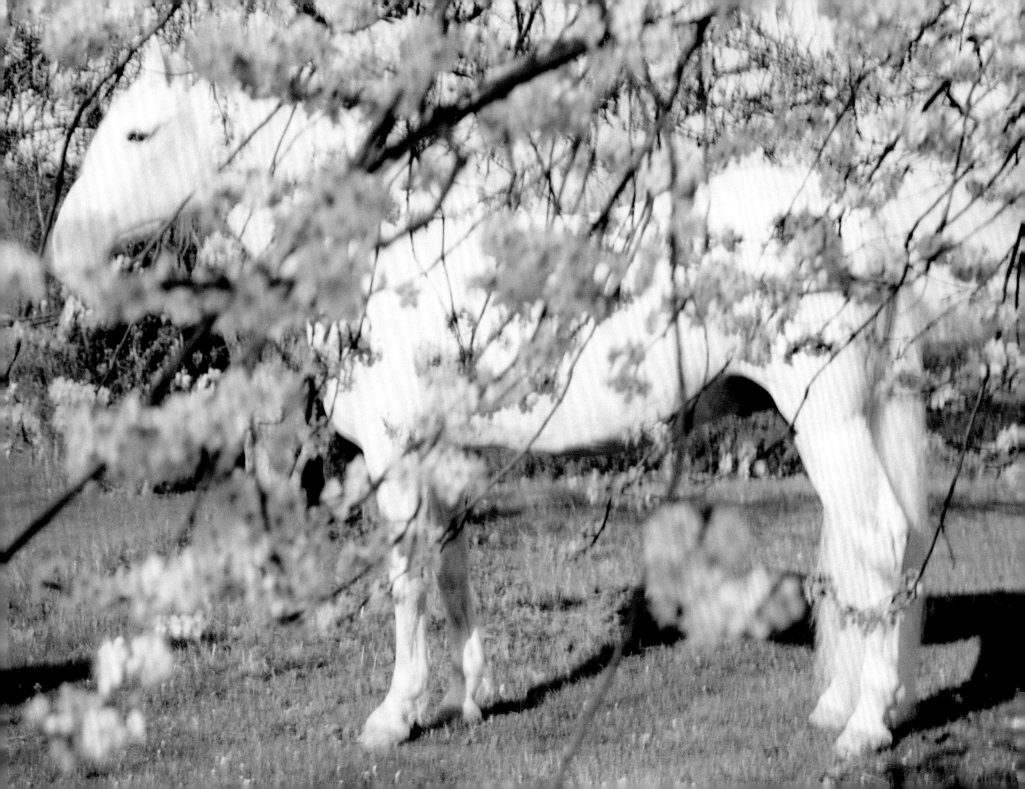

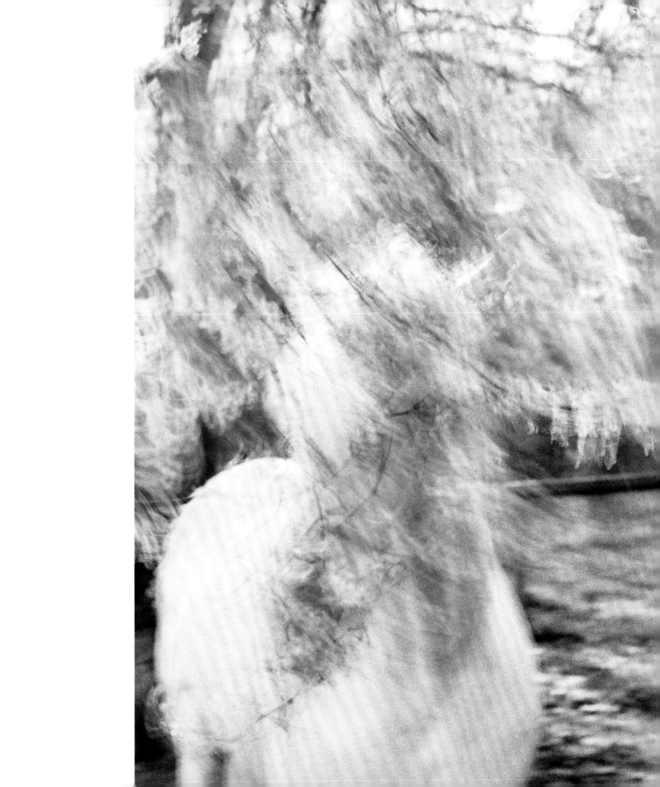

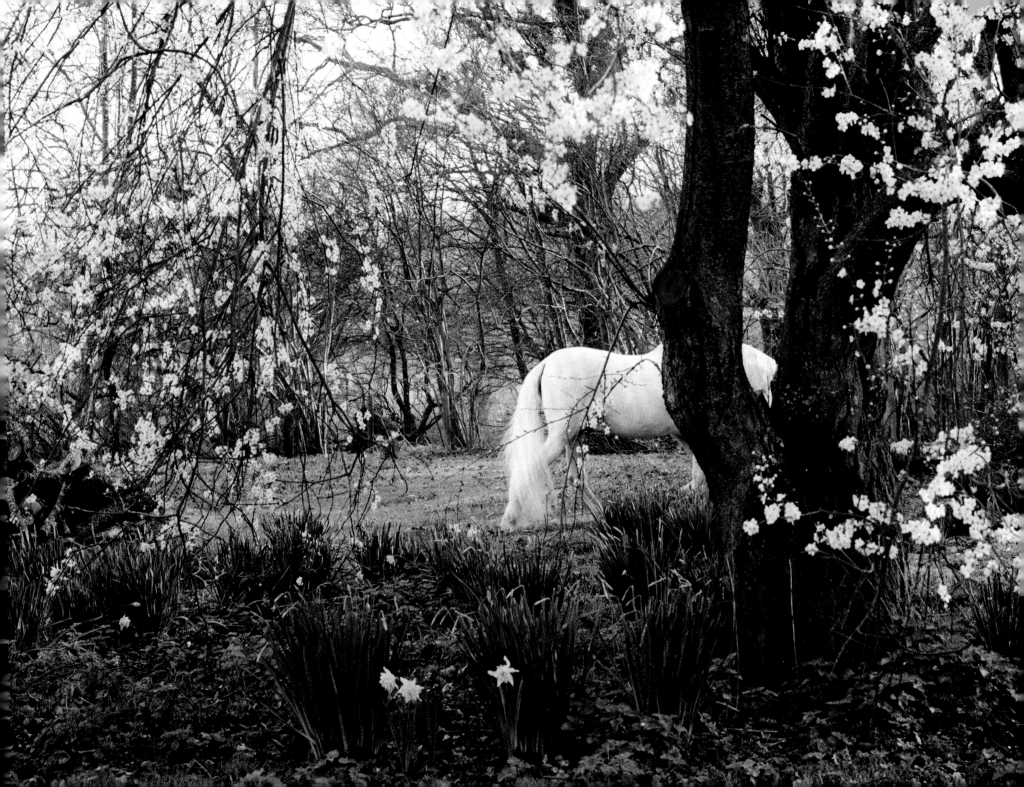

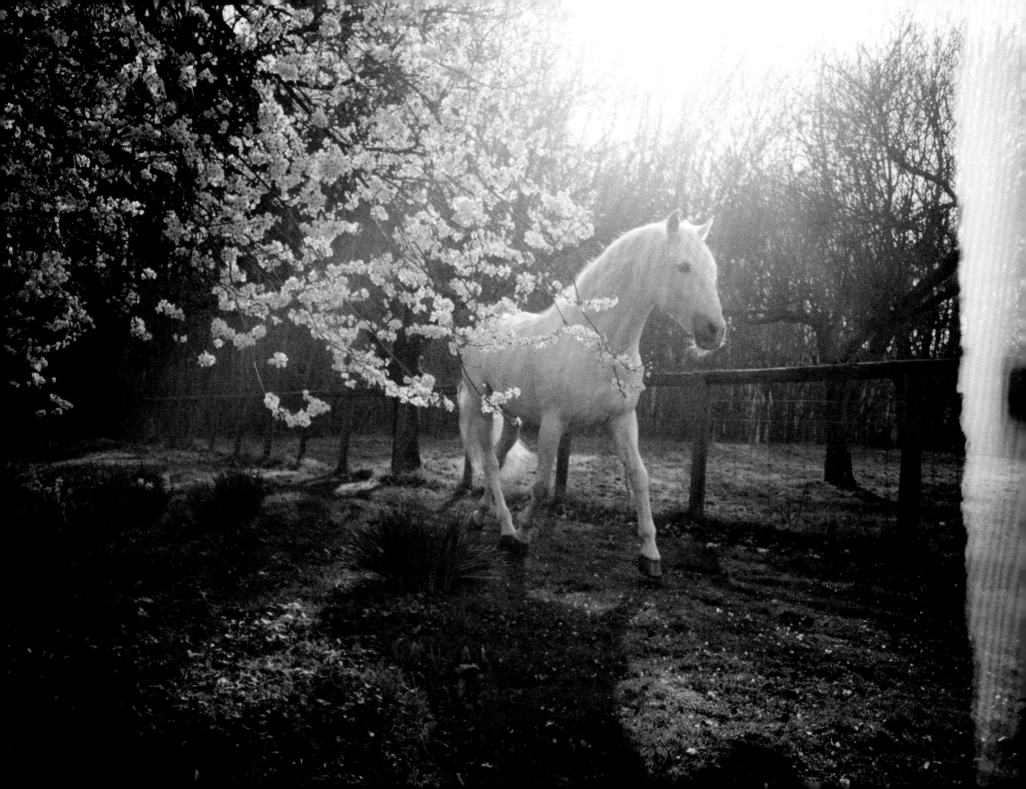

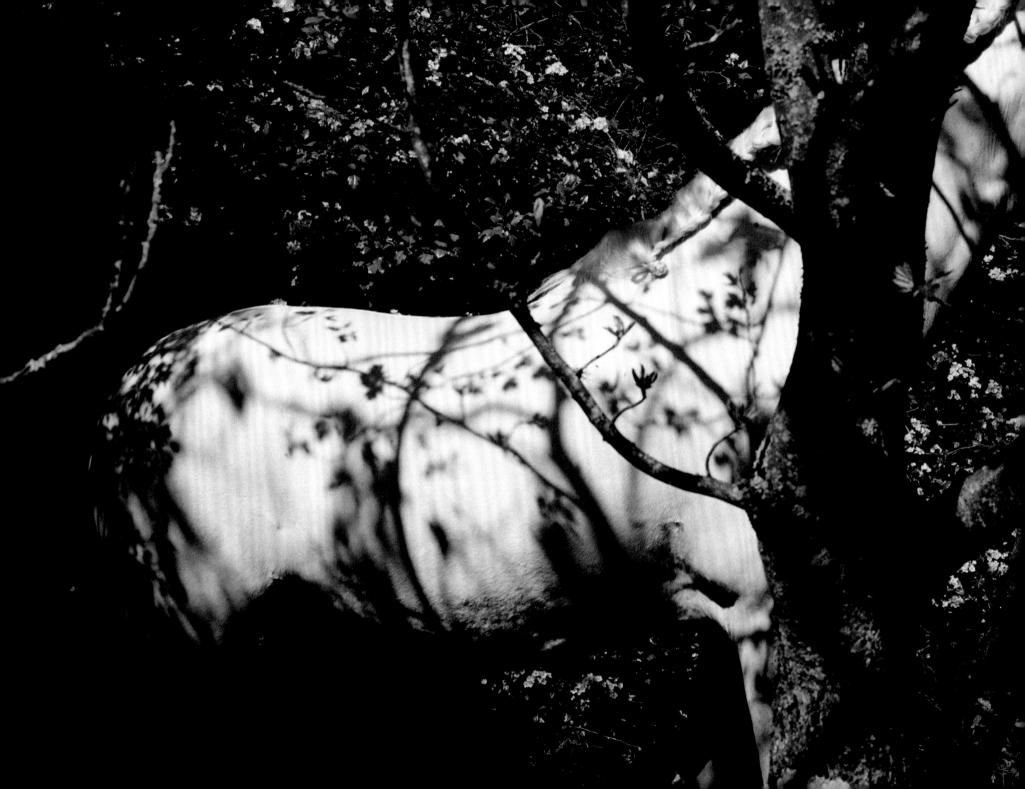

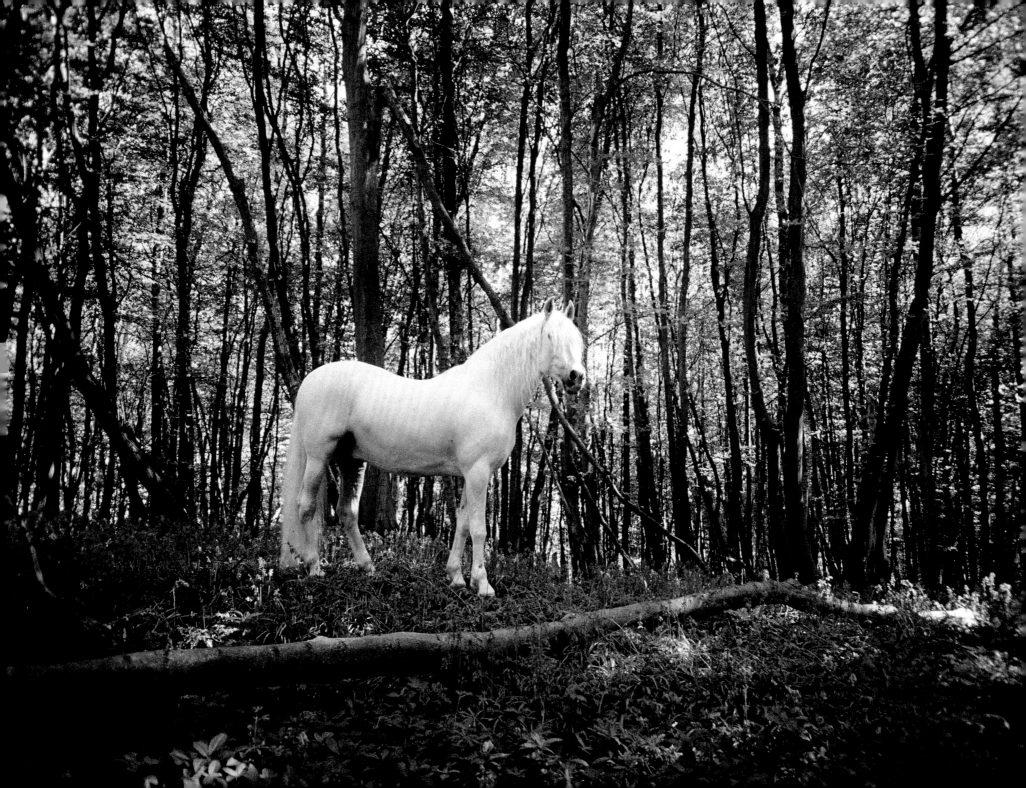

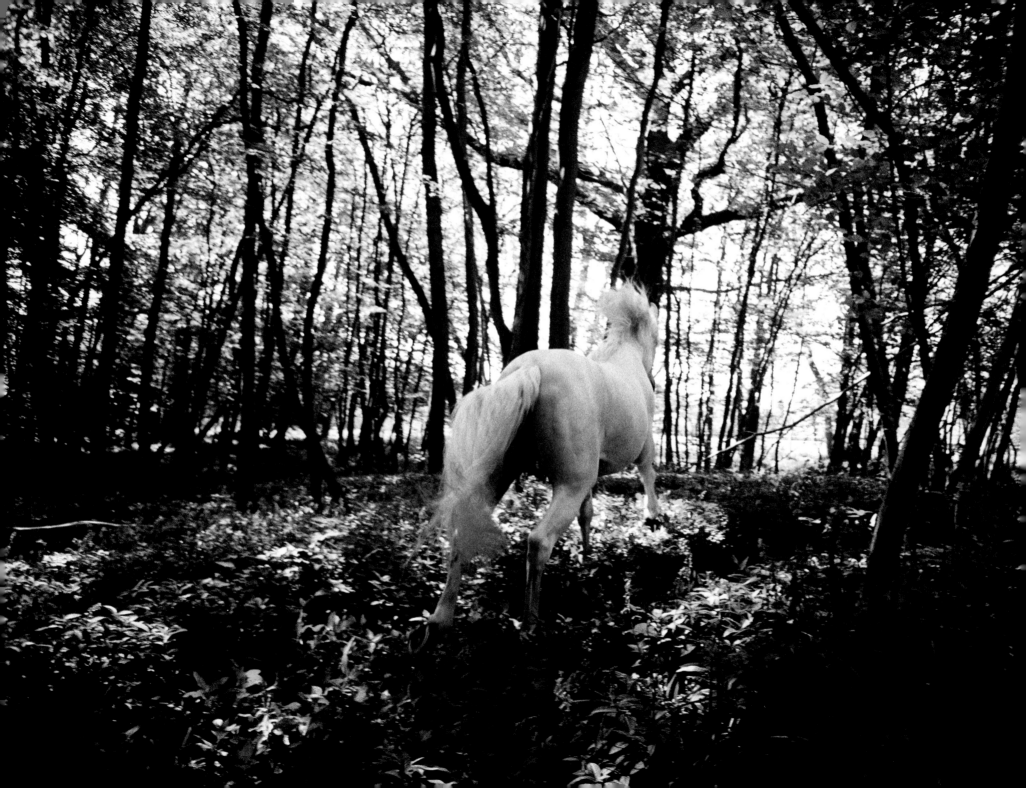

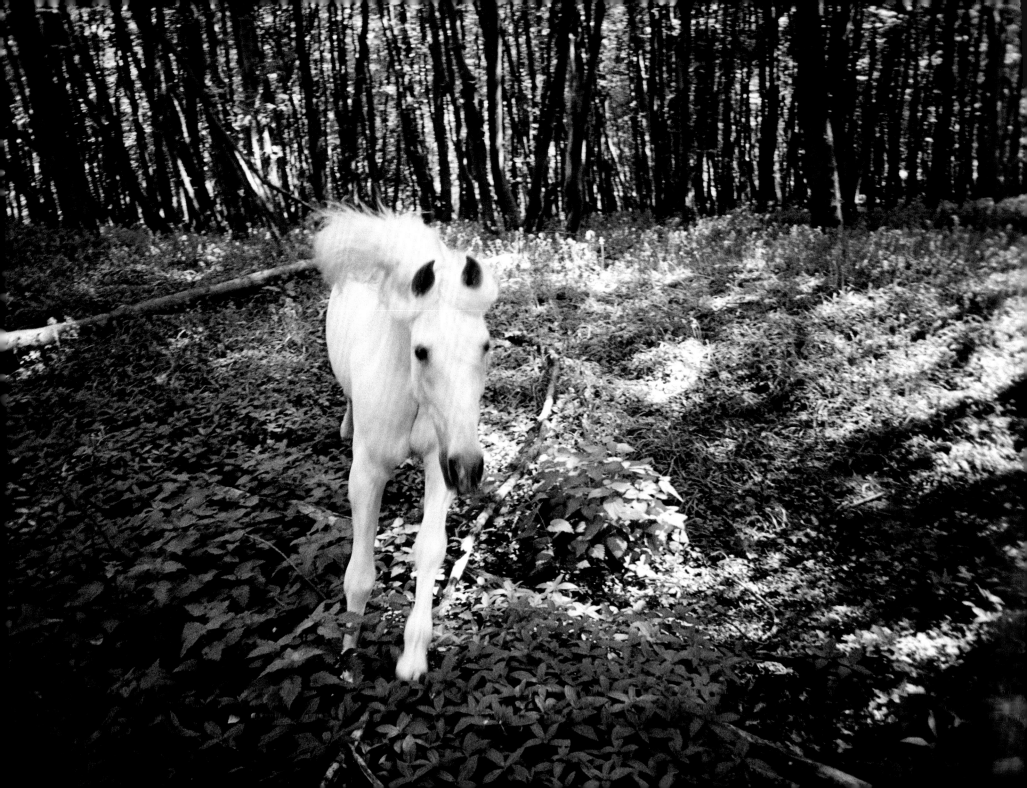

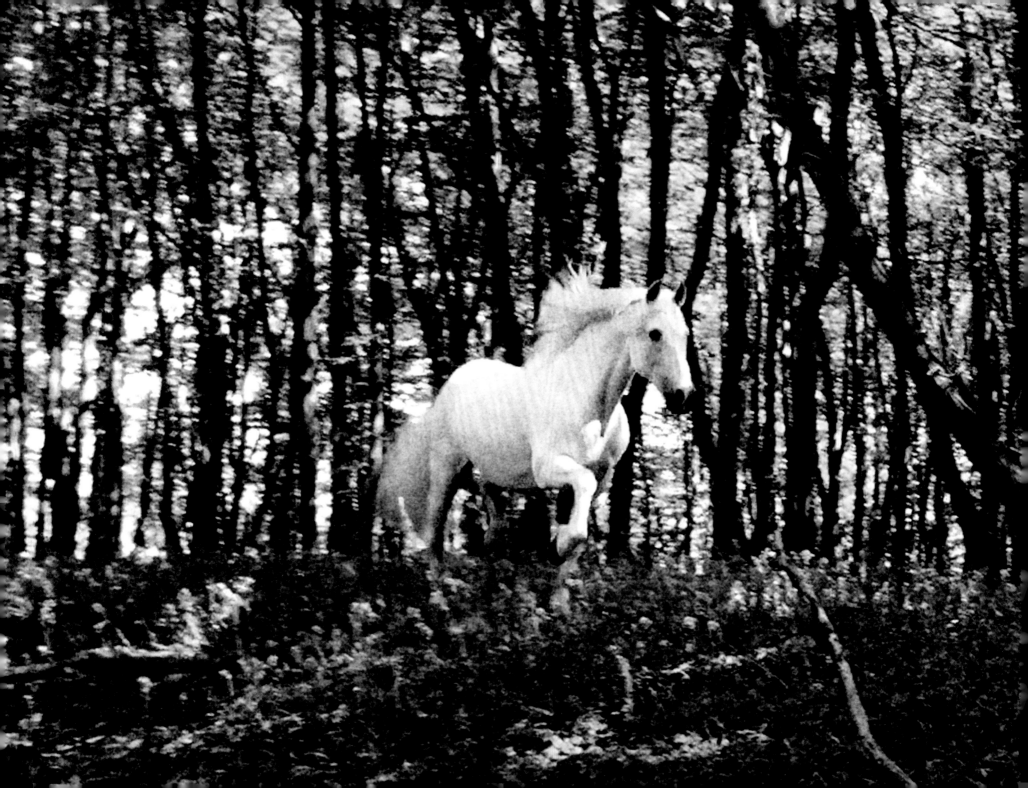

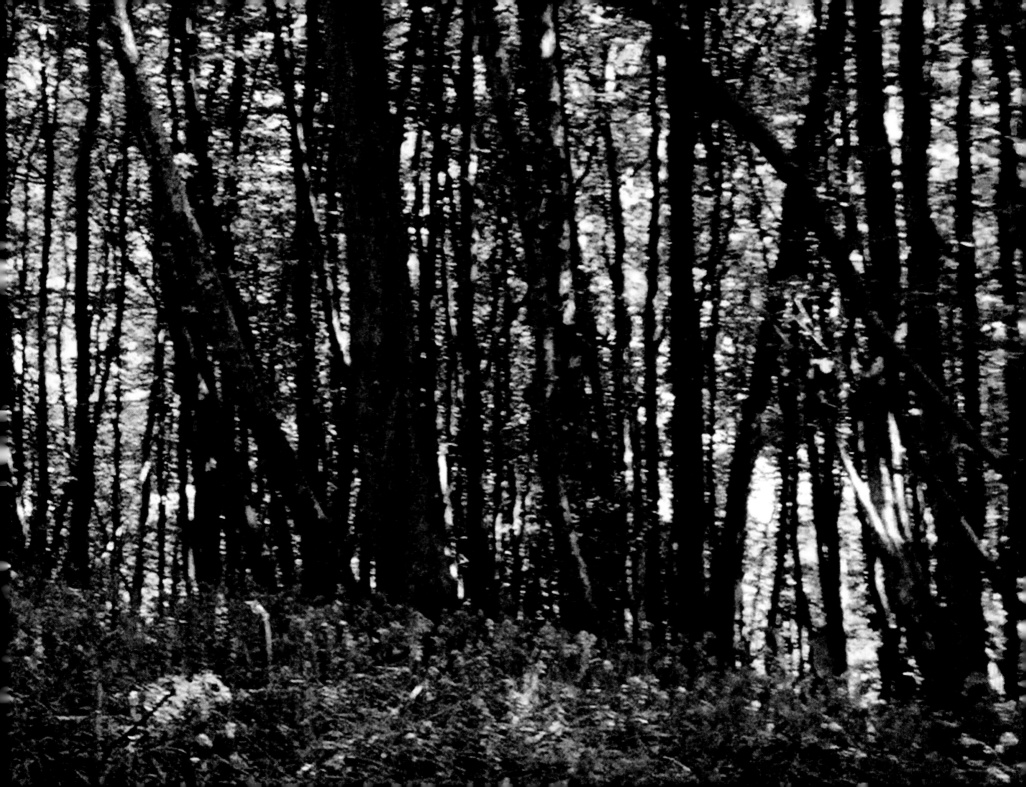

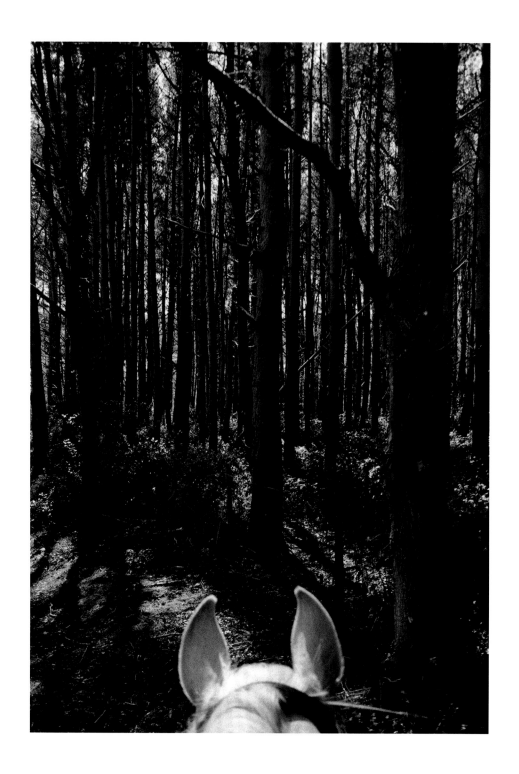

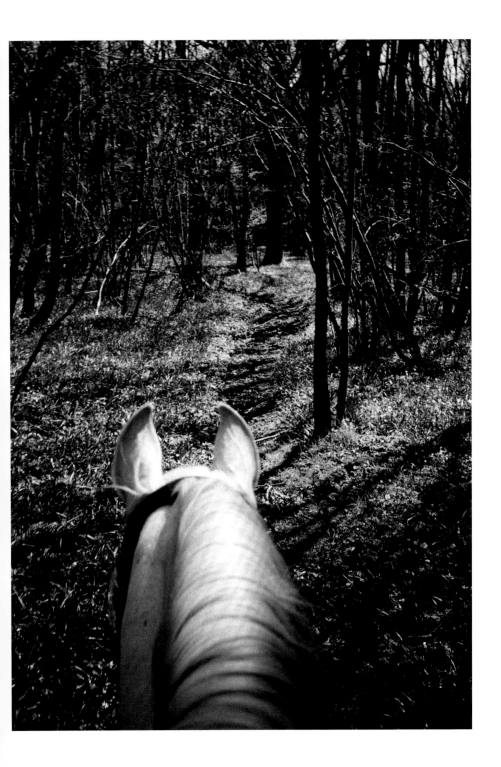
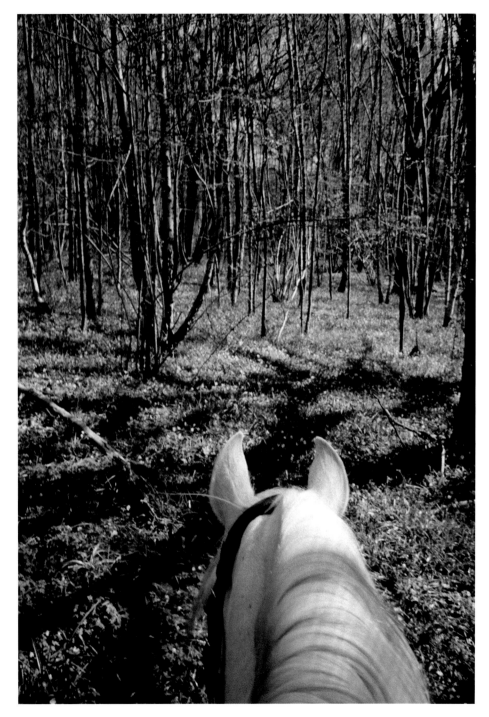

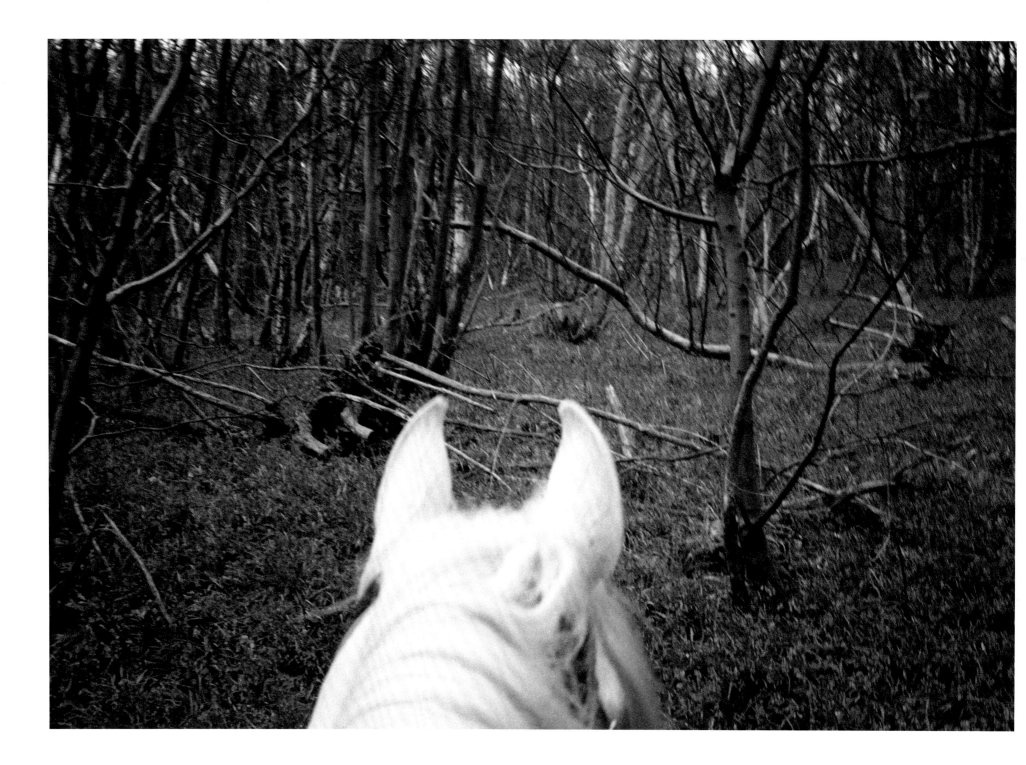

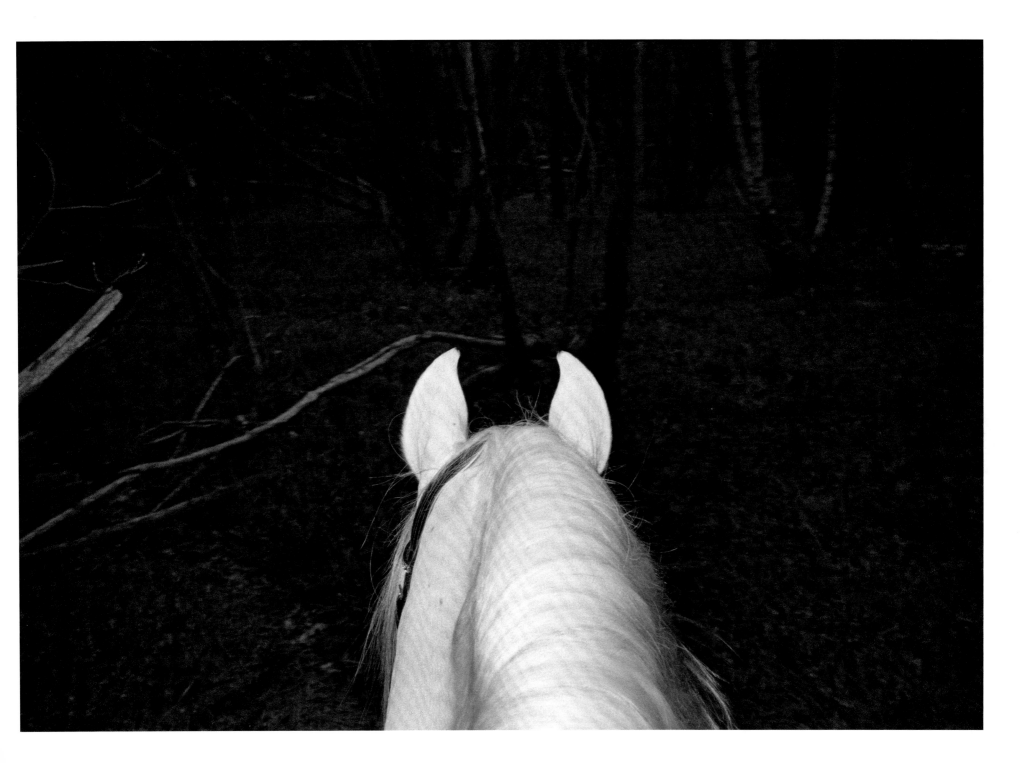

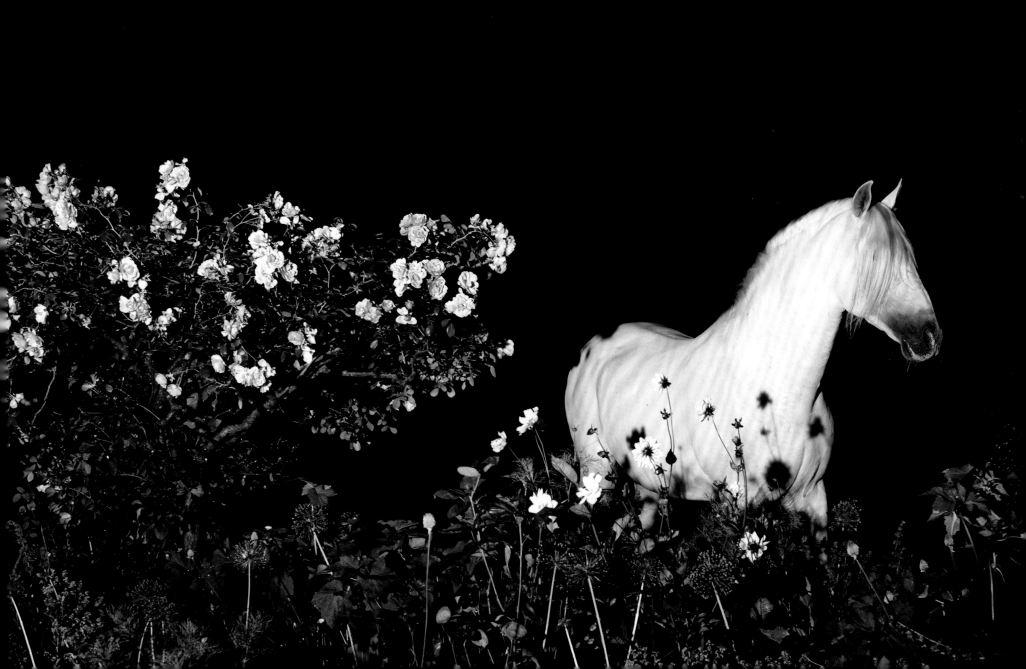

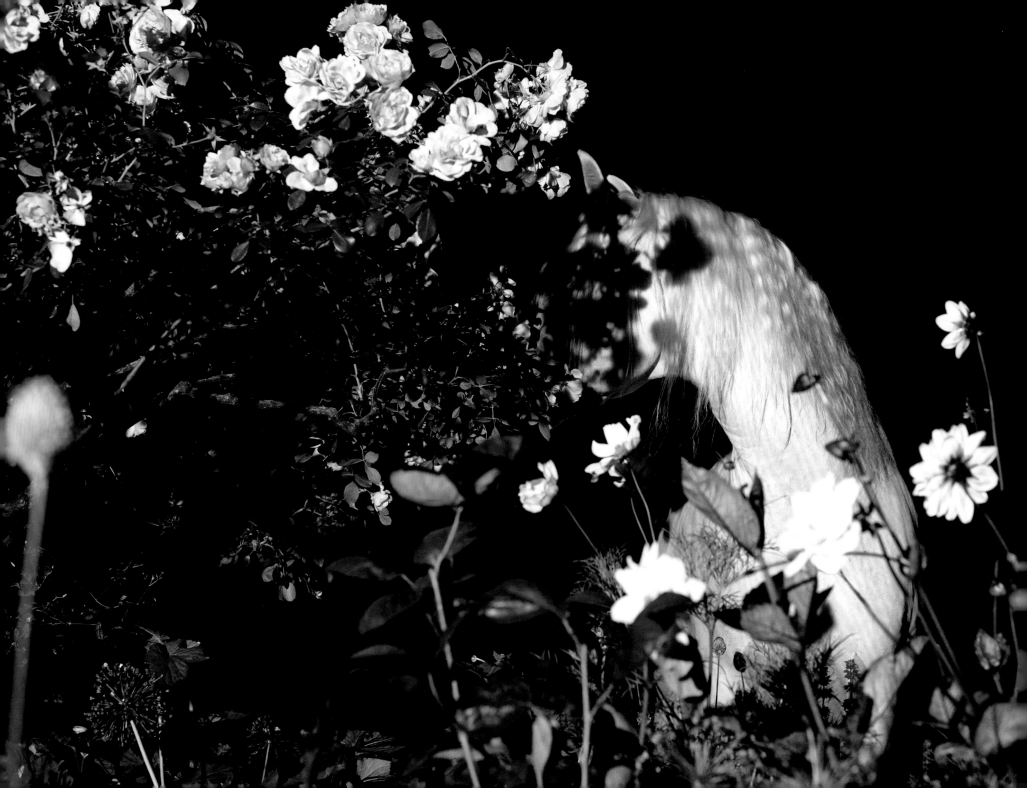

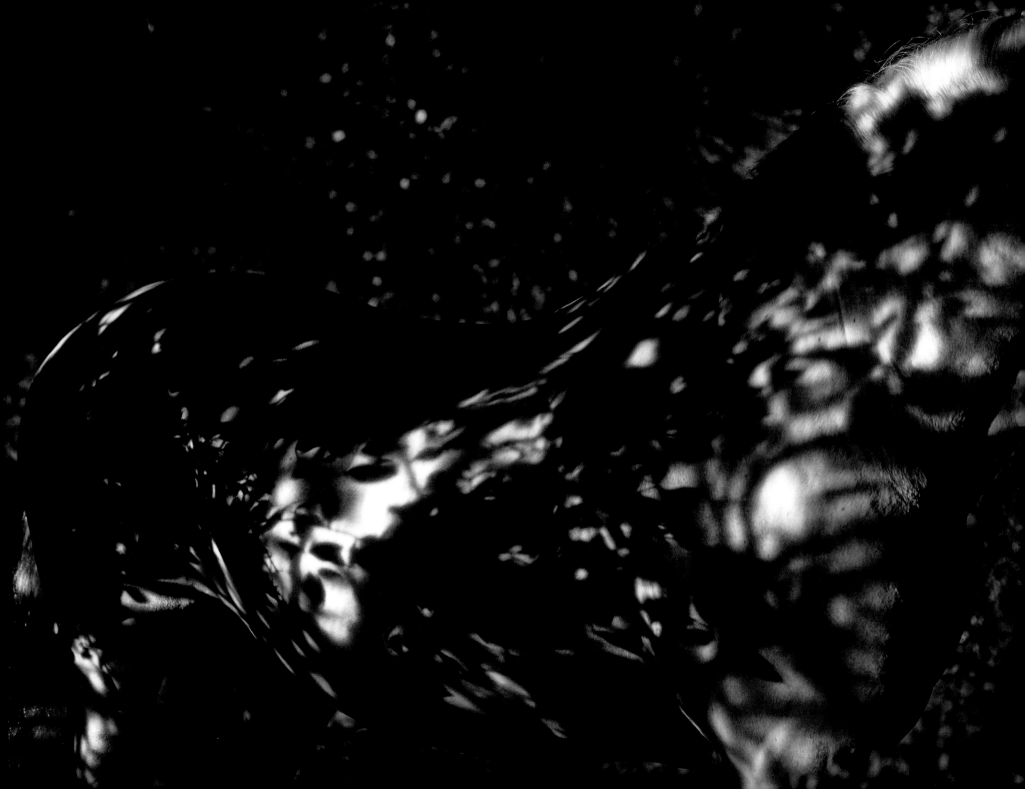

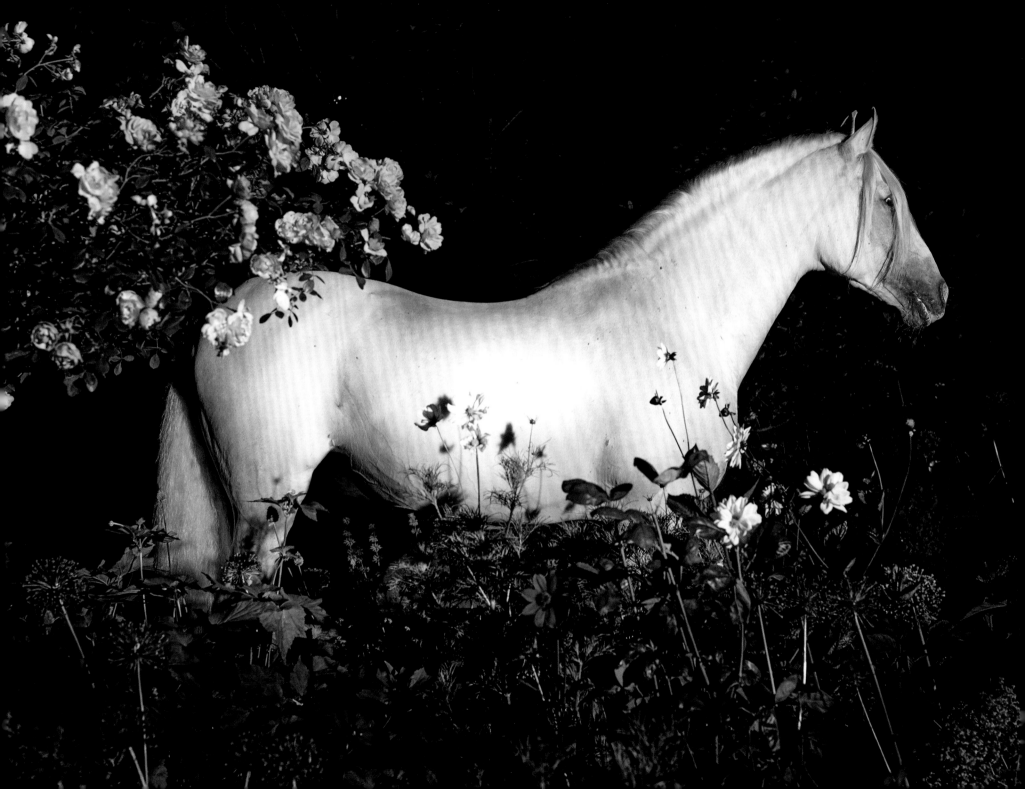

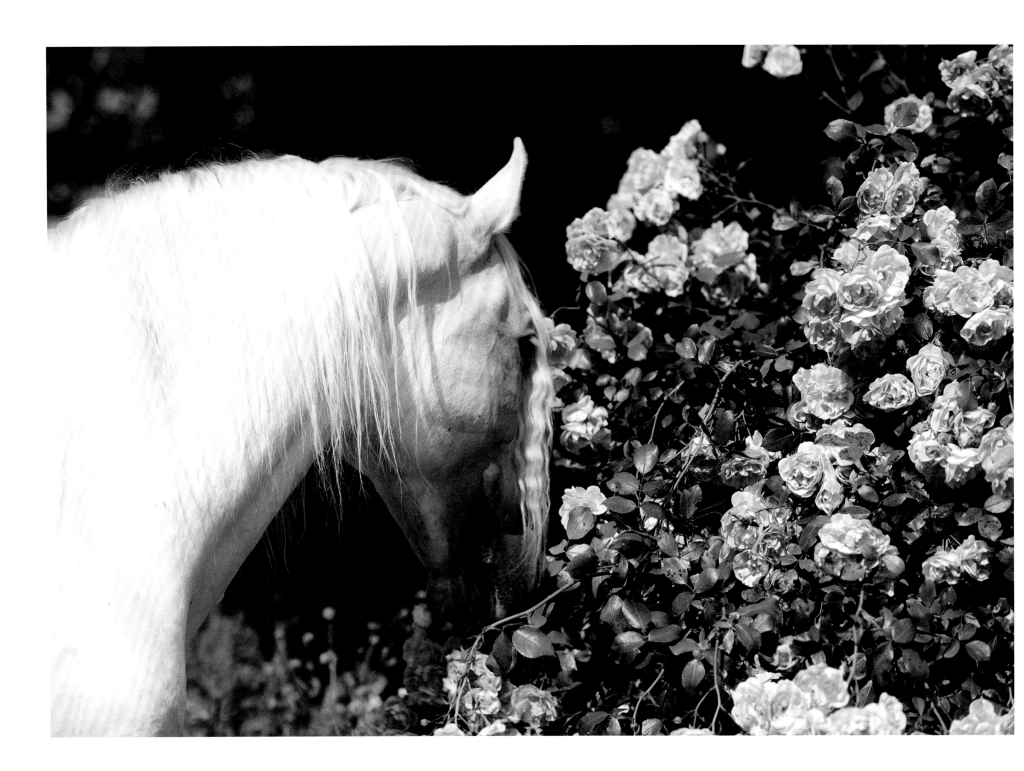

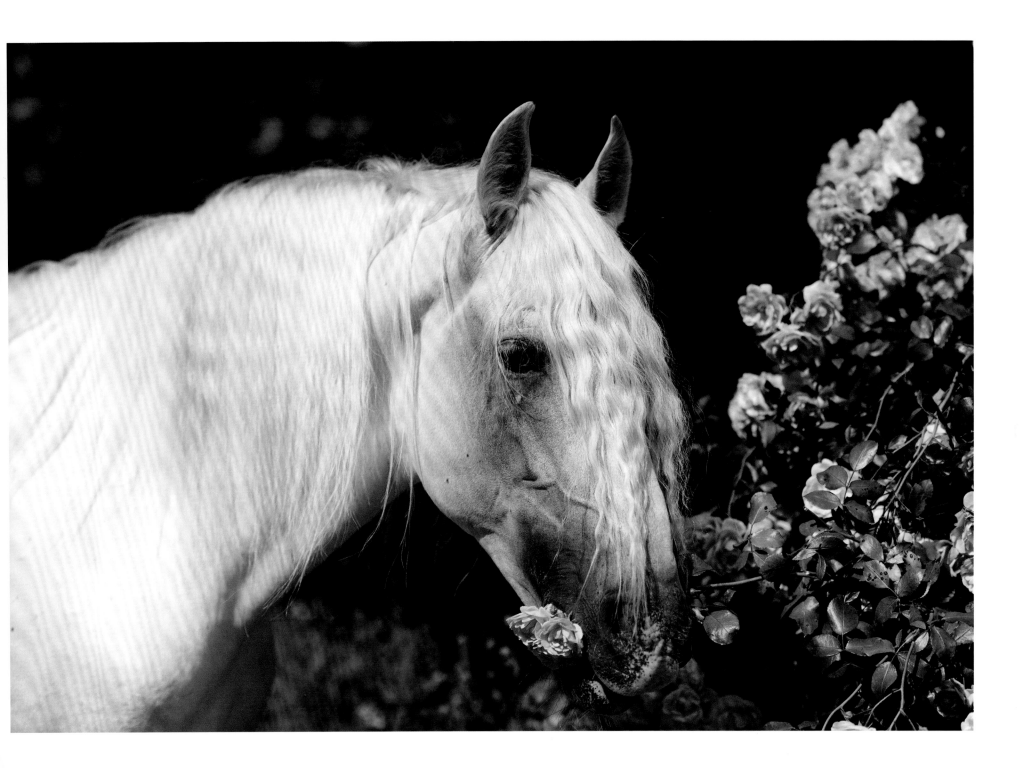

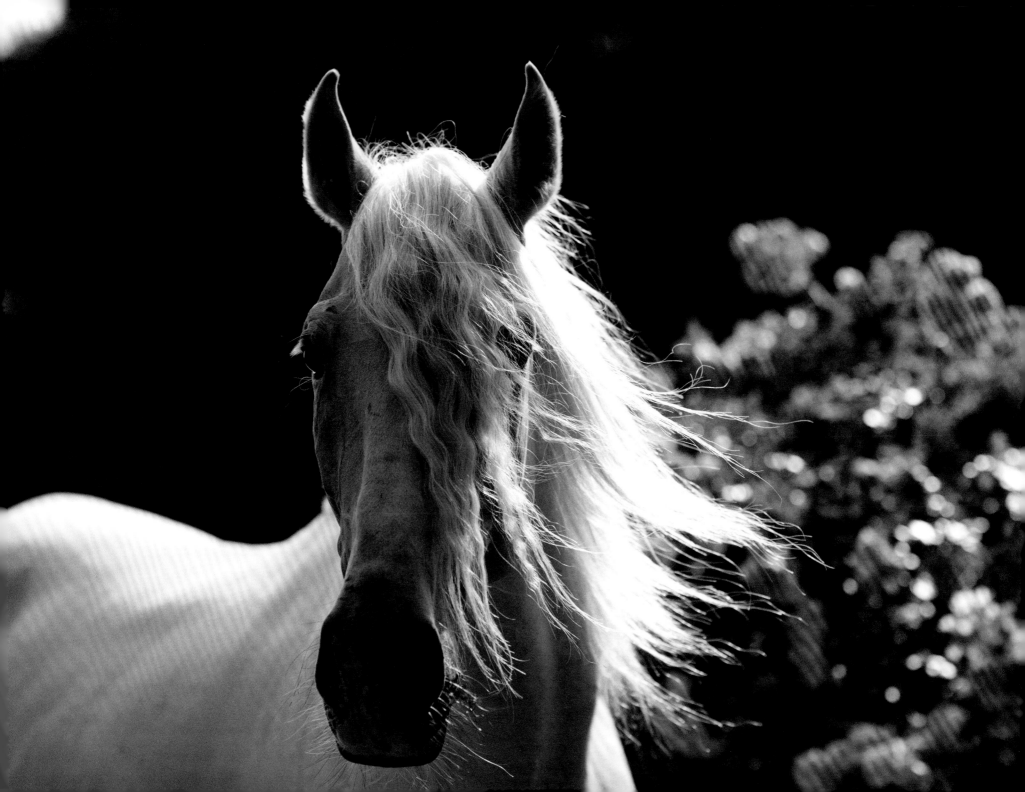

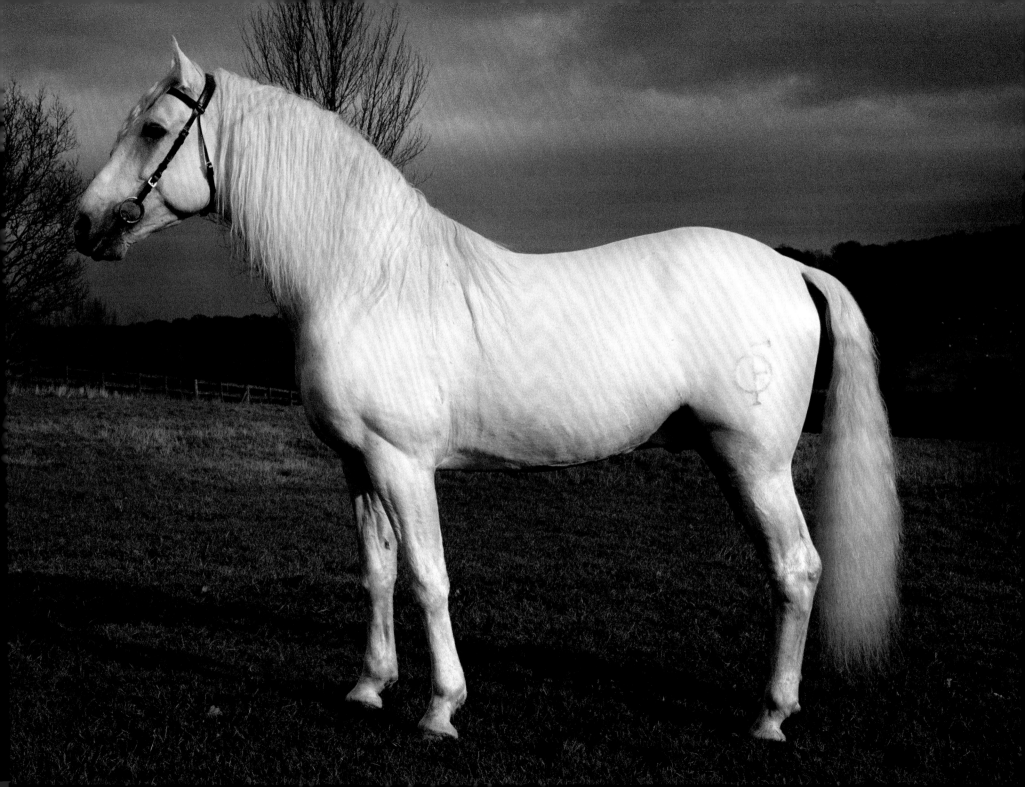

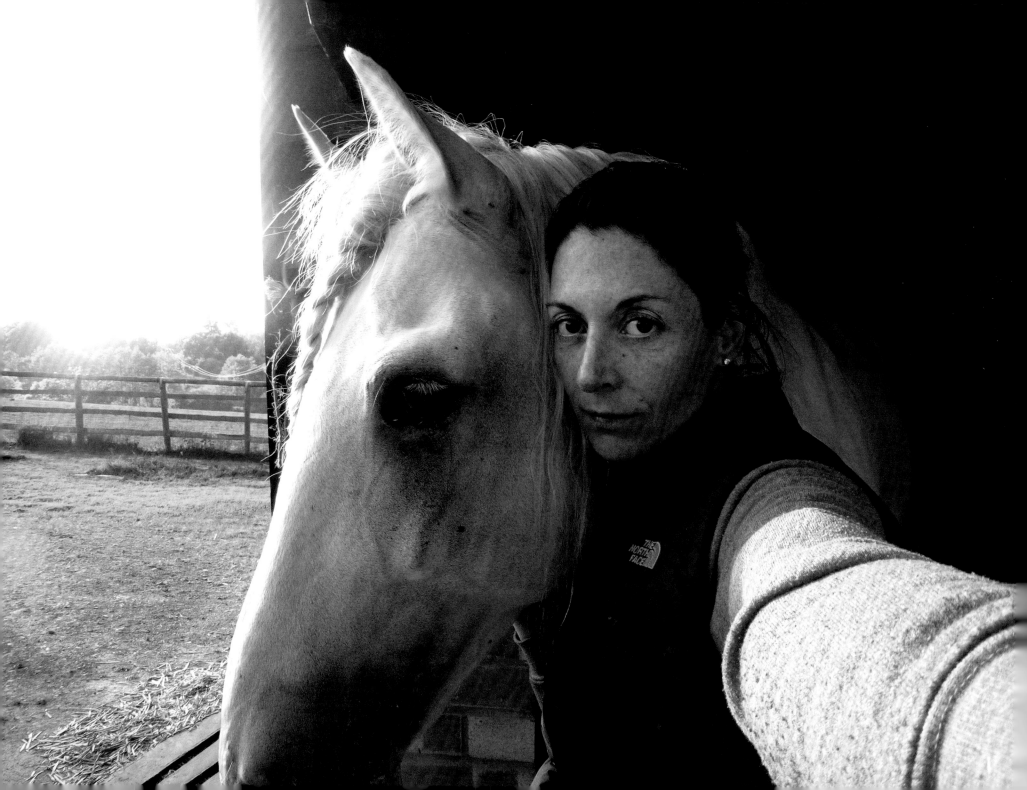

ACKNOWLEDGMENTS

My family, Bayeux, Alexander Brooks, Sean Davenport, Tina Deane, Charlotte Ellis, Giulia Garbin, Maria Pia Gramaglia, Will Grundy, Grace Guppy, Terry Hack, Louise Hedley, Sara Hickman, Chris Howgate, Metro Imaging, Rachel Leadbitter, Steve Macleod, Daniel Melamud, Charles Miers, John Mcilfatrick, Louise Morris, Sean Mulcahy, Ryan O'Toole, Jackie Parkinson, Thomas Persson, Sue Redmond, Rizzoli New York, Tarma Rowles, Richard Seymour, Louise Smith, Mel Trafford, Simon Turner, Tom Upton, Andrius Vystartas, Kasia Zdanowska.

Alejandro X was born in 2003 at the stud farm of Francisco Olivera Bermúdez, in El Pinar de Oromana, Alcalá de Guardaíra Sevilla. At twenty months of age he was purchased by Juan Manuel Fernandez of Caballos Camp Rodó and transported to Barcelona. At three years of age he started his training and the following year was requested by two Catalan stud farms as a stallion to improve their stock and has sired eight foals. After covering, Alejandro X returned to Caballos Camp Rodó to continue his training before arriving at his current home.

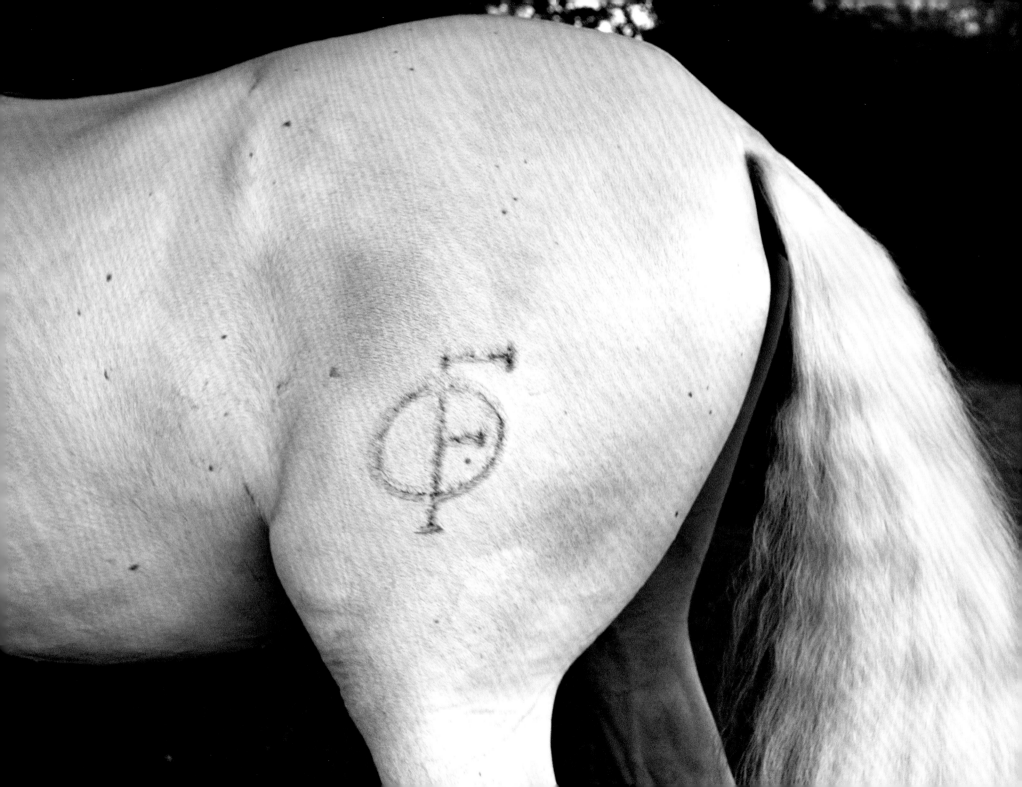

First published in the United States of America in 2018 by
Rizzoli International Publications, Inc.
300 Park Avenue South
New York, NY 10010
www.rizzoliusa.com

Photographs and foreword © 2017 Mary McCartney
Introduction © 2017 Simon Aboud

Edited by Daniel Melamud
Art Direction by Thomas Persson
Graphic Design by Giulia Garbin
Production by Maria Pia Gramaglia

ISBN-13: 978-0-8478-5849-1
Library of Congress Control Number: 2017955936

2018 2019 2020 2021 / 10 9 8 7 6 5 4 3 2 1
Printed in China